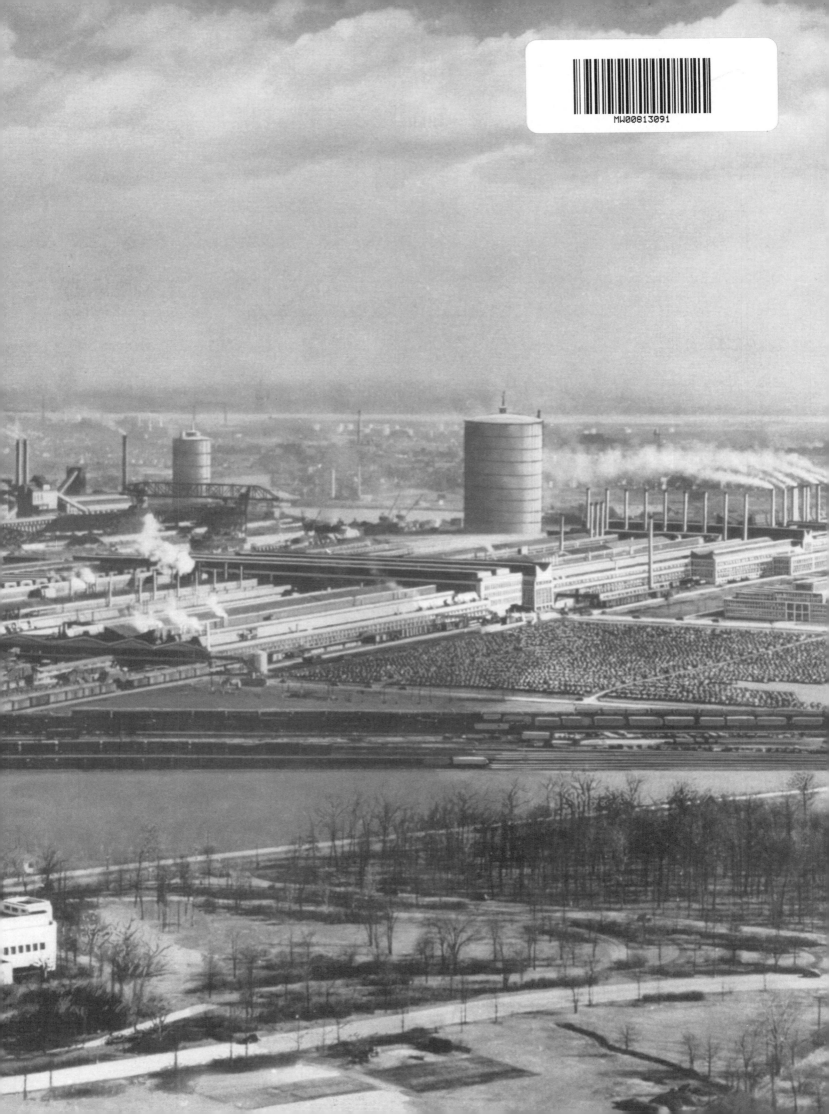

ROUGE

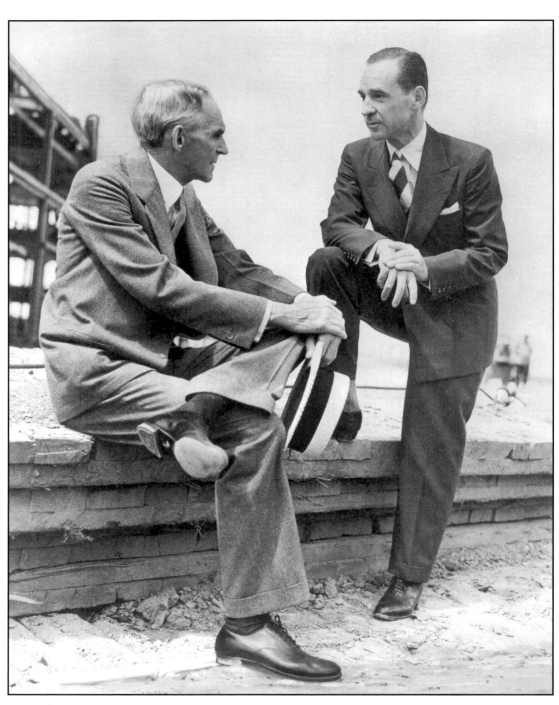

Henry and Edsel Ford discuss future plans at the Rouge Plant on June 16, 1938, the thirty-fifth anniversary of the founding of Ford Motor Company. (833.70942)

ROUGE

PICTURED IN ITS PRIME

FORD R. BRYAN

COVERING THE YEARS 1917–1940

Wayne State University Press
Detroit

18 17 16 15 14 11 10 9 8 7

ISBN 978-0-9727843-0-6

Designed by Mary Primeau

This book is dedicated to the Ford Motor Company photographers who have recorded the scenes over the years that make a book like this possible. With bulky cameras and lamps of that day, it was no easy task to produce the high-quality photographs they have made available to us. Of the many Rouge photographers, such names as these are found in the records: Breeden, Carlson, DeLonge, Dorsey, Ebling, Edmonson, Ellis, Farkus, Helmich, Hullhorst, MacKenzie, McKay, Nachmann, Pollock, Powers, Purrington, Stetler, Sullivan, Taylor, Walters, Wilson.

CONTENTS

Contents

ACKNOWLEDGMENTS

Publication of this book was possible only with the full cooperation of the staff of the Benson Ford Research Center of Henry Ford Museum & Greenfield Village. Permission to select photographs from a collection of more than 70,000 was granted by Judith Endelman, Terry Hoover, Cynthia Read Miller, and Catherine Latendresse. Help in finding appropriate photographs for the book was provided by Carol Wright, Jan Hiatt, Alene Solloway, and Andrea Gietzen. Melissa Haddock ably accomplished the scanning of the 390 photographs used in the book. Book compositor and designer was Mary Primeau. Wendy Warren Keebler did the editing. Arthur Evans and Alice Nigoghosian arranged for the distribution of the book by Wayne State University Press of Detroit, Michigan. Many, many others provided enthusiastic support which I find very helpful in a project such as this.

— FRB

FOREWORD

It is always a pleasure to learn that a record is being set straight or a story is being told that has not been heard completely. It is an even greater pleasure when one discovers that it is done with style, accuracy, and great visual appeal. Ford Bryan's new book, *Rouge: Pictured in Its Prime*, is just this sort of historical presentation. The story of Ford Motor Company's world-famous Rouge factory has been told in footnotes and photo essays but never in the kind of detail presented by Mr. Bryan. This National Historic Landmark factory facility is fully revealed, from the early vision of my grandfather, Henry Ford, through its full development in his lifetime as the most vertically integrated manufacturing facility in the world. *Rouge: Pictured in It's Prime* joins a solid shelf of equally fine books by Ford Bryan that document the many facets, friends, and activities of Henry Ford.

— William Clay Ford

INTRODUCTION

Now, in this new millennium, when the famous Rouge factory site in Dearborn, Michigan, is undergoing an industrial renaissance, it is imperative that we vividly portray its illustrious past before it is entirely forgotten. Once the largest, most efficient, and most highly integrated automotive manufacturing complex in the world, "the Rouge," as Detroiters called it, supplied direct sustenance to nearly 100,000 American families.

Based on experience building automobiles at Detroit's Piquette and Highland Park factories, Henry Ford by 1914 had visualized the ultimate—the continuous, uninterrupted processing of minerals from the earth into tractors and automobiles. Beginning with iron ore, within a matter of hours rather than days or weeks, the very same iron would be processed into a vehicle. This concept of manufacture was indeed unique within the automotive industry.

Despite contentious stockholders within Ford Motor Company, Ford maneuvered to begin construction of his idealized factory on the River Rouge, where he could build as many Fordson tractors as he was building Model T automobiles at Highland Park. Leading in the construction were the powerplant, blast furnaces, ore bins, coke ovens, and a giant foundry, iron castings being the major components of Fordson tractors as well as Model T automobile engines. Following a few years later would be the open-hearth furnaces, steel mills, press shop, glass plant, and complete automotive assembly operations.

Equipment and processes at the Rouge were always being changed to provide improved productivity. A machine was replaced as soon as a more efficient one could be either designed and built or purchased. Entire operations such as power generation, the coking process, glass manufacture, steelmaking and fabrication, and vehicle assembly were upgraded at frequent intervals. The story of the Rouge is a story of progress both industrially and socially. Investments totaling many millions of dollars, especially during the depressed 1930s, provided Ford workers with gainful employment during those otherwise hard times.

First known as the River Rouge Plant, in 1926 it became known as the Fordson Plant, because the Village of Springwells in which it was located then became the Village of Fordson, named after Henry and Edsel Ford. In 1929, when the Village of Fordson and the Village of Dearborn consolidated into the City of Dearborn, the Fordson Plant was renamed the Rouge Plant.

The Rouge was an industrial city in itself, covering an area of 1300 acres, with 23 miles of roadways, 100 miles of railroad tracks, 120 miles of conveyors, and more than a mile of docks facing storage bins capable of holding 2 million tons of raw materials. The main powerhouse burned pulverized coal to provide 330,000 kilowatts of electricity, enough to supply the City of Detroit if necessary. Gas produced by the coke ovens could supply the domestic requirements of a city of 1.5 million population. Water pumped from the Detroit River through a two-mile-long, fifteen-foot-diameter tunnel supplied 700 million gallons a day, as much as was consumed by the cities of Detroit, Cincinnati, and Washington combined. The Ford Fleet, with its twenty-nine vessels, connected the Rouge with the industrial world beyond.

Henry and Edsel Ford spent considerable time at the Rouge Plant prior

to 1940. They were especially concerned about working conditions in the buildings that covered 170 acres within the plant. All buildings were to be clean, the lighting adequate, and ventilation acceptable. Air conditioning was provided to the foundry at the same time as it was provided to the Miller Road executive offices at Gate Four. Rigid control of temperature was essential in some manufacturing areas in order to maintain precise and interchangeable sizes of parts, such as pistons in engines.

From its very beginning until about 1940, the Rouge Plant, under the personal direction of Henry and Edsel Ford, prospered as the company's main and most efficient automotive production plant. With the coming of World War II and immense government defense contracts, production peaked temporarily, but immediately following the war, decentralization of manufacturing was deemed advisable partly because of the fear of Soviet nuclear attacks. As a result, the Rouge has been relieved of much of its previous burden, and its glorious past becomes history.

From time to time over the years, guest photographers such as Charles Sheeler and Michael Kenna have produced limited collections of photographs depicting the unique architecture and machinery of the Rouge in exceptionally artistic fashion. And back in 1932, Diego Rivera was commissioned by Edsel Ford to execute a series of colorful frescoes depicting Rouge scenes that to this day decorate the walls of the Detroit Institute of Arts. These refined renditions of the Rouge are not to be overlooked, but to save the past in raw reality, one needs to involve the literally thousands of photographs taken routinely within the Rouge over the years by Ford Motor Company photographers. These professional-quality 8-by-10-inch photographs are saved with their dates in the Benson Ford Research Center of the Henry Ford Museum & Greenfield Village. In organizing this book, small groups of photographs, each representing a different department within the Rouge complex, are arranged in a sequence somewhat related to the order in which the operations were initiated at the Rouge. With such an abundance of photographs available, choosing the few to illustrate this book has been a challenging task. Unless otherwise indicated, all the photographs in this book are from Accession 833 of the collections of the Benson Ford Research Center of the Henry Ford Museum & Greenfield Village.

PROLOGUE

The Ford Motor Company was formed on June 16, 1903. Henry Ford, with several earlier partners — the Detroit Automobile Company in 1899, the Henry Ford Company in 1901, and the Ford and Malcomson Agreement in August 1902 — had failed in attempts to market a car. The first Ford Motor Company factory was located at 688–692 Mack Avenue in Detroit, where parts manufactured by the Dodge brothers and other suppliers were assembled into the Ford Model A automobile. This first assembly plant was a wooden one-story wagon shop for which Alexander Malcomson paid $75 a month in rent. Although a second story was soon added, the company would need a much larger factory by 1906.

This second Ford Motor Company factory, the Piquette Plant, was built to Henry Ford's specifications and occupied in 1906. Located on the northwest corner of Piquette and Beaubien Streets in Detroit, the main structure was a three-story brick building with about 100,000 square feet of floor space. Over the next three years, Ford Models B, C, F, K, N, R, and S and the first several thousand of the Model T were assembled at the Piquette Plant. While the Piquette Plant was used primarily for assembly, another factory, the Bellevue Plant, was put into operation for the manufacture of parts for assembly at Piquette. Beginning with the Model N, a four-cylinder car selling for $600, production began to skyrocket. Henry Ford's management team at Piquette included James Couzens, finance and sales; C. H. Wills, draftsman and metallurgist; Joseph Galamb, designer and draftsman; Eugene Farkas, machinery designer; Edward S. Huff, magneto and ignition specialist; Walter E. Flanders, manager of parts production; Peter E. Martin, manager of car assembly; and C. E. Sorensen, assistant to Martin.

The tremendous success of the R, S, and T models assembled at the Piquette Plant led to the need for a manufacturing plant at least an order of magnitude larger. The Model T had sold at the rate of 10,607 cars during the 1908–09 sales year. This proposed new Ford Motor Company manufacturing plant was to be located out in the northern countryside of Highland Park, a suburb of Detroit where sufficient land was available and where three railroads served the area. A plot of 56 acres on the east side of Woodward Avenue was chosen. Preliminary plans for some of the buildings were drawn by Ford construction engineers and turned over to Albert Kahn, who furnished the detailed designs and is credited with the plant's general architecture. The plant was designed to manufacture only one model: the Model T.

Although the initial move from Piquette to Highland Park took place at the end of 1909, building of the mammoth new plant continued into 1914. Early on, a gigantic machine shop produced engines, transmissions, and axles, and a large assembly room led to a shipping room. A state-of-the-art foundry was soon to follow, for the Model T was known for its many cast-iron parts. By 1913, Henry Ford had installed nine unique gas-steam powerplant engines producing 53,000 horsepower to furnish 36,000 watts of direct current to operate the shop machinery. These nine giant engines were installed in a glass-fronted building facing busy Woodward Avenue, Detroit's main thoroughfare, where all passersby would marvel at the sight. So sparkling clean from this front view, it was known to Detroiters as the "Crystal Palace." Also

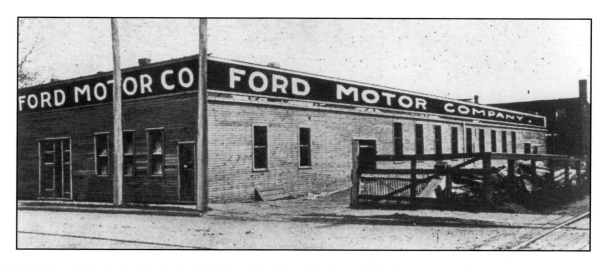

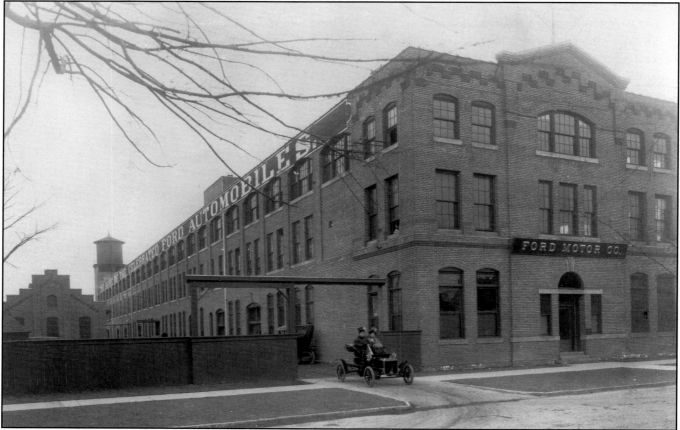

Top: Ford Motor Company's first automotive assembly plant on Mack Avenue in Detroit. (N.O.4135)

Bottom: Ford Motor Company's second automotive assembly plant at Piquette and Beaubien Streets in Detroit. This is where the Model T Ford was first produced. (N.O.3511)

facing Woodward Avenue was Ford's glitzy automotive showroom and a more than adequate administration building.

Production methods at the Highland Park Plant were especially innovative. It was here that many new automotive mass-production initiatives were undertaken, such as conveyors of many types to bring parts to the worker, with the worker seated or standing while his work came to him; subassembly lines to feed final assembly lines; and, most notable, in 1913, the moving automobile final assembly line.

The Highland Park Plant was then the "home plant" of the Ford Motor Company. Ford Motor Company of Canada had begun building Fords in 1905, Ford of Britain in 1912. It had been common practice at that time to ship completely assembled cars to domestic retail dealers until 1909, when it was determined that car parts could be shipped in bulk much more cheaply. This resulted in the decision to build branch assembly plants in a number of large cities in the United States. Thus, the Highland Park Plant could concentrate on the manufacture and shipping of parts.

With production reaching 300,000 a year and profits of more than $100 million, Ford could well afford in 1914 to offer his employees five dollars a day — twice what other employers were paying. With all the publicity, Ford's Highland Park Plant became a mecca for industrial tourists from throughout the world. Credit for much of the success at Highland Park should be shared with some of the Piquette principals — Couzens, Wills, Martin, Flanders, Galamb, Sorensen, Huff — and with newcomers such as William B. Mayo, William S. Knudsen, John Findlater, Clarence W. Avery, Norval Hawkins, John R. Lee, William H. Smith, and Frank L. Klingensmith.

But Henry Ford could see flaws in his plant's operation. Fifty-six acres was not enough land for necessary expansion. Another handicap was his dependence on railroads alone to bring materials into and out of the factory. A strike of railroad employees interfering with the supply of coal and temporarily closing the plant convinced Ford that he should henceforth insist that his manufacturing plants be situated on water and be accessible to foreign sources of supply.

On June 5, 1909, while the Highland Park Plant was under construction, Ford received a letter from John I. Turnbull, a Detroit real estate agent. Turnbull offered property known as Gaukler's or Milk River Point, described as frontage on East Jefferson Avenue of 796 feet, with a depth of about 1000 feet and fully 1800 feet of Lake St. Clair frontage. The offer also included 148 acres of adjoining land. To Turnbull's letter, Ford's secretary responded, "Dear Sir: regarding property known as the Gaukler's or Milk River Point, have to say that Mr. Ford is not at all interested." Beginning in August 1911, however, nine separate transactions are recorded for property purchased by the Fords lying between East Jefferson Avenue and Lake St. Clair. Included in these were five parcels from Josephine Gaukler costing $300,000, including what is known as the "Pointe." These nine properties cost the Fords a total of $677,640. In November 1912, still another piece of adjoining lakefront property was acquired for $53,000. Although it was rumored that the Fords were going to build a palatial home on Lake St. Clair, it is quite conceivable that Henry instead may have been planning for his next big factory to be at that site.

Henry and Clara Ford never did build either a home or a factory at Gaukler Pointe. It was not until fourteen years later that the land at the Pointe

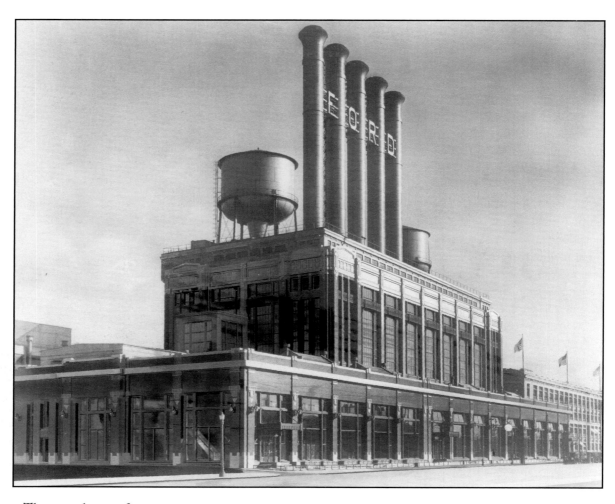

The powerhouse of the Highland Park manufacturing and assembly plant of Ford Motor Company as it faces Woodward Avenue in 1920. (833.29136)

was sold at cost to their son, Edsel, who engaged Albert Kahn to design the resplendent mansion that is today the most beautiful of the "auto baron" showplaces of the Detroit area.

By 1913, Henry Ford's thinking in regard to the location for a new and larger manufacturing plant was centered on the Rouge River less than three miles from his birthplace. That year, he asked his realty agent to look over the land bordering both sides of the Rouge River some two miles from where the Rouge flowed into the Detroit River. Although the land was low and the river barely navigable, he visualized improvements that would meet his needs. He realized that the first mile or so of the Rouge River had accommodated heavy industry nearly a century earlier; the U.S. Army Corps of Engineers had dredged a somewhat larger channel and had proposed in 1892 a turning basin about two miles from the mouth of the Rouge.

Ford could have been influenced considerably by William Livingstone, Jr., president of the Dime Savings Bank of Detroit, owner of the *Detroit Evening News,* and president of the Lake Carriers' Association. William and Susan Livingstone were close personal friends of Henry and Clara Ford. Having had considerable experience with Detroit River harbor development, on June 30, 1915, Livingstone supplied Ford with details of the costs and the amount of dredging of the Rouge River completed by the U.S. government between 1888 and 1912. Livingstone also described further dredging work to which the government was committed as far as Maples Road two miles north

of the Detroit River, a commitment that would be of substantial benefit to Ford in building a manufacturing plant on the Rouge River.

Through his agents, Ford began buying land on either side of the Rouge River, and especially north of a westward bend in the river, about two miles from the river's mouth. Much of the land had been subdivided into lots, and a number of truck gardeners were among the occupants. On May 17, 1915, Ford Motor Company officials C. E. Sorensen, P. E. Martin, and William B. Mayo, together with Henry Ford and his real estate agent, Fred Gregory, walked around the property, which, according to Martin's notes, was "bounded by Pere Marquette and Michigan Central Railroads on the northeast, by Dix Avenue on the south, and Maples Road on the west — a distance of five miles. Time from 4:50 P.M. to 6:20 P.M. 1115.12 acres in the above property."

On November 2, 1916, at a meeting of Ford Motor Company directors, the following resolution was moved by James Couzens and supported by Horace Rackham:

WHEREAS THIS company has for some time past been making preparations looking to the manufacture of its own iron and the erection of a manufacturing plant on lands to be acquired from Mr. Henry Ford at the River Rouge, Wayne County, Michigan for the purpose, and whereas approximate estimates have been submitted by the company's engineers for such work as follows:

Two (2) 500-ton Blast Furnaces, Stoves, Blowing Engines, Ore and Stock Bins and Ore Handling Equipment	$4,500,000
Ore Dock and River Dock Front	1,000,000
Turning Basin, Canal Dredging, etc.	250,000
1,000 Ton By-Product Coke Oven Plant with necessary Benzol Plant	2,000,000
Power Plant	1,500,000
Foundry Buildings	550,000
Foundry Equipment	250,000
Malleable Foundry	500,000
Malleable Foundry Equipment	150,000
Office Building Equipment	25,000
Office Building	150,000
Track and Transportation Equipment	250,000
Miscellaneous Buildings	200,000
	$11,325,000

AND whereas certain steps have been taken by the management preliminary to such work, including the hiring of an engineer, preparation of plans, etc.,

Now, therefore, resolved that the undertaking aforesaid be proceeded with, that the action heretofore taken in that behalf be ratified and confirmed and the officers and management are authorized to go forward with said works as in their judgment may be most advantageous and economical to this company and they are authorized to execute and carry out the necessary contracts in connection with such work and make all payments required in the course therof.

And resolved that this company purchase of Henry Ford for the purposes aforesaid the following described lands, vis. — Lands in Springwells Township, Wayne County, Michigan described as follows: bounded on the north by the Michigan Central R.R., bounded on the east by the Pere Marquette R.R., on the south by Dix Avenue and River Rouge, and on the west by a line approximately fifty feet east P.C. 29 extended to the River

Rouge — at the cost thereof to Mr. Ford with interest at the rate of 6% per annum, approximately $700,000 and that the officers are instructed to accept conveyance from Mr. Ford and pay the price stated upon transfer being completed, and

Resolved further that the expense of Turning Basin and dredging of canal as shown upon plans of the engineers, half of such canal being upon lands of Mr. Ford and half upon lands of this company, be borne equally by this company and by Mr. Ford, and that management be authorized to proceed with such work and make necessary arrangements to divide the expenses. Carried unanimously.

On November 13, 1916, the following letter regarding plant site justification was received by Ford Motor Company from Julian Kennedy, a steel plant specialist in Pittsburgh, Pennsylvania:

Regarding the proper location of blast furnaces. I suppose that every one would, other things being equal, prefer a site on the Detroit River, but the site that has been chosen has about 1,000 acres of land lying very level and admirably served by railroads practically surrounding it. It is well located with reference to your present works and is surrounded by a large amount of territory available for residence sites for employees.

It has been the universal experience of successful iron and steel works that sites which are thought to be extremely ample at the outset are found in a few years, to be entirely inadequate and more lands have to be acquired at a very greatly enhanced cost, so that the only safe way is to start with an acreage which seems absurdly large.

Blast furnaces, coke ovens, open hearth works, bar and sheet mills and the other mills which naturally are liable to be added to an iron and steel plant require a good deal of territory as most of them are one-story plants, as compared with several stories which can be used in other manufacturing plants. The location chosen involves about two miles of channel made by improving the River Rouge, but this is a very simple job compared with the improvement of the Cuyahoga River in Cleveland, which has several large works along its length. This improvement is one that will inevitably be made in the near future as the city of Detroit needs the additional harbor frontage which this would give in order to properly handle the rapidly growing tonnage she will send out. The cost of this improvement will be so little compared with the benefit that it must come soon in any event.

While I have not had an opportunity to examine the other available sites in and around Detroit, I am told that it is not possible to find a large site having the advantages possessed by this one, not the least of which is the facility with which it can be connected by belt line with your present works.

In my judgment these advantages far outweigh the disadvantages due to the distance of the site from the Detroit River. The advantage of Detroit as a distribution point due to its being on the main artery of transportation of ore southward and coal to the north, together with the splendid facilities for shipping finished products both by rail and water make it desirable to start any new plant with an acreage of land so large as to do away with any chance of shortage developing in the future as the extent to which the work will grow is likely to be beyond the most optimistic dreams of any of us today.

Also in November 1916, William B. Mayo, Ford Motor Company's chief power engineer, provided his own "Report on River Rouge Location":

My opinion of the selection of the River Rouge site as compared with a

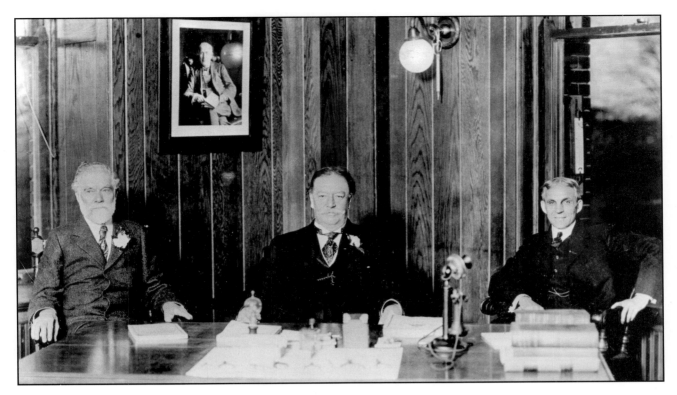

location at the Detroit River for a blast furnace and motor manufacturing plant is as follows:

From a strictly engineering point of view disregarding all other essentials, a blast furnace operation on the Detroit River would probably be conducted with little more ease of operation and with slightly better economy if viewed from the standpoint of the transportation and delivery of raw materials only. But a plant on the Rouge River has many other advantages which more than offset this one feature.

My understanding of the reasons for the selection of the Rouge River site was first to select a location on which a blast furnace, with connecting foundry, steel plant and motor manufacturing plant could be erected that would be different and better than any existing plant of a similar kind and to be of such highly specialized construction to be more economical than anything yet devised, and to this end it was necessary to pick out a location that would embrace all the necessary essentials from both the civic and engineering viewpoint and, in addition, be so located as to have easy connection with the existing plant at Highland Park.

In my opinion it is of absolutely prime importance in the selection of a location for an operation of this kind for the Ford Motor Company, which has always made a special feature of building both tools and buildings along more advanced ideas than others and paving the way for advancement in the manufacture of their particular product, and with special reference to the worldwide advertising feature to the very large numbers of visitors as to how well everything is done and as to its cleanliness and sanitary standards and particularly to the extensive welfare work for their employees, that of all other things the location should be such as near as possible a spotless town appearance that could be attained both in regards to the plant and to its surroundings, with a country-like atmosphere and yet close to the city.

The River Rouge location seems to have all of these possibilities together with the opportunity for good cheap village residences and garden plot for a large number of employees, who would also have easy and cheap access to the city.

A meeting in the Highland Park office of Henry Ford on December 3, 1914. At the left is William Livingstone, at the desk is William Howard Taft, and at the right is Henry Ford. Taft may be examining documents concerning the federal government's role in the development of the Rouge River. (P.O.585)

19

In regard to the cost of delivery of raw materials to this site by water, after the river is properly dredged, as compared with a delivery on the Detroit River — if any difference did exist it would be insignificant as an offset, this property is bounded on three sides by railroads and is of easy access to practically every railroad in Detroit that does not already touch it.

It is accessible to employees from all points of the compass and adjoins one of the largest labor sections in the city of Detroit, Michigan Avenue, Dix Avenue and Fort Street are all close to the property and everything is free to so arrange street railroad facilities especially for this particular improvement. A Detroit River location could not have these advantages.

With the river improvement an adequate water supply is provided which, while not of as much volume as the Detroit River, should be sufficient.

In the very near future, manufacturing plants will be prohibited from polluting the rivers with their sewage, hence this site is such that it has sufficient space to properly take care of this and treat its sewage, which in time should be led off through sewers into the Detroit River at a considerable distance below the City of Detroit.

The boulevard that is projected and assured between Highland Park and this site gives a quick vehicle connection between the two plants and paves the way for connecting car lines.

The plot of ground as a whole is practically level with no costly bad grades to contend with and the bottom is, in my opinion, equally as good or better than the Detroit River location.

The dredging of the River Rouge opens up a considerable new dock frontage for the city which is of great value, and our private island dock thoroughly protected from the elements and a perfect harbor for laying up boats in the winter is of great importance.

The parking of the river banks and the rural advantages that are possible makes the site an ideal one from the employee's point of view and will in time have an untold bearing on the efficiency of the men and a great bearing on the profits and prosperity of the Ford Motor Company.

From the information I have gathered, we have not been able to find a piece of property as close to the city, of approximately 400 acres and even if a piece of property of this size could be found it is my opinion that it would cost at least double the cost of the Rouge property, and added to this there would be a very expensive additional work to be done in foundation and grading work; also the Detroit River location could only be served by one or two railroads and access to the property could only be gained from one side, with a difficult arrangement of yard and terminal facilities which need a great deal of space outside of our own acreage.

From information given to me from what I consider reliable authority, there is not over two hundred and twenty-seven acres available in one tract on the Detroit River and the selling price will be four thousand (4,000) dollars, or more, per acre. We have had a price of two tracts of land, each of about two hundred acres, the price of one piece being $2,000 per acre and the other $2,500 per acre.

The decision had now been made. Ford officials, particularly Couzens, Rackham, Mayo, Martin, and Sorensen, together with Henry Ford, had decided that the banks of the Rouge River were best suited as the site of what would be the largest manufacturing plant in the world. Ford had already purchased more than enough land northwest of the factory site to provide for extensive plant expansion and residences for the families of several thousand employees.

ROUGE

PICTURED IN ITS PRIME

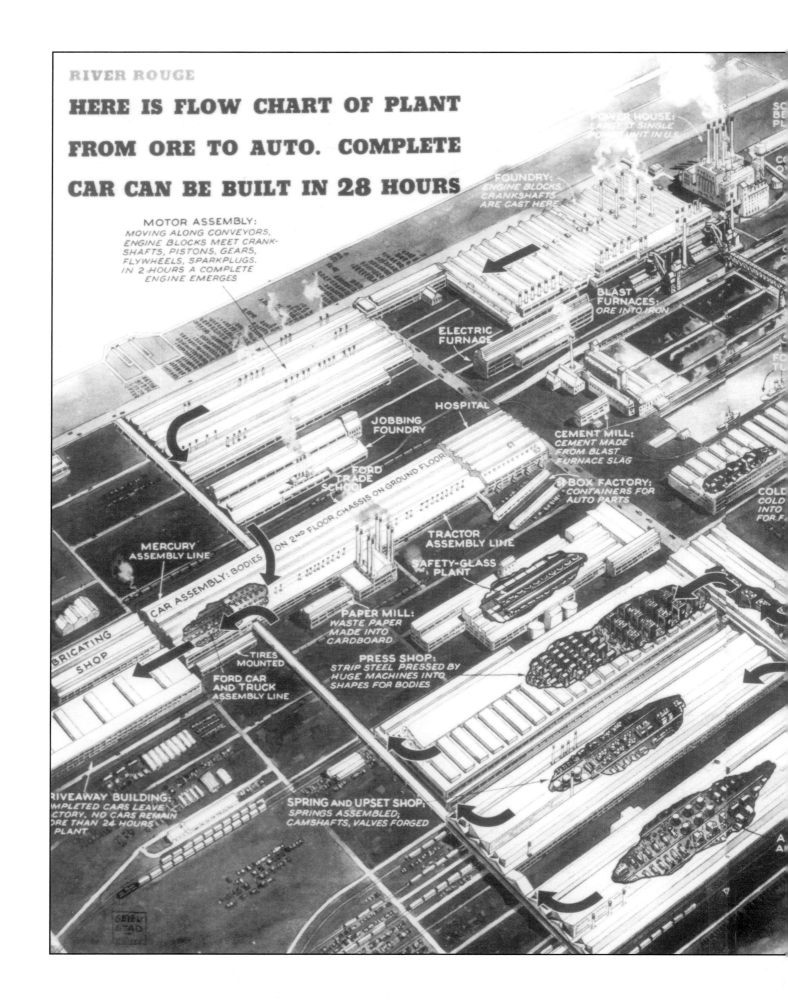

RIVER ROUGE

HERE IS FLOW CHART OF PLANT FROM ORE TO AUTO. COMPLETE CAR CAN BE BUILT IN 28 HOURS

MOTOR ASSEMBLY:
MOVING ALONG CONVEYORS,
ENGINE BLOCKS MEET CRANK-
SHAFTS, PISTONS, GEARS,
FLYWHEELS, SPARKPLUGS.
IN 2 HOURS A COMPLETE
ENGINE EMERGES

FOUNDRY:
ENGINE BLOCKS,
CRANKSHAFTS
ARE CAST HERE

POWER HOUSE:
LARGEST SINGLE
POWER UNIT IN U.S.

BLAST
FURNACES:
ORE INTO IRON

ELECTRIC
FURNACE

HOSPITAL

JOBBING
FOUNDRY

CEMENT MILL:
CEMENT MADE
FROM BLAST
FURNACE SLAG

FORD
TRADE
SCHOOL

ON 2ND FLOOR, CHASSIS ON GROUND FLOOR

BOX FACTORY:
CONTAINERS FOR
AUTO PARTS

MERCURY
ASSEMBLY LINE

CAR ASSEMBLY: BODIES

TRACTOR
ASSEMBLY LINE

SAFETY-GLASS
PLANT

LUBRICATING

SHOP

PAPER MILL:
WASTE PAPER
MADE INTO
CARDBOARD

TIRES
MOUNTED

PRESS SHOP:
STRIP STEEL PRESSED BY
HUGE MACHINES INTO
SHAPES FOR BODIES

FORD CAR
AND TRUCK
ASSEMBLY LINE

DRIVEAWAY BUILDING:
COMPLETED CARS LEAVE
FACTORY. NO CARS REMAIN
MORE THAN 24 HOURS
IN PLANT

SPRING AND UPSET SHOP:
SPRINGS ASSEMBLED;
CAMSHAFTS, VALVES FORGED

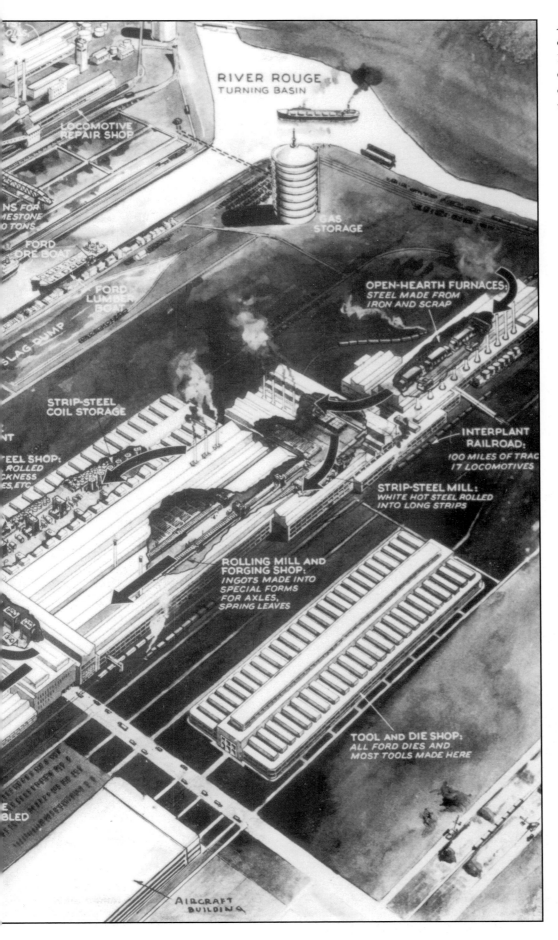

A diagrammatic rendition of the Rouge Plant circa 1940, showing locations of buildings and the flow of materials from building to building.

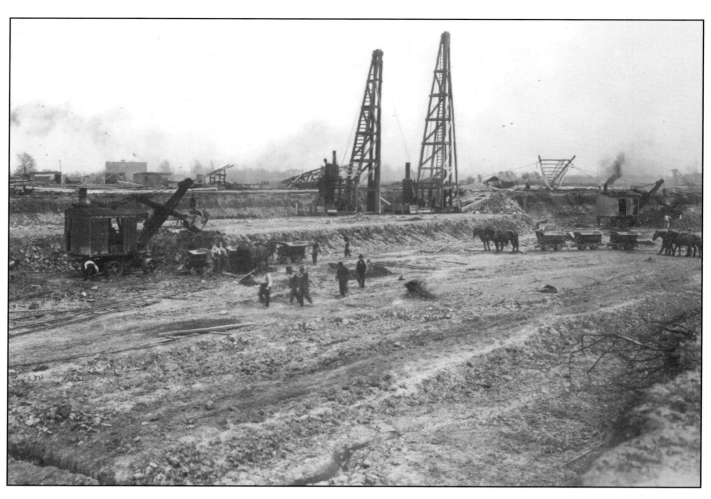

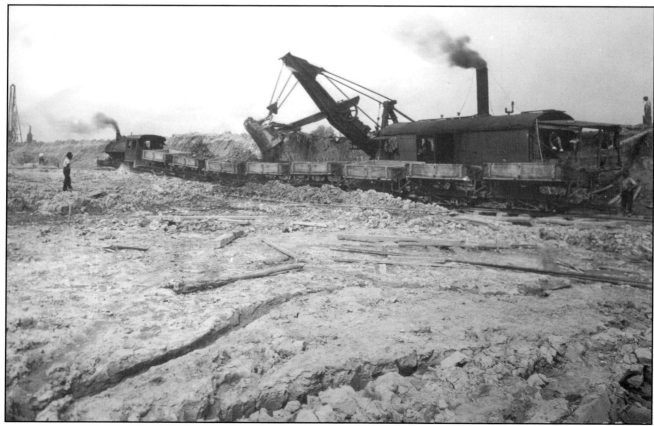

1
EARLY CONSTRUCTION

Ironically, on the same December 2, 1916, that the company passed its resolution approving the Rouge development, the Dodge brothers, minor stockholders of Ford Motor Company, filed a bill of complaint insisting that additional company dividends be given to stockholders instead of being spent on expansion such as that planned on the Rouge River. This legal case kept Henry Ford and William Mayo busy defending the Rouge expansion project in court until December 5, 1917, when a special dividend of $19,275,385 was ordered to be delivered to the stockholders within ninety days. Although the company was immersed in the court battle and caught in a financial bind, work at the Rouge location had begun. Dock construction and bins for iron ore, coal, and limestone had been started in April 1917, months before Congress gave final approval for the river dredging work. In June 1917, extensive excavation work was under way for blast-furnace construction. Under general supervision of Mayo, Julian Kennedy of Pittsburgh designed the Rouge blast furnaces, and Albert Kahn of Detroit designed the foundry and other buildings to fit whatever function for which they were to be used. Coke ovens were designed by the Semet-Solvay Company and constructed by the Heyl-Patterson Company.

Cement for the construction of Rouge building foundations and the giant storage bins was furnished by the Edison Portland Cement Company of Stewartville, New Jersey. Two twenty-five-car railroad trains a week hauled cement to the Rouge, the limit being reached when there was a shortage of cars, not cement. In charge of river dredging was Col. Edward R. Markham, U.S. engineer for the Michigan District, who was to complete the dredging by 1921 but found it took until 1923 with a cost of $10 million to establish widths and depths sufficient to permit oceangoing ships to dock at the Rouge. Henry Ford, who was to furnish land on each side of the river downstream of the plant so that the dredged mud and silt could be discarded on the river banks, found himself in trouble with many landowners not wishing to give up their land.

Entry of the United States into World War I on April 6, 1917, found Ford Motor Company's far-flung factories immediately assigned to the manufacture of a variety of defense products, such as aircraft engines, tanks, trucks, tractors, ambulances, and helmets. The partially developed Rouge site, because of its embryonic ship canal, was promptly put to use building small seagoing submarine chasers.

Opposite, top: Steam shovels and horse-drawn carts on narrow-gauge rails remove soil where ore and coal bins will be, while steam-driven pile drivers sink long posts for future building foundations. The date is May 18, 1917. (833.20015)

Opposite, bottom: By July 1917, a much larger steam shovel together with steam railroad equipment has greatly increased the efficiency of operations. This constant improvement in equipment to provide greater efficiency is characteristic of all Ford operations. (833.20296)

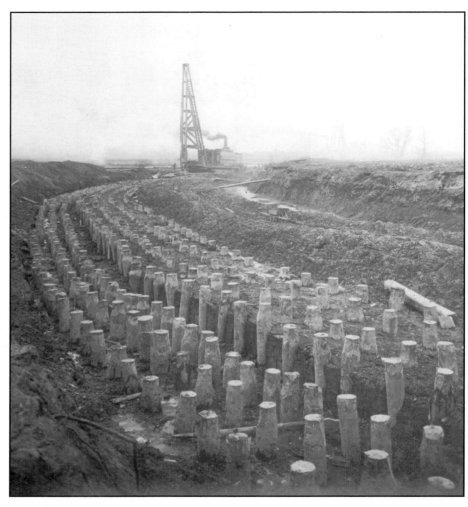

Right: Piles are driven into the earth to support one of the circular blast-furnace foundations. Because of the great weight carried by the furnace when it is filled, the foundation must be supported very solidly, as any settling caused by insufficient support would make it necessary to shut down the furnace. This photograph was taken on November 30, 1917. (833.20935)

Below: The site of the Rouge Plant is a morass of mud in the early spring of 1918. The dredge *Niagara* makes its way slowly up from the river, forming the boat slip. (833.21874)

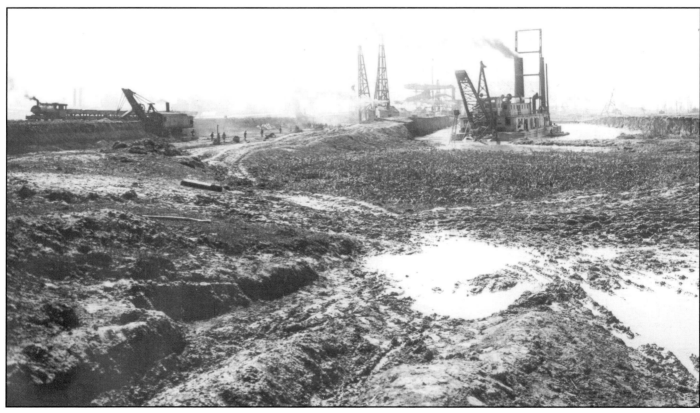

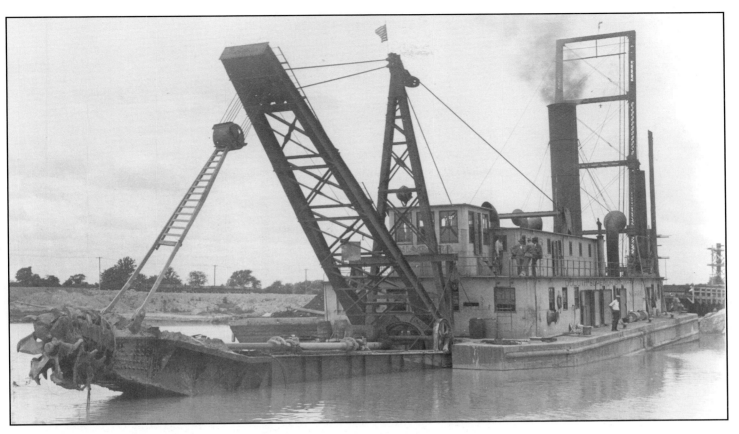

Above: The *Niagara*, belonging to the Duluth-Superior Dredging Company, contractors for river and harbor improvements, was employed by the U.S. government between 1918 and 1923 in dredging the Rouge River, the turning basin, and the boat slip.
(Photograph courtesy of Dearborn Historical Museum)

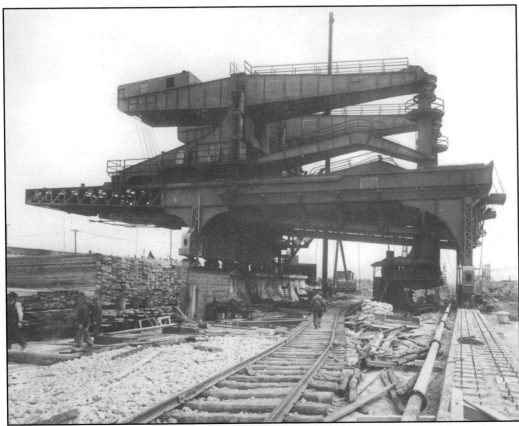

An April 25, 1918, photograph of the two Hulett ship unloaders that would dip into the holds of the ore- or limestone-laden ships and transfer the load from the ships into the proper storage bins. (833.21924)

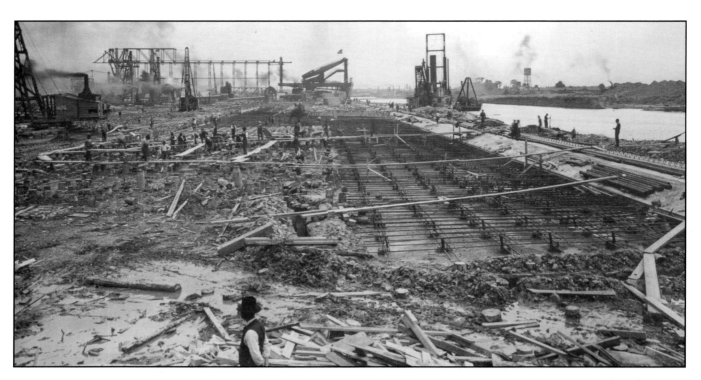

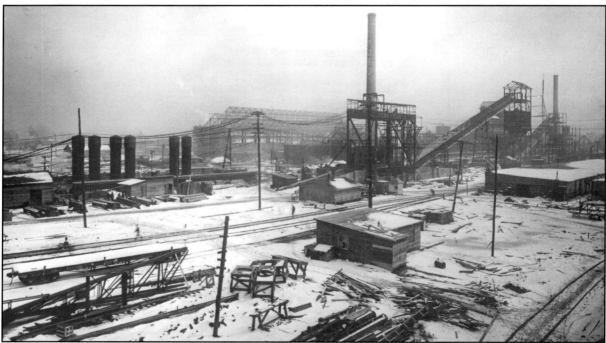

Top: Looking south from the north end of the boat slip on July 3, 1918, while the *Niagara* works to deepen the channel, men are separating bins into limestone, ore, and coal sections. To the left of the Hulett unloaders, one can see the skeleton of one of the new Mead-Morrison transfer bridges designed to move coal, ore, or limestone from their respective bins to conveyors feeding the powerplant or the blast furnaces. (833.22573)

Bottom: On a snowy March 10, 1919, the complexity of the Rouge Plant is becoming apparent. All this construction, including coke ovens, blast furnaces, powerhouse, and iron foundry, is squeezed between the boat slip and Miller Road. This togetherness led to greater efficiencies for each operation. (833.26060)

2
EAGLE BOATS

In the summer of 1917, Henry Ford was asked by President Woodrow Wilson to serve on the U.S. Shipping Board. At that time, German submarines were sinking U.S. cargo ships in large numbers. It was assumed that Ford would offer some ideas concerning the mass production of cargo ships. Instead, Ford suggested mass production of submarine chasers to eliminate the submarines.

An experimental ship design with hull constructed of flat steel plates and powered by a relatively quiet steam turbine was agreed upon. The Navy ordered one hundred of these ships from Ford Motor Company on January 18, 1918, at a price of $275,000 each. As part of the deal, the federal government was to provide $490,000 toward widening and deepening the Rouge River. Additional funds allowed for a fabrication building, an erecting building, a launching trestle, and an outfitting dock. A cantonment with training school and barracks capable of housing twelve hundred men was built to the west of the boat slip.

Ford's forecast of building one or perhaps two Eagles a day was never met. All sorts of obstacles delayed progress. The first Eagle, however, was launched on July 11, 1918. But by that same July, an additional twelve Eagles were ordered by the Navy for use by the Italian government. To meet that need, Ford Motor Company hurried to build an Eagle assembly building on the ocean at Kearny, New Jersey — one identical to the B building at River Rouge. However, before the Kearny plant began operation, the war was over, and the additional contract was canceled.

In all, sixty Eagles had been built and commissioned by October 1919, when production was ended. Very few Eagles engaged in fighting. Eagles 1, 2, and 3 did patrol duty off the Gulf of Archangel, Russia. Six were to be sent to the Philippines to replace old destroyers and gunboats, another squadron was to join the International Patrol off the coast of China, some were sent to the Caribbean, some went to Italy, and a few became training ships. Eagles were also used by the government to chase rum runners, for geodetic surveys, as lighthouse tenders, and by the Treasury Department for the Internal Revenue and Customs Services. Eight Eagles were still in commission in 1941.

The Eagle contract with the government ended November 10, 1919, with a total expenditure of $46,104,042. Ford bought the B building from the government for $180,000; the other buildings were of little use to Ford. In August 1919, before the last Eagle hull was completed in the south end of the B building, Model T automobile bodies were being assembled in the north end of that same building.

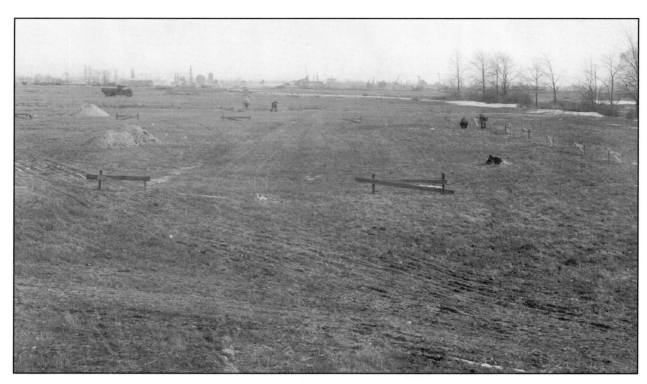

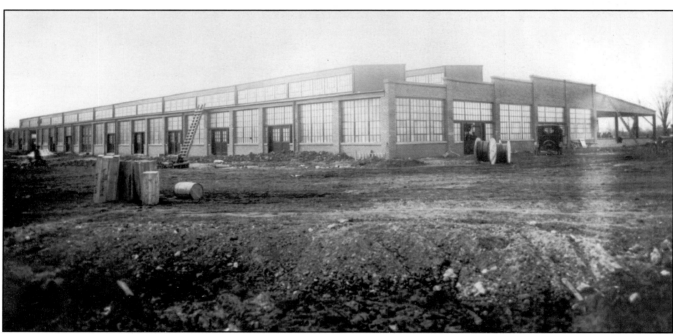

Top: On this building site of approximately 2000 acres purchased in 1915 by Henry Ford is staked out the location of Building A, the first structure of the Eagle boat factory. The photograph was taken on February 20, 1918, scarcely one month after the Eagle boat contract was signed with the government. The land is dry and frozen, with iced-over Roulo Creek barely visible in the distance. (833.21330)

Bottom: The A building, first of the buildings of the Rouge shipbuilding plant, finished in March 1918 after only twenty-four days of work. The foreground shows some of the 175 carloads of cinders used to fill in the Roulo Creek bed to obtain proper elevation. (833.21559)

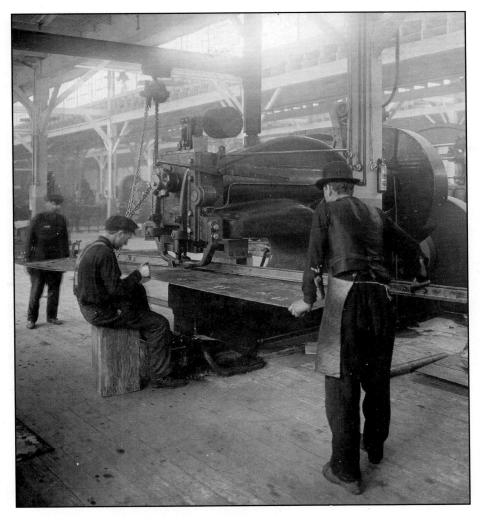

Left: Workmen in Building A prepare sections of sheet steel to be used in the assembly of the Eagle boats in Building B. (833.21994)

Below: The B building under construction. The photograph was taken from the south end of the structure on May 11, 1918. The first Eagle keel was laid in the more finished north end of the same building four days earlier. (833.22074)

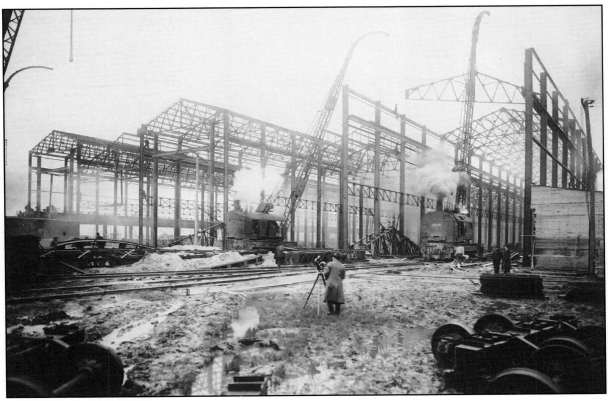

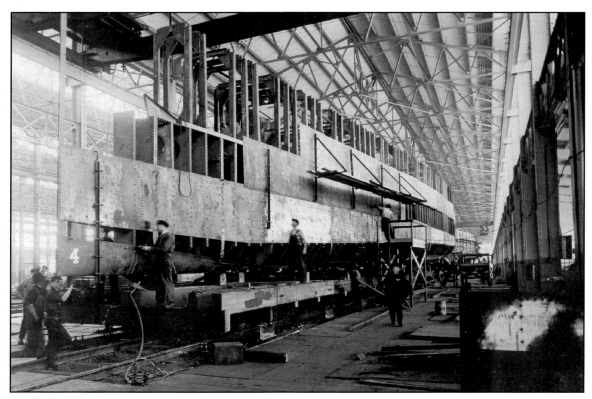

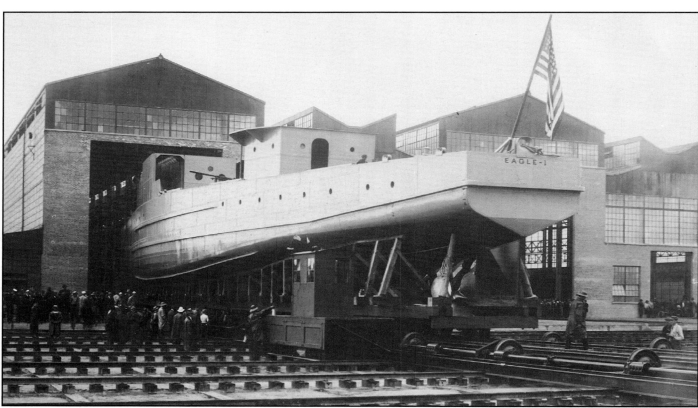

Top: The hull of Eagle No. 1 being assembled in the B building on June 10, 1918. The place is very noisy because of the tremendous amount of riveting necessary in fabrication. (833.22341)

Bottom: The hull of Eagle No. 1 emerging from the south end of Building B onto the transfer platform preparatory to launching into the boat slip. (833.22621)

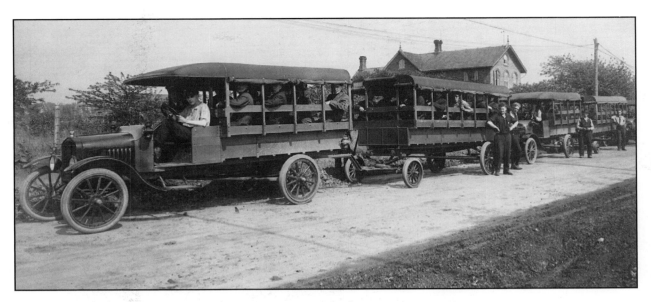

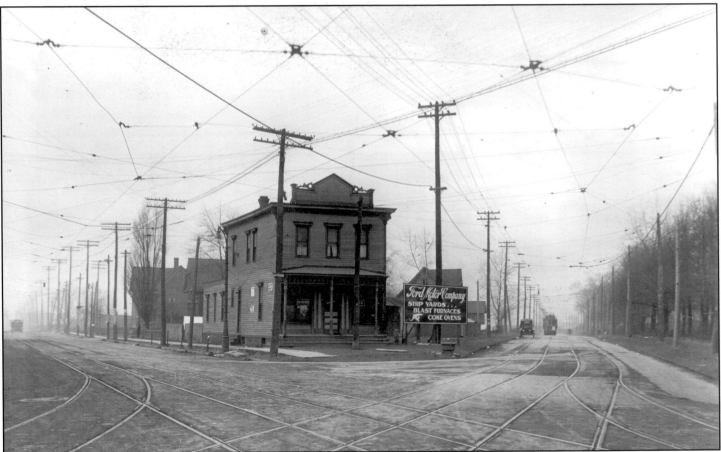

Top: Some of the Ford Motor Company trucks and trailers used to transport workers to the Rouge site to build Eagle boats. There are no streetcars or buses to this remote area outside Detroit. Twenty-nine such vehicles brought 6000 men to work in September 1918. (833.22263)

Bottom: Looking northwest at the intersection of Fort Street and Dearborn Road on December 9, 1918. Electric streetcar lines have been recently installed. The Ford Motor sign points toward the "Shipyards," "Blast Furnaces," and "Coke Ovens" about a mile to the north. Woodmere Cemetery is at the right in the photograph. (833.25164)

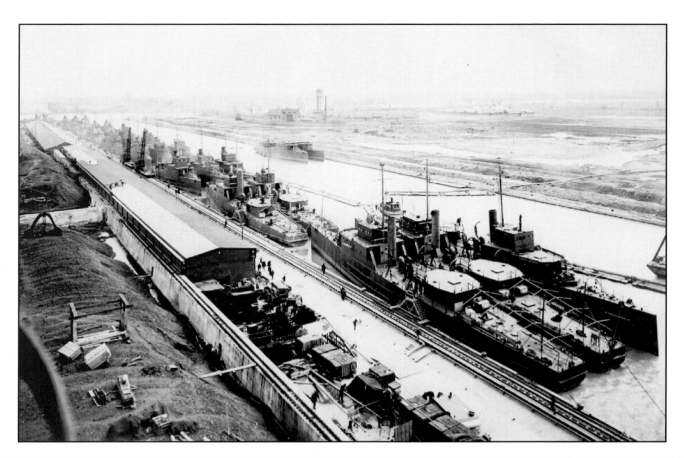

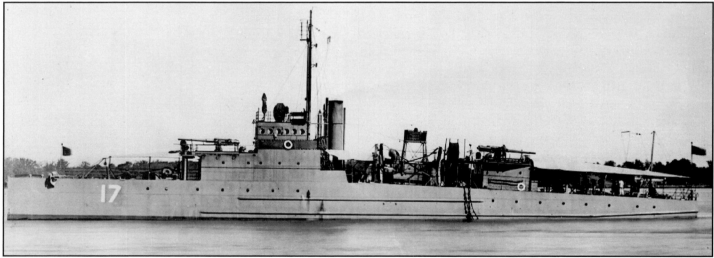

Top: Some of the forty-two ships awaiting transfer to the East Coast in April 1919. Ships hug the outfitting docks along the east side of the slip. Visible at the top center of the photograph (water tank) is the cantonment where several hundred naval personnel were housed. (833.26555)

Bottom: One of the sixty Eagle boats produced by Ford Motor Company. Hulls are produced at the Rouge and equipped with 2500-horsepower steam turbines produced at Highland Park and installed at the Rouge. The length of the ship is 209 feet, beam 25.6 feet, displacement 500 tons, and maximum speed 23 knots per hour. Armament includes two four-inch 50-caliber rapid-fire rifles, one three-inch 50-caliber anti-aircraft rifle, and two machine guns. On each side of the after part of the main deck is one Y gun depth-charge projector. (833.27148)

3
POWERHOUSE

Steam powerplants were dear to Henry Ford. Ever since he saw his first steam traction engine on a country road at age thirteen, he was charmed by them. He loved to display his powerplants as he had in his "Crystal Palace" at Highland Park. At the Rouge, however, a powerplant of gigantic proportions was necessary, and brute strength was the objective.

The first powerhouse at the Rouge was the small one built for Eagle boat production and torn down at the end of the Eagle contract. For the mammoth steel plant planned by Ford, a much larger one had to be built. Construction of this main Rouge powerplant started in 1919, with operation beginning in May 1920, just ten days before the first blast furnace was put into operation. Unique for its time, the plant utilized considerably higher steam temperatures and pressures than normal in order to provide greater generating efficiency. Also unusual was the use of pulverized coal as fuel.

Henry Ford, as well as Thomas Edison, preferred direct current to alternating current because it operated at lower voltage, so this initial powerplant was designed, built, and operated solely on direct current. After installing and operating no fewer than 27,000 direct-current motors, however, it was found that the uncovered motors became clogged with dust and grit in the dirty factory atmosphere. At tremendous expense, during 1930 and 1931, the direct-current motors were exchanged for those operating on alternating current. In the process, Ford insisted that all his electric motors be totally enclosed. Some DC power was retained, however, for operating equipment such as for welding.

William B. Mayo, who had designed the Highland Park power equipment, was responsible for all Rouge Plant power requirements. Working under Mayo, William F. Verner was responsible for powerplant construction, and put in charge of powerplant operations was William W. Dulmage. With cooperation from equipment manufacturers such as General Electric, Combustion Engineering, and Foster Wheeler, significant upgrading of equipment from time to time became routine. Particularly in the mid-1930s, the investment of $5.5 million in three new turbo-generators kept the plant up to date.

During May 1935, for example, records show a total of 51,349,863 kilowatt-hours of power produced and distributed to twenty-five departments in the Rouge Plant. The major user was the production foundry, with 11,236,890 kilowatt-hours, followed by the steel mill, the spring-and-upset building, the motor building, and the B building. In addition to distributing power through its 200 or more substations within the Rouge complex, the Rouge powerplant, by means of 23,200-volt transmission lines, also supplied power to the Highland Park Plant, the Lincoln Plant, and the Flat Rock Plant, all of which were in the Detroit area. At times, surplus Rouge power was sold to the Detroit Edison Company.

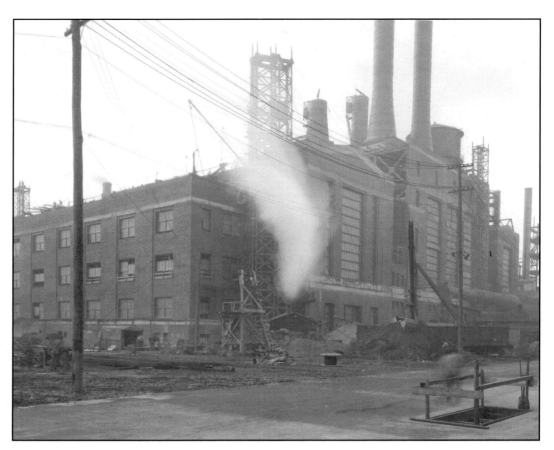

Producing power in stages, the main Rouge powerhouse under construction in December 1920. (833.31648)

Eighty feet behind the powerhouse is the pulverizing building. In it, ten high-speed mills pulverize the coal, and two ball mills grind the coke breeze and coal. Capacity is 180 tons per hour, pulverized to a fineness of 65 percent through a 200-mesh screen. As much as 900,778 tons of coal would be used in a peak year such as 1929. This amounted to approximately thirty carloads a day. (833.32500)

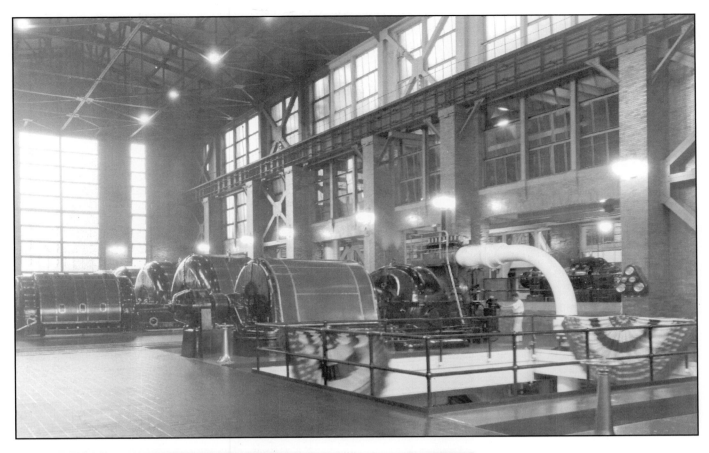

Above: Interior of the main powerhouse turbine room containing three steam-driven turbine units in October 1929. (833.54041)

Left: Interior of the main powerhouse generator room with its three 30,000-kilowatt turbo-generators operating in 1931. (833.56199)

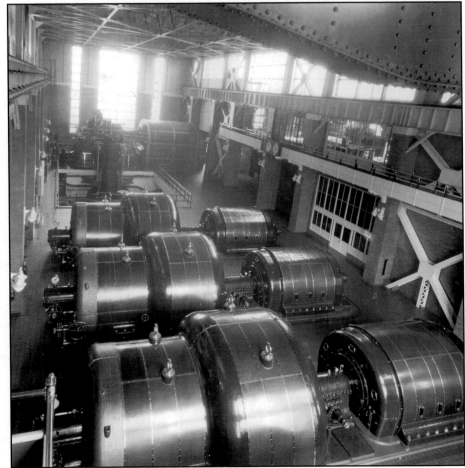

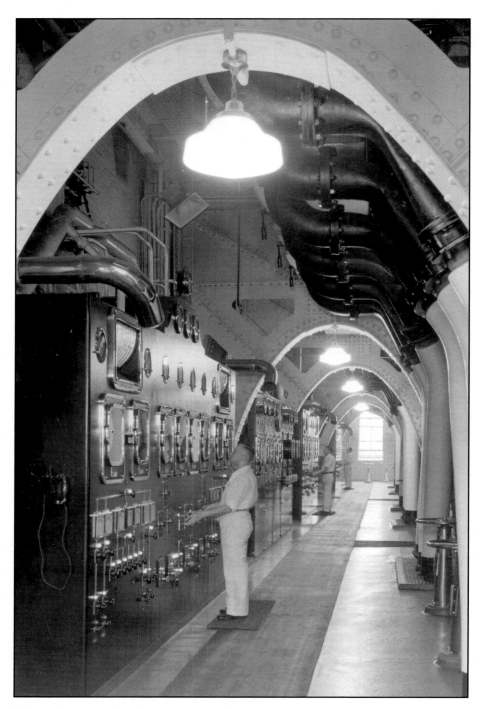

The high-pressure boiler control room in May 1937. (833.68302)

Opposite, top: An enlarged Rouge powerhouse in 1934. Now its eight stacks, each serving a boiler, reach a height of 333 feet and measure 13 feet across the top. Each boiler produces steam for the operation of a turbo-generator that in turn generates electricity equivalent to 62,500 horsepower, the ultimate goal being 500,000 horsepower. (833.59281)

Opposite, bottom: A control panel in the main Rouge powerhouse in December 1931. These two operators control the turbines and the switching of power from the main powerhouse to Rouge substations and to outside Ford plants. (833.56683)

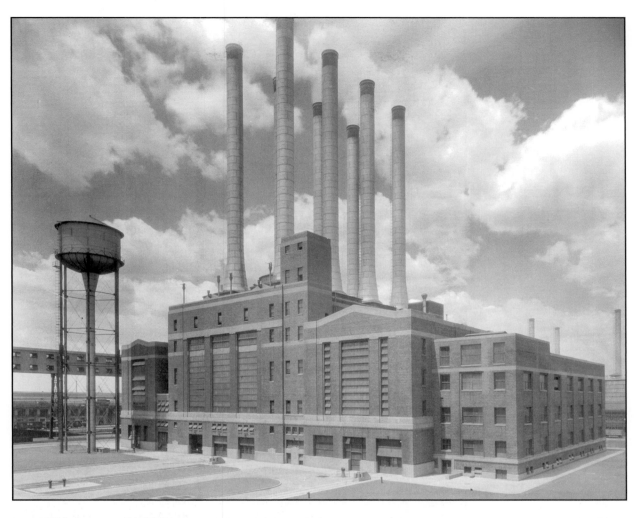

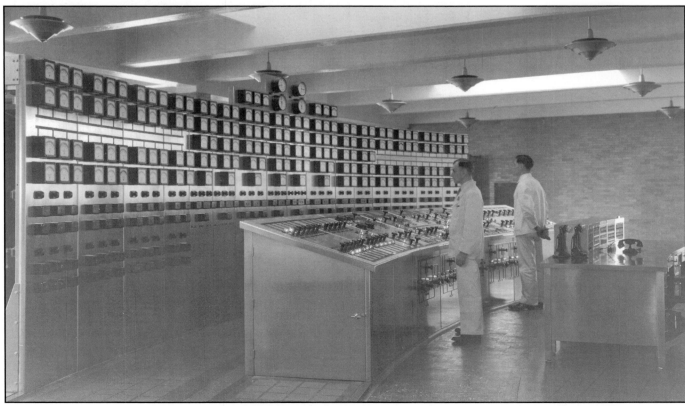

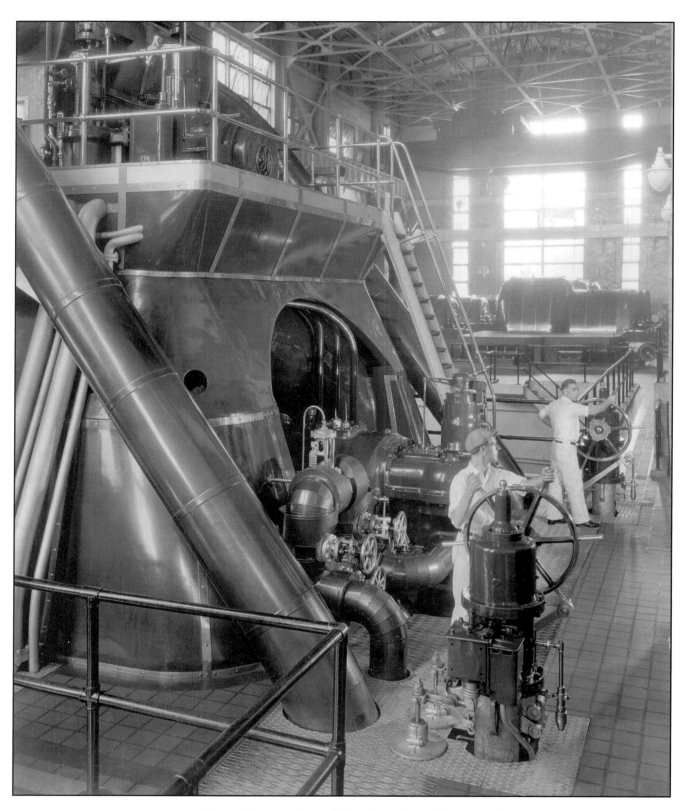

One of the new General Electric 110,000-kilowatt turbo-generators installed in the main powerhouse in 1934. The two men are operating steam throttle valves. These turbo-units have both a high-pressure element and a low-pressure element, each producing 55,000 kilowatts, turning at 1850 revolutions per minute, using initial steam at 1200 pounds pressure and 900 degrees temperature. Spent steam is condensed using water obtained by means of a tunnel from the Detroit River. (833.59279)

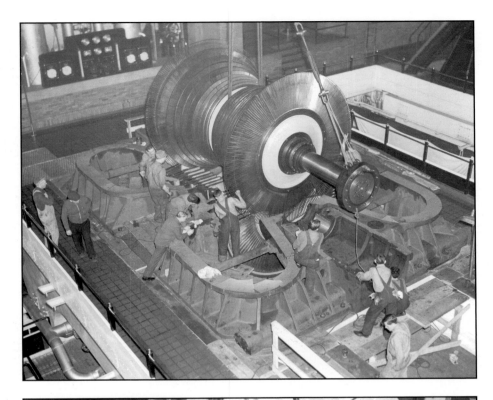

Installing a new steam turbine wheel to drive a 110,000-kilowatt generator. The photo is dated February 2, 1939. (833.71392-E)

Installing a new generator armature in one of the 110,000-kilowatt generators, also in February 1939. (833.71438-B)

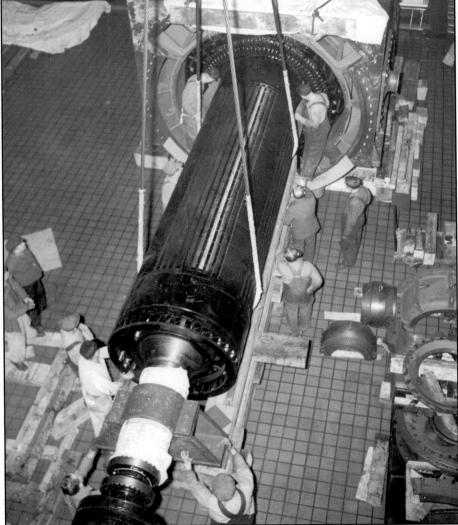

4
BLAST FURNACES

When Henry Ford spoke of steel operations, he meant from the very beginning to the end. The very heart of these operations was the blast furnaces — the devices that reduced iron oxide ore dug from the earth to metallic iron. Eagle boat building at the Rouge did not get in the way; in fact, dredging of the ship canal and building of the docks were necessities for his steel operations. While Eagles were being launched, preparations for the ore bins and blast furnaces were visible in the background. The blast furnaces, in particular, are seen rising east of the boat slip on Ford Motor Company property while Ford's personal land west of the boat slip remains undeveloped.

Conventionally, blast furnaces produce raw iron which is poured into pig molds; the pigs are then allowed to cool and stored to be remelted at some later date in cupola furnaces at another location and poured into final castings. The Ford system, however, was designed with the foundry right next to the blast furnaces so that the blast-furnace iron was delivered in molten form to the cupolas from which automotive and tractor castings were poured. Only a small portion of the Ford blast-furnace iron was pigged. In the beginning, the blast furnaces at the Rouge Plant supplied the foundry for the production of iron castings, but later the blast furnaces also supplied molten iron to the open-hearth furnaces for the production of steels.

The two blast furnaces under construction at River Rouge beginning in 1918 were identical in size, one called the Henry or A furnace, first lighted May 17, 1920, and the other called the Benson or B furnace, first lighted October 11, 1922. Each of the furnaces was charged at the top with 24,000 pounds of iron ore, 6000 pounds of limestone, and 12,000 pounds of coke. Operated twenty-four hours a day, each furnace received about 120 charges a day, was tapped every six hours, and produced 1200 tons of iron a day. Continual improvements in operation of the furnaces over the years produced greater tonnages of iron. A useful by-product of blast-furnace operations was the daily production of about 250 million cubic feet of blast-furnace gas, a useful fuel containing considerable carbon monoxide.

Opposite, top: An excellent view of the proximity of the blast furnaces and the bins of ore and limestone as seen from high over the boat slip. At the top of the photograph are the smoky stacks of the iron foundry which uses metal produced by the blast furnaces. The bridge crane at far left moves ore and limestone from the bins to the furnaces, and rail cars on the "high line" bring coke and scrap iron to the furnaces. (833.63660)

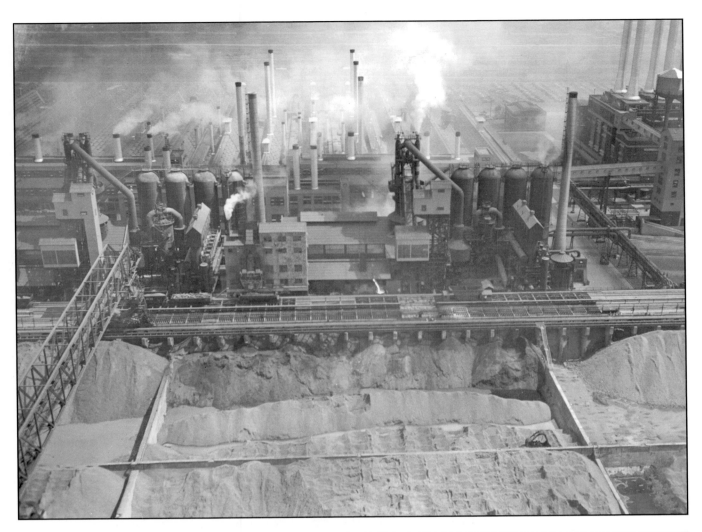

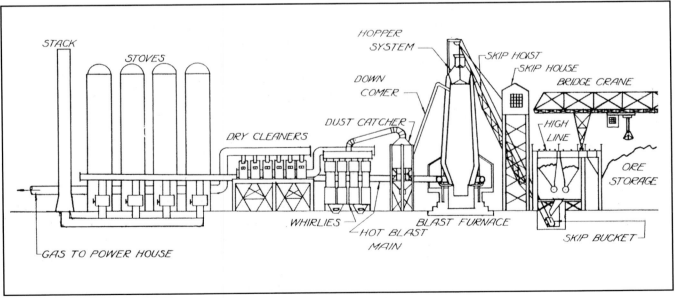

Sketch of a blast furnace and its accessories, copied from a Henry Ford Trade School metallurgical textbook.

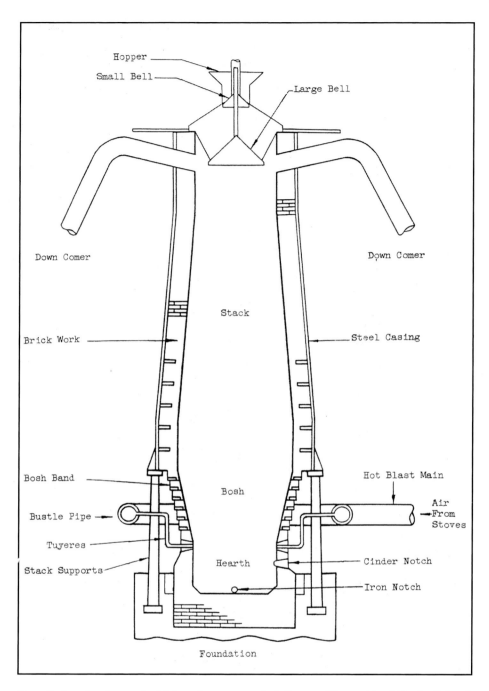

Detail sketch of a typical blast furnace, copied from a Henry Ford Trade School metallurgical textbook.

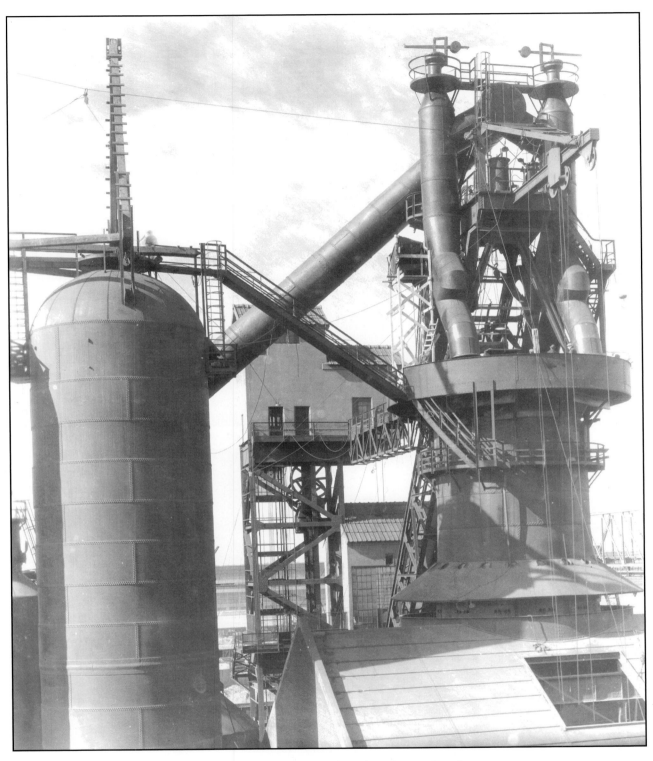

A close-up of the top of one of the Ford blast furnaces (right) and one of its four stoves (left) which supply hot air under pressure. Between them can be seen the "skip house." (833.56856)

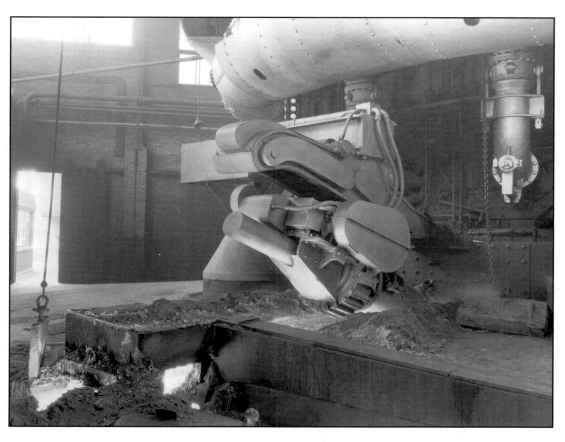

Above: The Brassert "mud gun" installed in the "Henry" blast furnace in 1932. This device, operated remotely, seals and unseals the "iron notch" by plugging the notch with nine cubic feet of wet clay that is quickly hardened by furnace heat and unplugging the notch when necessary to allow molten iron to pour forth from the furnace without fear of personal injury. The photograph was taken in 1935. (833. 61964)

Right: Molten iron flowing from the iron notch of the blast furnace downward and out of the furnace building into large 75-ton-capacity ladles. (833.65667)

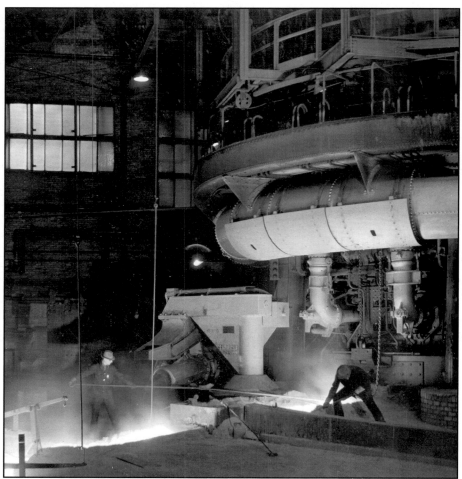

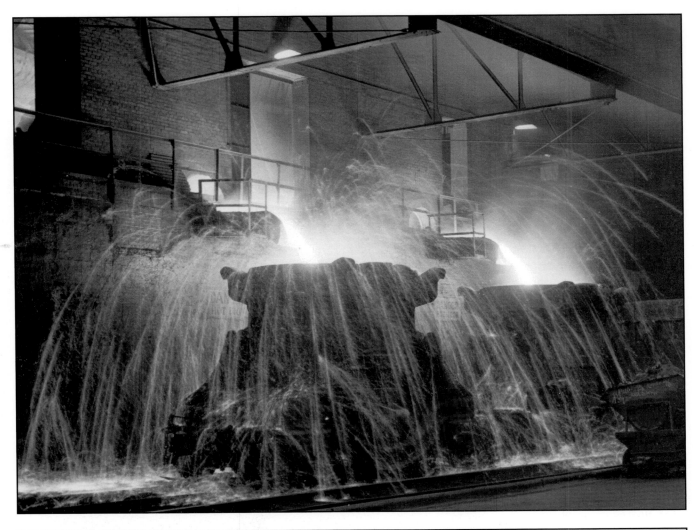

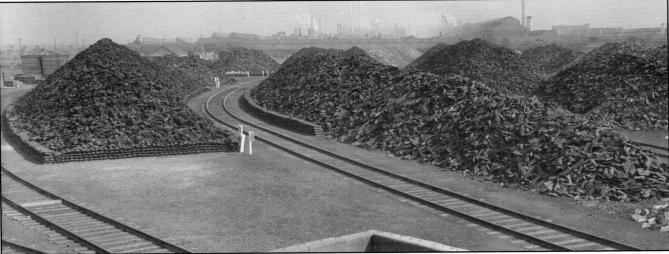

Top: Molten iron from the blast furnace flows into two railroad-car ladles and is transported before it cools to the open-hearth furnaces for steelmaking or to the foundry for casting into automotive parts. (N-1592)

Bottom: Piles of pig iron held in reserve at the Rouge Plant for use in case blast-furnace production is inadvertently interrupted. Each pig weighs 80 pounds. (833.68611)

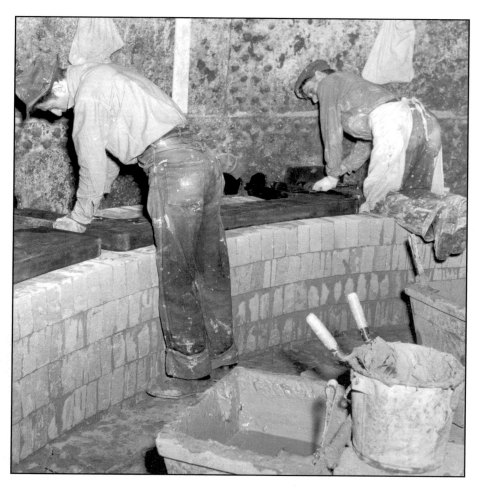

Relining the three-foot-thick blast-furnace interior wall. The outer steel plate supports the thick refractory brick lining. (833.74189-H)

5
FOUNDRY

The foundry at the Rouge, the largest, cleanest, and coolest production foundry in the world, could pour 2900 tons of automotive and tractor castings every twenty-four hours. Molten iron from the blast furnaces, arriving in 75-ton ladle cars, was poured into a 1200-ton mixer furnace from which it was fed together with scrap metal, coke, and limestone to make up the charge for each of twenty-eight cupola furnaces. The Ford production foundry was uniquely designed to allow molds to be moved by conveyor to the furnace spout, rather than the molten metal being taken from the furnaces to the molds in small ladles. The cupola furnaces were on the west side of the foundry close to the blast furnaces. The east side of the foundry building was devoted to rough machining of the multitude of engine castings before they were sent on a long overhead conveyor to the motor building for finish machining and assembly.

In the foundry's large mold and core rooms, hundreds of women were employed to assemble the damp sand molds and cores as they moved by on a bench-high conveyor. Complex castings such as cylinder blocks, cylinder heads, intake and exhaust manifolds, flywheels, and housings, as well as other automotive parts, were cast in iron by the thousands every day. In the process of shaking each casting from its mold, the mold and cores were destroyed. The very first Rouge castings were poured on December 25, 1920. By November 1922, four-cylinder engine blocks for the Model T were being cast. In 1931, a single V-8 engine block required twenty-five 14-quart pails of sand, 6.5 quarts of mixed oils, and 9 quarts of flour, all in a uniform mixture to fashion a single V-8 motor block mold. Accurately placed within the mold were forty-six small cores of various shapes. For its day, the intricate Ford V-8 single-piece casting was a benchmark in foundry practice.

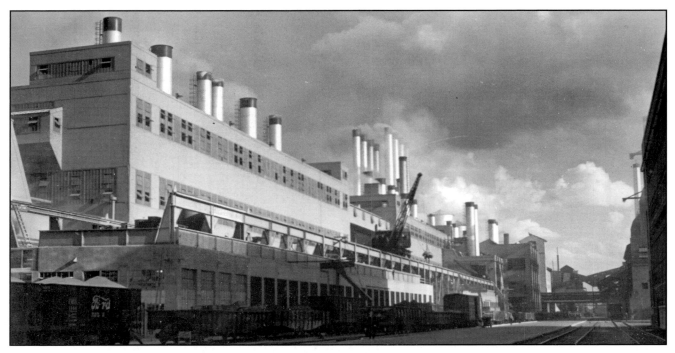

Above: The west side (furnace side) of the production foundry as seen looking southeast on a sunny afternoon. In the shadows on the far right are the blast furnaces. (833.68808-H)

Right: Detail sketch of a foundry cupola furnace, copied from a Henry Ford Trade School metallurgy textbook.

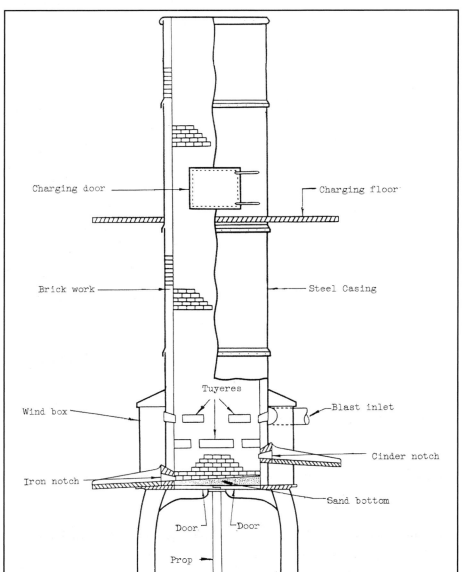

Charging door

Charging floor

Brick work

Steel Casing

Tuyeres

Wind box

Blast inlet

Iron notch

Cinder notch

Sand bottom

Door

Door

Prop

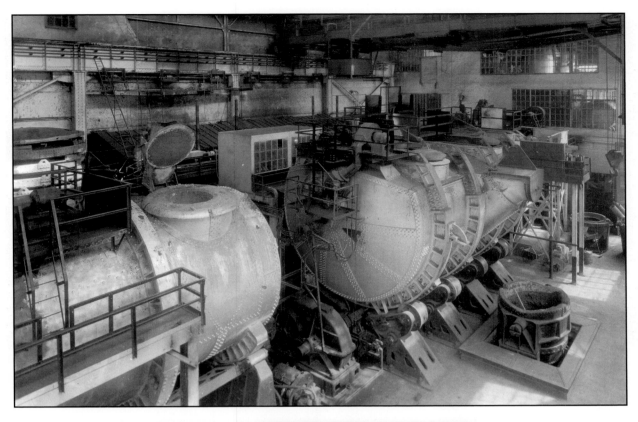

Above: A pair of 1200-ton mixers on rollers so that they can be turned on their sides to pour their contents of molten iron into ladles from which castings are poured. (833.56403)

Left: Pouring molten iron into V-8 engine molds as the molds move along on a conveyor, each mold held by a long vertical arm. (833.59575)

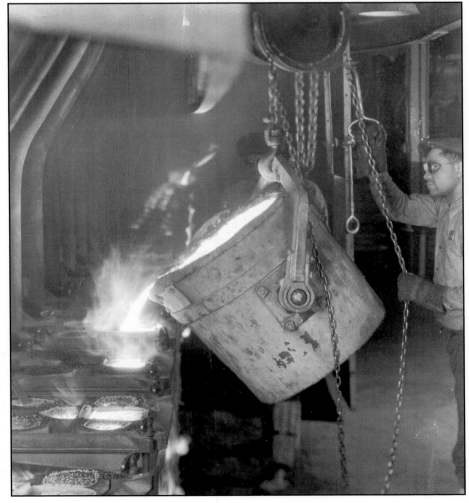

Right: The engine block "shake-out" area, where the solidified but still hot iron block is shaken out of the mold. In the process, the mold is destroyed. The open grill floor allows the loose sand to be recovered below for further use. (833.62801-A)

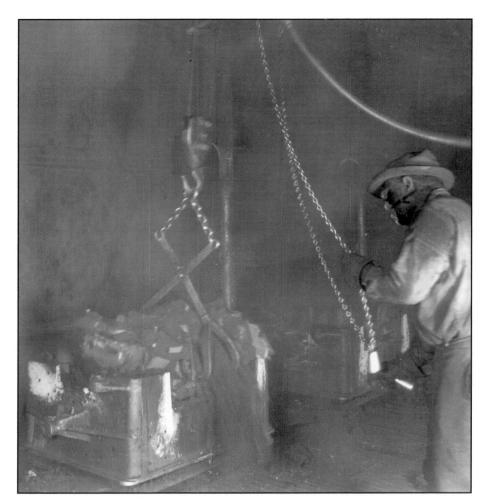

Below: The upside-down engine block after being shaken from the mold and cleaned. The metal surface has a sandy texture because the mold was composed of sand. Considerable rough machining is necessary to remove excess metal, including the tall "risers" needed to fill the mold completely during the pouring. (833.628850)

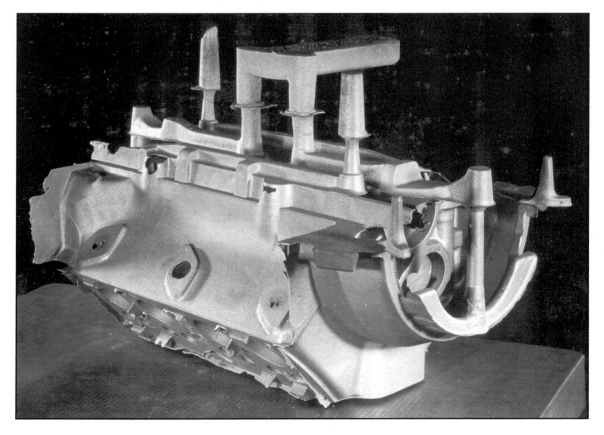

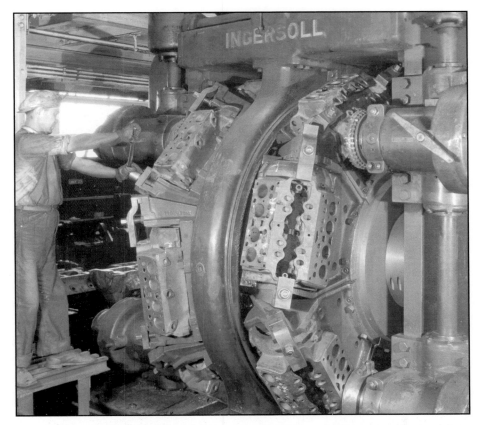

Left: In the foundry machine shop, mammoth rotary milling machines are used to remove the rough top surface of the V-8 cylinder blocks. (833.57787)

Below: A multiple-spindle drill press machining a V-8 cylinder block in the foundry machine shop. Stud holes for the cylinder head and valve chamber cover holes are all drilled into the block at the same time. The milky fluid sprayed onto the spots being drilled is a specially formulated "cutting fluid." After machining in the foundry, the engine castings are moved by conveyor to the motor building for finish machining. (833.11060)

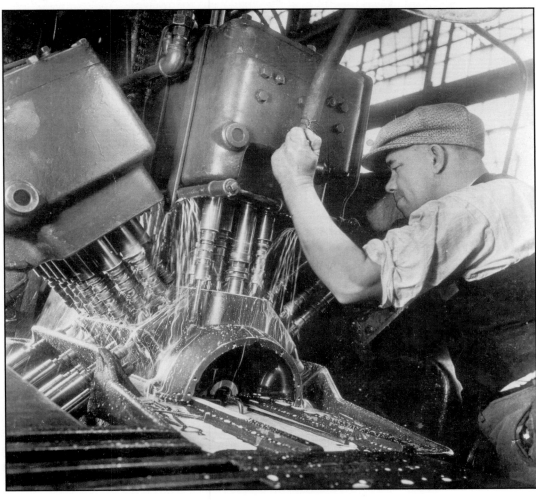

6
COKE OVENS

Essential for the operation of the blast furnaces were coke for reducing the iron ore and gas for heating the furnaces. Therefore, concurrent with the building of the blast furnaces, groups of Semet-Solvay and Wilputte coking ovens were constructed immediately south of the Rouge powerplant and within conveyor reach of the coal bins at dockside. As early as 1917, coal from several West Virginia and Kentucky mines had been sampled by Ford, and by 1920, several bituminous coal mines were being purchased by Ford. Bituminous coal being a relatively impure form of carbon, coking ovens were used to drive off the impurities. These initial Rouge coke ovens, operating during 1921, coked 4800 tons of coal daily to produce 3600 tons of coke and 33 million cubic feet of gas (a mixture of mostly hydrogen and methane), together with a series of useful by-products including coal tar, light oils, Benzol, toluol, and ammonia. In the process of coking, each oven was loaded with about 18 tons of coal and heated for seventeen hours before the gases and other impurities were fully released as a result of the intense heat in the brick-lined, airtight oven. The coal, costing about five dollars a ton, thus produced products worth nine to ten dollars. In this first installation, however, two-thirds of the gas produced by the coke ovens was used to heat the coke ovens themselves.

In 1937, three batteries of new and much more efficient coke ovens were installed. These consisted of 183 Koppers-Becker ovens designed to use blast-furnace gas containing considerable carbon monoxide for heating the ovens, thus allowing the entire 52.5 million cubic feet of coke-oven gas from 4500 tons of coal to be available for additional Rouge Plant heating purposes, such as open-hearth and glass furnaces. A gas holder of 10-million-cubic-foot capacity was also constructed conveniently near the open-hearth building in 1937.

There being more coke produced than what was needed by the Rouge blast furnaces, surplus coke was offered to Ford employees and delivered to their homes at low prices. The coke-oven by-product Benzol was mixed with ordinary gasoline, used to fill the gasoline tanks of newly assembled Ford vehicles, and sold at Detroit area gas stations as a premium fuel. The by-product ammonium sulfate was sold through Ford automobile dealers to agriculturalists as a high-nitrogen fertilizer.

Opposite, top: The early Semet-Solvay coke ovens with their conspicuous cooling tower and stack, as viewed toward the northeast on August 1, 1923. Coal conveyors are visible on the left, gas holding tanks on the right. (833.35060)

Opposite, bottom: The new and more efficient Koppers-Becker coke ovens completed in 1937 at a cost of $4 million. Coal is fed from the dockside bins to the ovens by means of the long, enclosed belt conveyor plainly visible at the left. Steam is rising from the brick quenching tower as the red-hot coke at ground level is being quenched by water from the adjacent water tank. (833.70694-B)

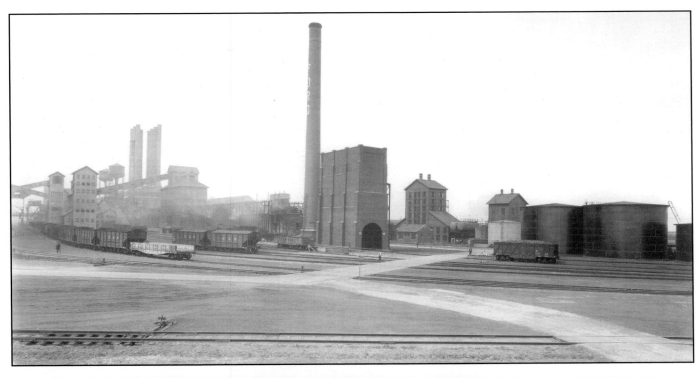

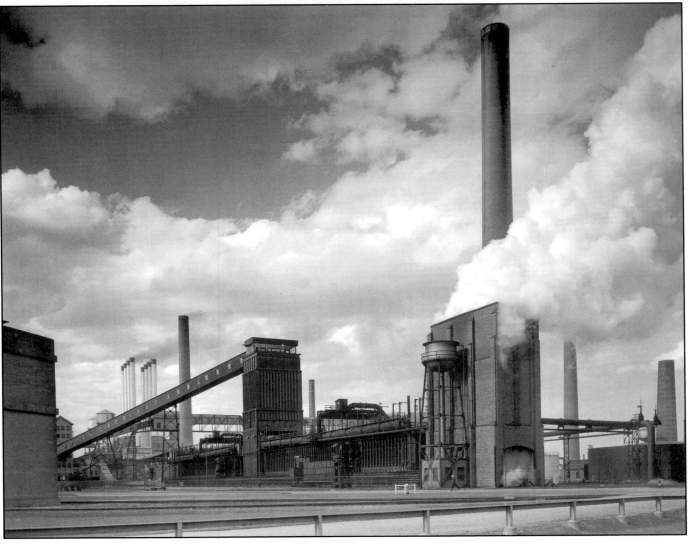

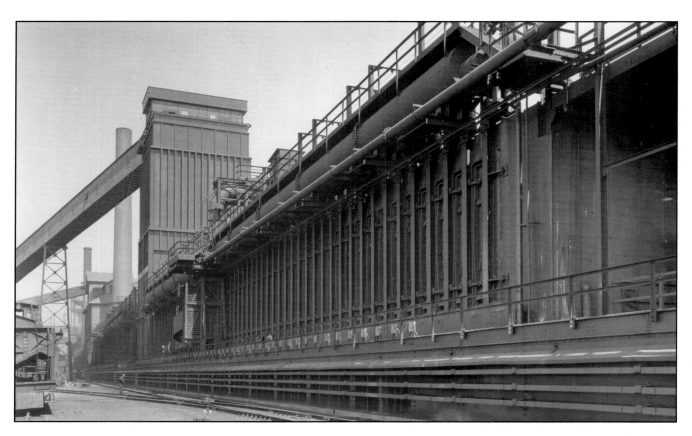

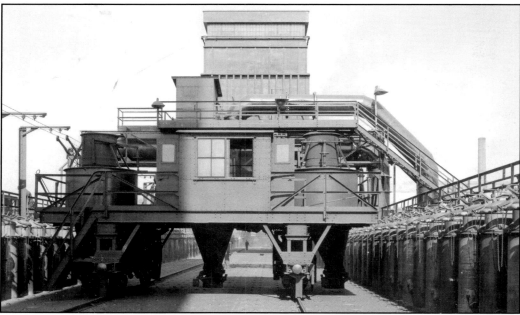

Top: The west discharge ends of the long, tall, narrow ovens in mid-April 1937. The coal feeder building juts high at the midway point above the 183 ovens, with the coal conveyor rising from the far left. Each oven holds 17 tons and is 40 feet long and 13 feet high, with widths of 16 inches on the pusher end and 19 inches on the discharge end for ease of unloading. (833.63250-134)

Bottom: Rolling along on top of the coke ovens is this huge electrically driven "larry car," which receives coal from the coal feeder building seen rising behind it. Loaded with two hoppers of coal, the larry car moves along over the ovens, filling empty ovens one at a time through two capped holes, one near each end of the oven. (833.63250-125)

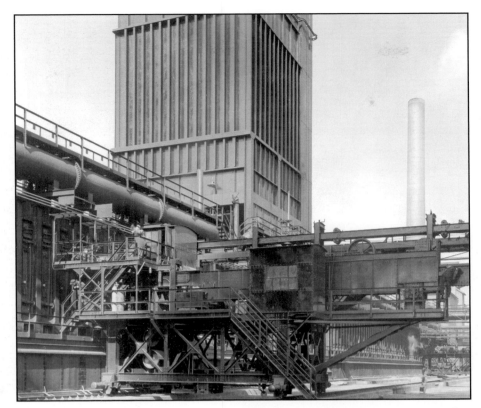

Left: On rails at ground level along the east side of the 183 coking ovens is this "pusher," or ramming machine, which, following about twenty hours of coking in each oven, pushes the red-hot coke out of the opposite end of the oven into a "skip car." (833.63250-124)

Below: Red-hot coke is rammed out of its oven into a "skip car," which immediately rushes its load of coke to beneath the quenching tower, where 2200 gallons of water are poured onto the flaming coke. After quenching, the coke is dumped onto a conveyor belt and taken to screening rooms, where it is sorted by size. Larger sizes are sent to the blast furnaces and foundry, while the smaller sizes are sold to Ford employees. (0.9408)

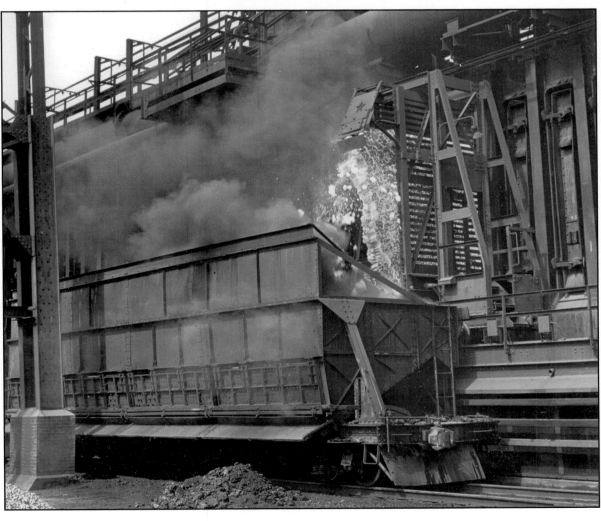

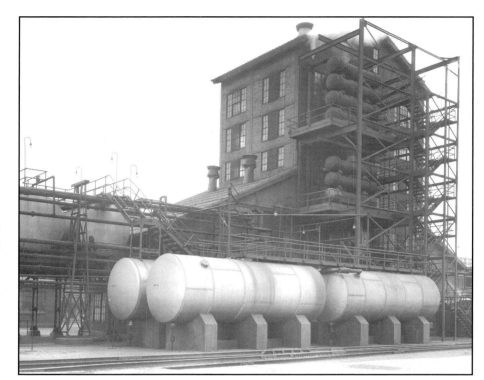

The coke-oven by-product extraction building with tank containers outside. In addition to the primary products of coke and coke-oven gas, a ton of coal produces about 7 gallons of tar, 17 pounds of ammonium sulfate, and 2.5 gallons of crude light oil. (833.61961)

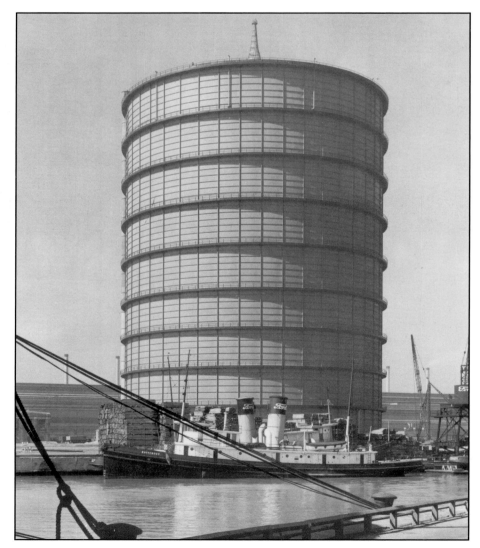

This, the larger of two gas holders, was built in 1937 to hold coke-oven gas from the new Koppers-Becker coke ovens. This one has a capacity of 10 million cubic feet, is 390 feet high, is 219 feet in diameter, and is located near the open-hearth building, where it stores coke-oven gas for heating open-hearth furnaces. A smaller gas holder of 2.5-million-cubic-feet capacity is located near the coke ovens, where it holds blast-furnace gas used to heat the coke ovens. (833.66275-83)

7
STORAGE BINS

The gigantic storage bins of the Rouge Plant extended along the east side of the boat slip for half a mile. Their total capacity was in the neighborhood of 2 million tons. These huge bins, walled in concrete, are said to have been constructed using cement from the Edison Portland Cement Company of Stewartsville, New Jersey. Much of the cement used in building the Rouge Plant came by the trainload from Edison's plant.

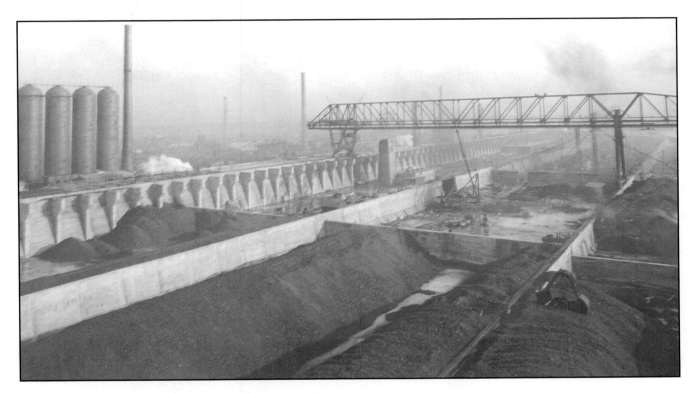

Iron ore from upper Michigan and Minnesota was brought down across Lake Superior, Lake Huron, and Lake St. Clair into the Detroit River and to the Rouge docks by the motor cargo ships *Henry Ford II* and *Benson Ford*.

Limestone also was brought by Ford cargo ships from Rogers City on Lake Huron. Coal was brought by rail from the Fordson Coal Company mines in Kentucky and West Virginia.

Placement in the several bins was according to use. Coal was stored mainly at the south end of the bins close to the powerplant and the coke ovens, iron ore was stored close to the blast furnaces, and limestone was stored at the north end near the blast furnaces and the cement plant. Ore and lime-stone bins were filled to capacity during the summer months when the ships were in service. During the summer, coal was sometimes shipped by rail to Toledo and then transferred to barges for shipment across the west end of Lake Erie to the Detroit River and Rouge docks. During winter, coal was shipped all the way from the mines by rail.

Rouge storage bins under construction in January 1919. Boats other than Ford-owned boats have already arrived and been unloaded and their loads transferred to an assigned bin, although neither blast furnaces nor coke ovens will be operating for another year. (833.25392)

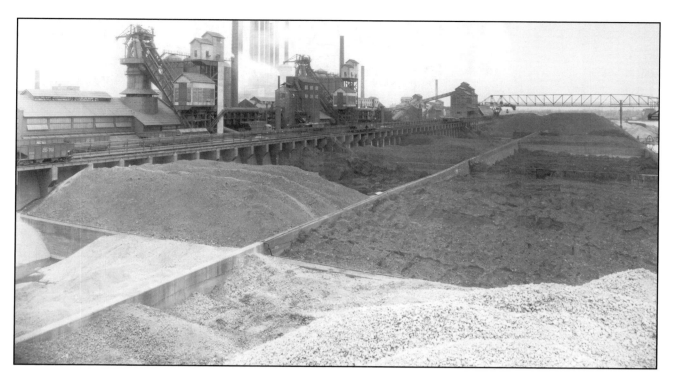

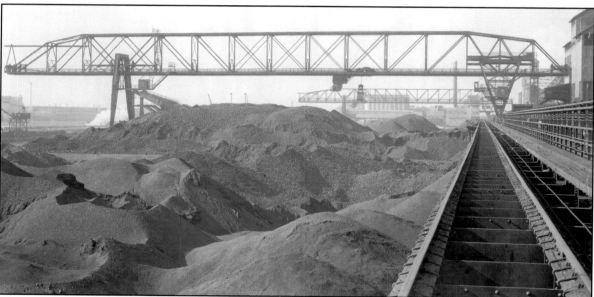

Top: This view of the storage bins, looking southward from atop a pile of limestone on May 2, 1924, shows both blast furnaces and the Semet-Solvay coke ovens in full operation. (833.37501)

Bottom: The storage bins are heaped full on this late-September day in 1934. The photograph was taken from the high-line tracks looking north. Aerial shovels are seen moving on the transfer cranes rearranging supplies for the winter season. In another month, shipping on the Great Lakes will begin drawing to a close. (833.60216-R)

Opposite, top: The Rouge Plant looking northeast between the ship canal and Miller Road on November 14, 1939. The photograph is thought to have been taken from atop the 10-million-cubic-foot coke-oven gas holder constructed in 1937. (833.72684)

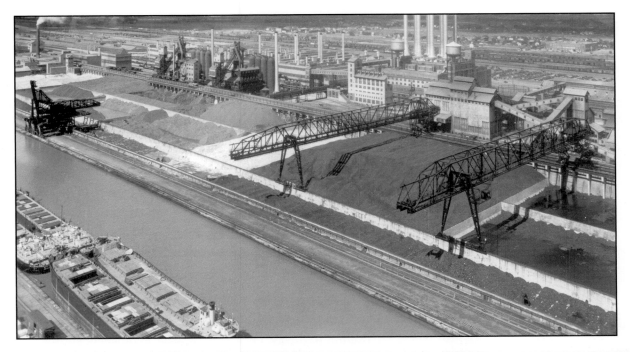

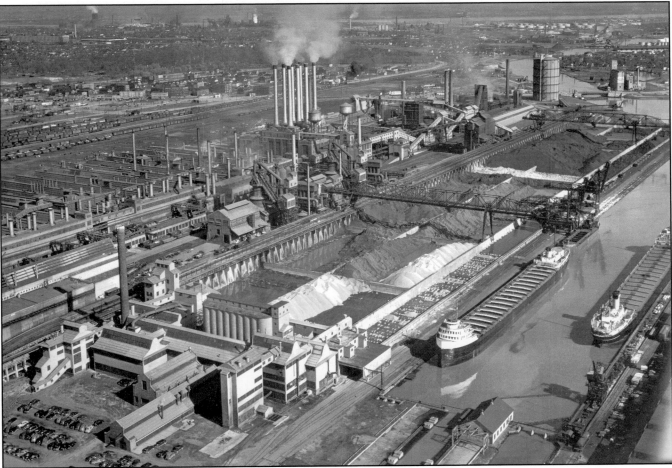

A magnificent 1940s aerial view of the Rouge looking southeast toward the Detroit River. The two large Ford cargo ships *(Henry II* and *Benson Ford)* are resting at the docks which extend for more than a mile. Capacious storage bins and adjacent manufacturing operations are centered around the powerhouse with its conspicuous eight tall stacks. (833.85200)

8
RAILROADS

From the very beginning of work at the River Rouge site, hauling of soil from place to place was done by rail car. In the very beginning, on narrow-gauge tracks, a few small cars were pulled by horses. As needed, heavier rails, much larger hopper cars, and steam locomotives were put into service. Although well-established railroads such as the Michigan Central and the Pere Marquette were adjacent to the Rouge Plant, Ford Motor Company needed to have its own railroad system to move materials within the plant itself.

Supplies of iron ore and limestone were to come by boat from Great Lakes ports, but coal from Kentucky and West Virginia had to be moved by rail, and Ford Motor Company had earlier experienced difficulty in depending on the railroads. In 1920, the same year the company was building boats to haul ore and limestone to the Rouge, Henry Ford personally bought the Detroit, Toledo & Ironton Railroad (DT&I) to provide an independent route in the direction of his sources of coal. It was not legal for Ford Motor Company itself to own an interstate railroad.

Within the Rouge Plant, however, Ford built a mammoth locomotive repair shop that began operation in June 1921. Employing as many as 475 men, the shop is said to have restored four long-neglected DT&I locomotives a month until 1926. Responsibilities of the shop included repair and maintenance not only of Rouge locomotives but also of other heavy plant equipment such as steam cranes, bulldozers, shovels, and coal unloaders. Along with their normal Rouge repair work, workers were assigned general DT&I maintenance, as well as the restoration of a number of antique engines for the Henry Ford Museum.

Ford loved steam locomotives and insisted that each of them in his sight be elaborately nickel trimmed, be highly polished, and sport white tires. Despite his love of steam, by 1940, steam locomotives had been displaced by diesels.

Opposite, top: The locomotive repair shop under construction at the Rouge Plant as photographed the day before Christmas, 1920. Henry Ford purchased the Detroit, Toledo & Ironton in July of that year. This is to be a major repair shop for both the Rouge and DT&I rolling stock. (833.31732)

Opposite, bottom: The interior of the locomotive repair shop in operation on August 10, 1922. Huge traveling cranes can lift locomotives off the floor so that wheels, axles, and other mechanical components can be removed and repaired in the machine shops at the opposite end of this large building. (833.32624)

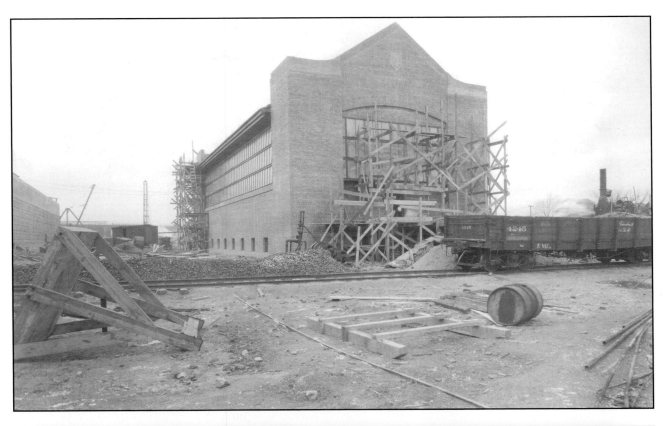

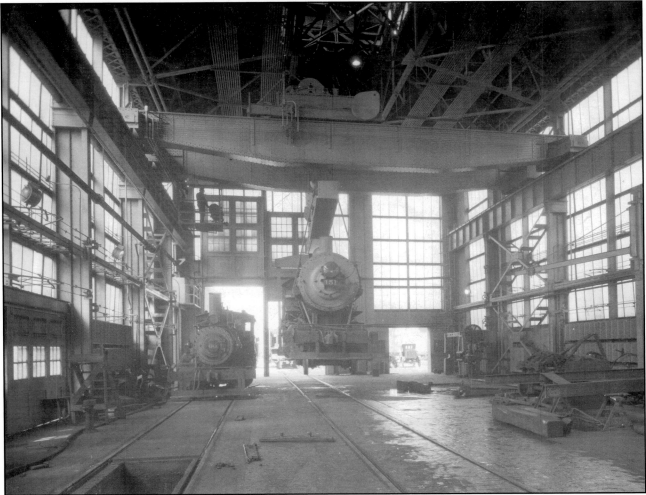

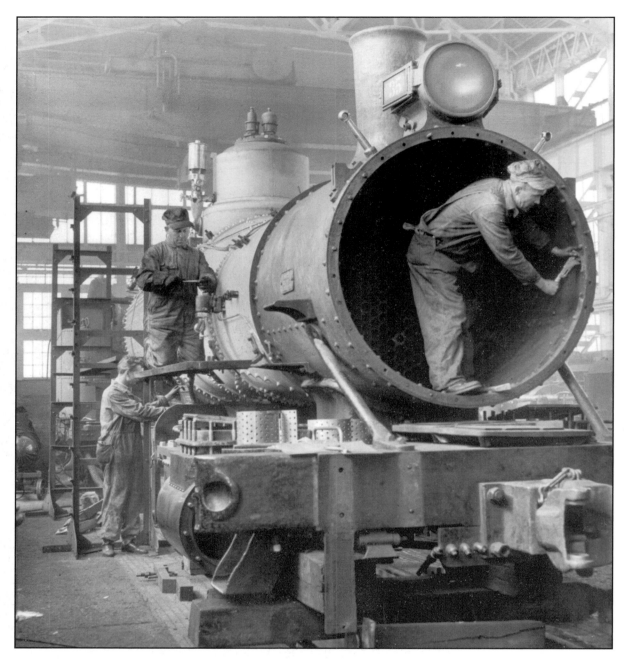

Men restore a vintage steam locomotive. Workers in the shop are kept busy repairing not only locomotives but also cranes, bulldozers, and railroad cars of every type. As shown in this 1937 photograph, Henry Ford continues to have his favorite steam locomotives overhauled while, for routine work at the Rouge, diesels are fast replacing steam locomotives. (833.68145-H)

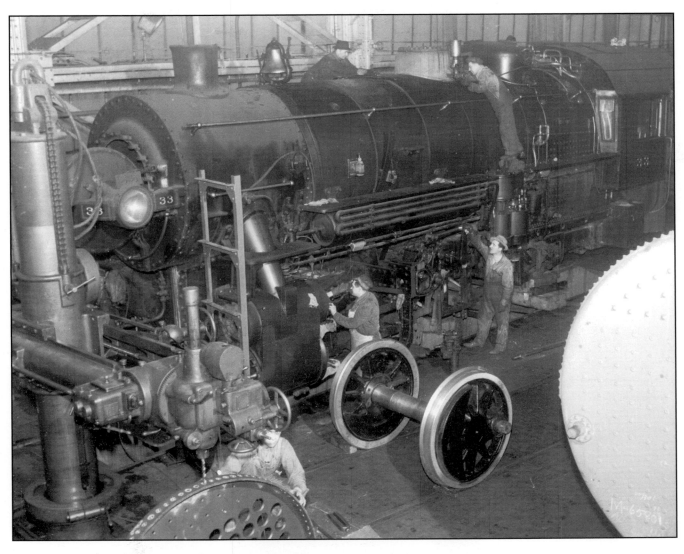

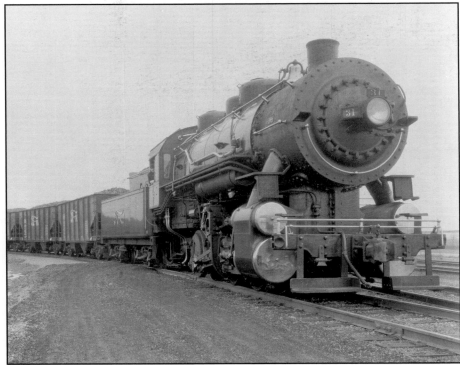

Above: One of Henry Ford's favorite steam engines, No. 33, undergoes reconditioning, as late as the 1940s. (833.79051-B)

Left: Ford steam locomotive No. 31 pulls a trainload of coke from the Rouge Plant in November 1933. (833.58082-1)

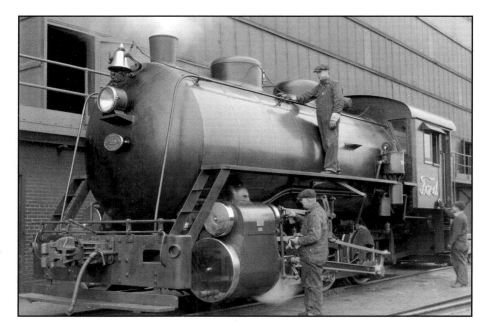

For hauling small loads, this "fireless" locomotive in the "donkey engine" class is charged with high-pressure steam and able to work for eight hours before losing power. These engines often worked inside buildings with no fear of fire, smoke, or fumes. This photograph is dated April 8, 1937. (833.68145-E)

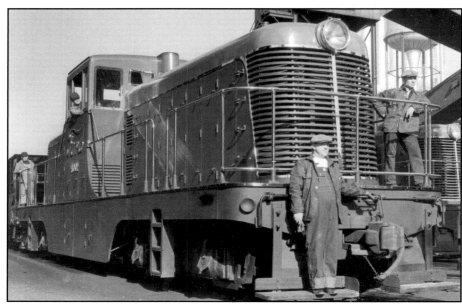

Right: One of a series of new diesel locomotives purchased for use as switch engines within the Rouge in 1937. (833.69302)

Below: Diesel switching engines move cars in the north yards of the Rouge Plant in March 1938. The Ford administration building is visible at the upper right. Acres and acres of Ford land extend westward beyond Rouge Plant boundaries. (833.69951-C)

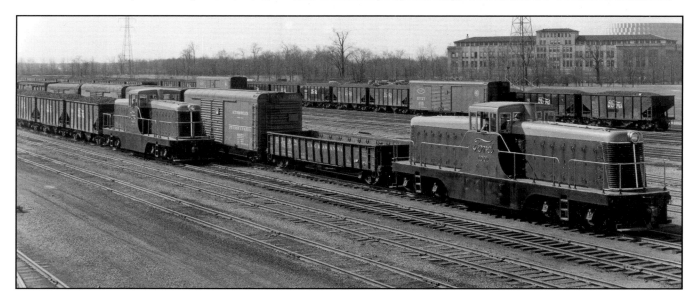

9
CARPENTER SHOP

When Henry Ford first operated the Rouge Plant, both sedan and touring-car automobile bodies were manufactured with stout wooden frames. Ford purchased approximately 400,000 acres of hardwood forest in the Upper Peninsula of Michigan, where he established several sawmills to furnish lumber for his automobile bodies. After being sawed into long boards in the Upper Peninsula, the wood was shipped by boat to the Rouge, where a sawmill built in 1919 could further shape the boards for specific uses. During 1921, for example, 140,000 board-feet of lumber was used daily. Some of the most select lumber was needed by pattern makers in designing molds for the hundreds of different castings being poured in the production foundry. In addition to automotive body framework, boxes of many sizes were needed to serve as shipping cases for automotive parts manufactured at the Rouge and shipped to domestic and foreign assembly plants. The Rouge Plant was at first exclusively a parts supplier to Highland Park and other Ford vehicle assembly plants and did not assemble complete cars in quantity until the Model A in 1927. All of these subassemblies, such as body panels, engines, axles, and window glass, required wooden crates or wooden bracing when shipped by either water or rail. Over the years, the use of wooden boxes did not diminish. By 1938, a Rouge box factory was in operation, where approximately 3 million board-feet of lumber a month was utilized in making 125 kinds of boxes used mostly for shipping purposes. About 7000 boxes a day were then being made by the 300 workmen employed.

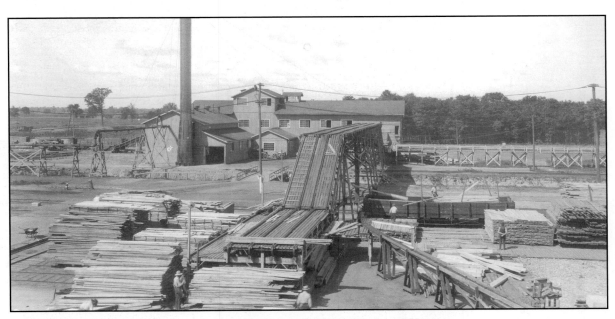

The Rouge sawmill on the very west edge of Rouge property in July 1922. Long wooden boards in the foreground are shipped from Ford's lumber mills in the Upper Peninsula of Michigan and are cut as needed at this mill to form wooden parts for Model T bodies and for building a variety of wooden crates for the shipment of automotive parts to Ford assembly plants and Ford dealers. (833.33114)

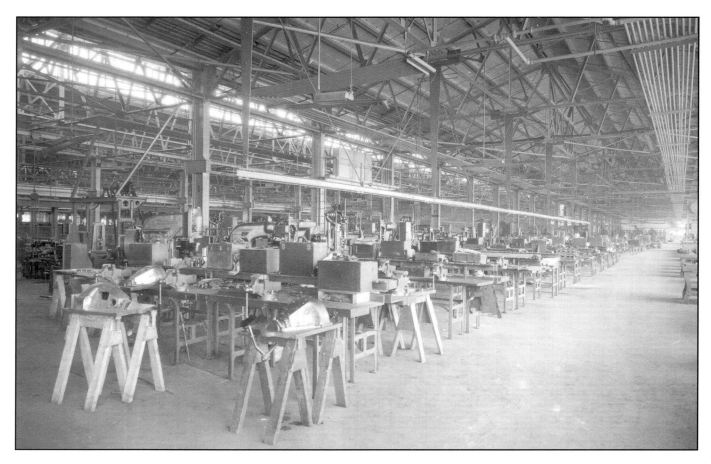

Above: The wood pattern shop at the Rouge in March 1923. In the foreground, on horses, is the pattern for a Model T transmission case. (833.34141-81)

Right: A veteran pattern maker prepares a wooden pattern for an engine manifold casting. (833.94502-4)

Opposite, top: Several types of saws and planers are used in this area of the carpenter shop in October 1926. (833.47808)

Opposite, bottom: In 1935, boards are cut to size and nailed together using machines capable of driving several nails at once. Most of these boxes are sized to be used as shipping cases for specific automotive parts. (833.62289-A)

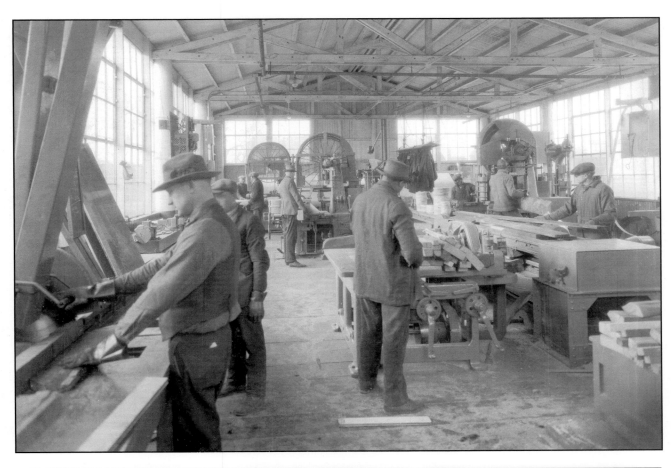

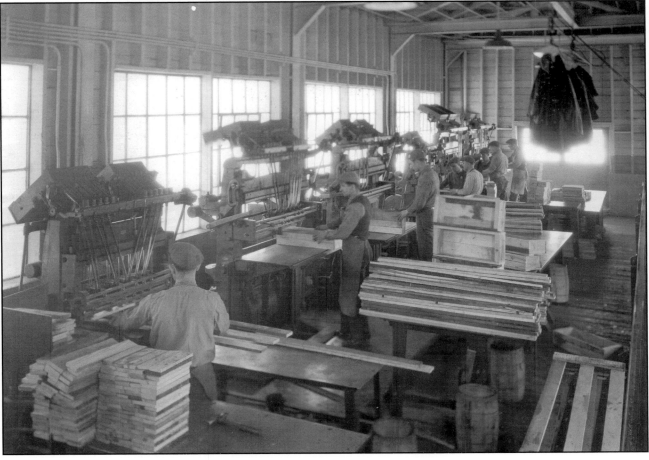

This device pulls nails from used boards so that the lumber can be reused. (833.69632-A)

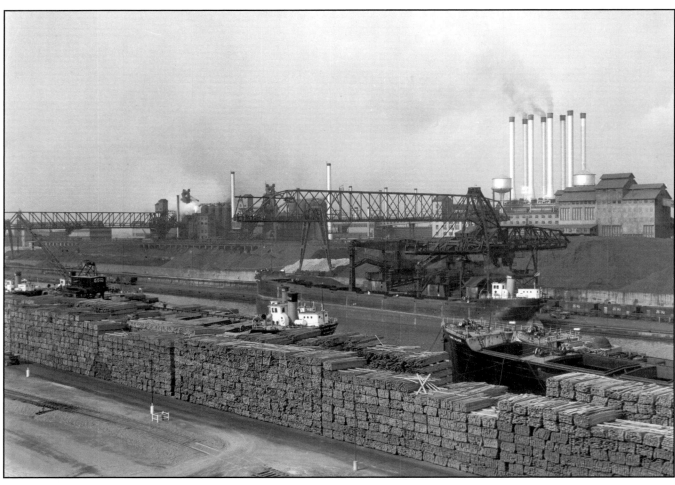

The hardwood lumber in the foreground is from Michigan's Upper Peninsula, stacked temporarily on the west docks at the Rouge. This photograph was taken in December 1937, but the shipping of rough lumber from the Upper Peninsula to the Rouge began in 1921. (833.69626)

10
PAPER MILL

Henry Ford believed in cleanliness and abhorred waste of any sort. At the Rouge, it took at least 5000 cleaners to keep the immense plant "shipshape." In one month, 32,500 gallons of paint were applied, 7000 mops and 2700 brooms were worn out, and 30,000 pounds of soap chips were used. In this ongoing massive cleanup, Ford recognized the value of the tons of waste paper accumulating daily. By October 1922, he had constructed and put into operation a paper mill. Trash such as empty cartons, paper bags, lunch wrappings, newspapers, and waste office paper was baled and sent to the paper mill, where it was all torn to bits and mixed with resinous chemical binders to form a dark, gummy mass that could be pressed and dried to form a strong, relatively oil- and waterproof "binder board." The many compositions, shapes, and sizes of binder board provided a variety of uses, such as cartons for shipping automotive parts and binder-board panels for use as upholstery backing in car body interiors. A workforce of about thirty-five employees was processing as much as 25 tons of paper a day by 1931. A small research laboratory staff in the paper mill kept improving the products of the mill, so that in 1937, an additional investment of $300,000 was provided, adding more space and improving facilities.

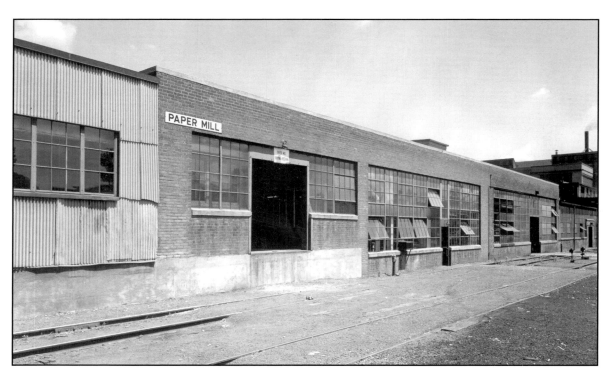

Top: Exterior of the first paper mill built in the heart of the Rouge Plant in 1922.
(833.96170-1)

72 Bottom: A Howland beater containing a batch of well-beaten binder-board slurry.
(833.37278)

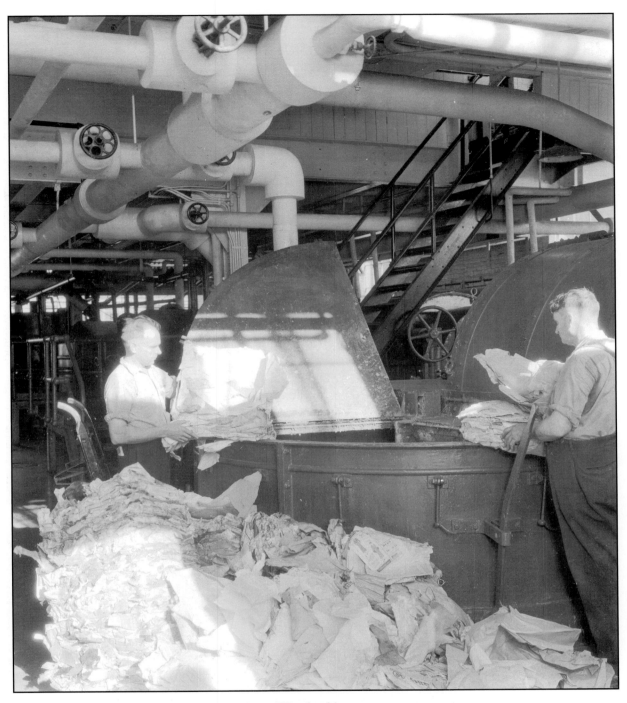

Salvaged paper being examined as it is put into a Howland beater. (833.56476.A.5)

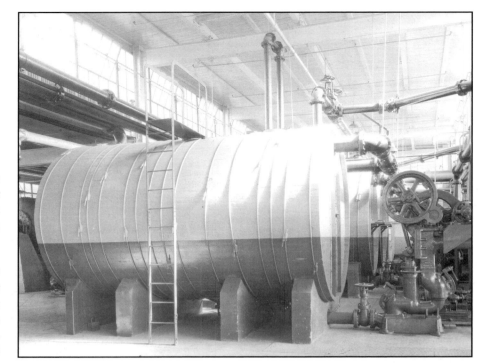

Right: Stock storage tanks containing slurry ready for pressing into binder board. (833.37280)

Below: A new Merritt press, added to the paper mill in 1939, converts the slurry into a continuous sheet of wet binder board. (833.72704-C)

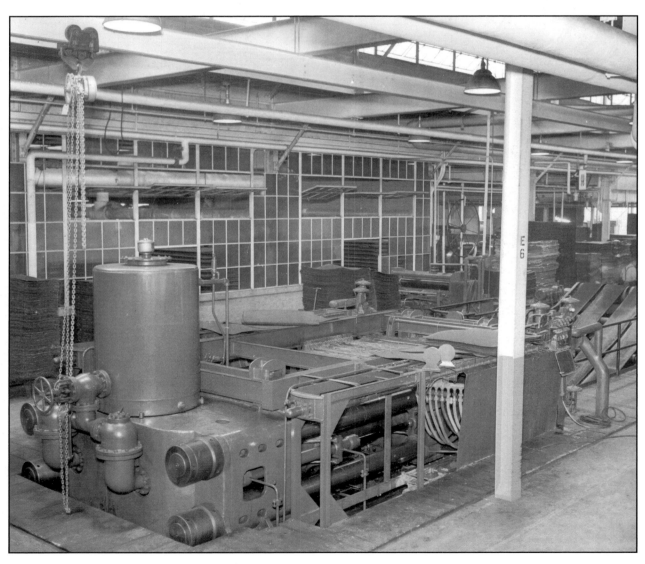

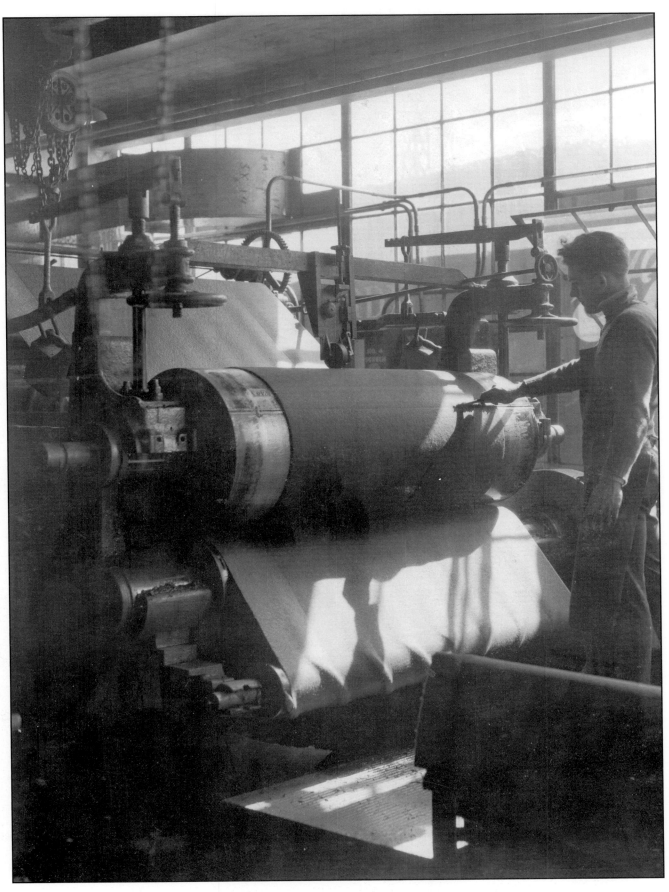

Wet sheet from the Merritt press is cut into large sections and piled in stacks.
(833.65728)

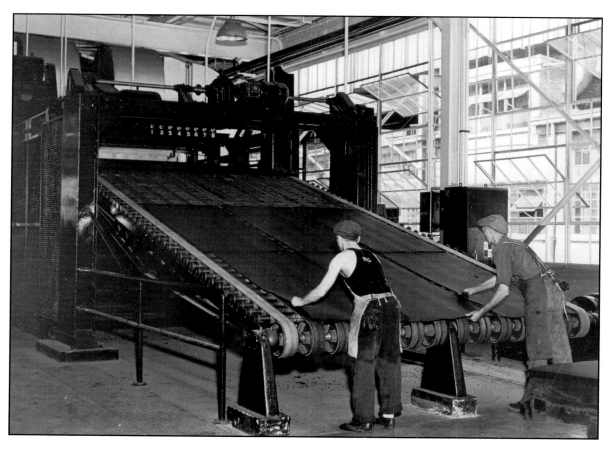

Top: Wet board sheets from the stack at bottom right are placed on a dryer. (833.70428-B)

76 Bottom: A display of samples of finished panel boards used in the Model A as interior body parts. (P.833.56476.A.2)

11
TRACTORS

The River Rouge Plant was first conceived by Henry Ford as solely a tractor plant. His highly successful farm tractors were being assembled in 1916 by Henry Ford & Son five miles away in Dearborn, and he visualized his tractor as being perhaps more important than his Model T automobile. It was for the manufacture of millions of tractors that he sorely needed blast furnaces and the largest foundry in the world.

The term *Fordson* was coined in 1917 and became the name of the tractor. When Henry Ford & Son became part of Ford Motor Company in 1920, Fordson tractor production was moved from Dearborn to the River Rouge Plant, where annual production in 1921 reached 36,781. In 1925, in honor of the Fordson tractor, the city of Springwells, in which the River Rouge Plant was located, changed its name to the City of Fordson. For the next four years, the River Rouge Plant was called the Fordson Plant.

To make way for Model A automobile production and assembly at the Fordson Plant, Fordson tractor production was discontinued on February 14, 1928. Tractor-manufacturing machinery was shipped that same year to Cork, Ireland, where Fordson tractor production resumed in 1929. Also that year, the cities of Fordson and Dearborn consolidated to become Greater Dearborn. The Fordson Plant then became known simply as the Rouge.

In a deal with Henry George (Harry) Ferguson of Ireland, Henry Ford again embarked on the manufacture of farm tractors. In June 1939, the first Ford-Ferguson tractor was produced at the Rouge Plant in the same B building where Fordsons had been built nearly twenty years earlier.

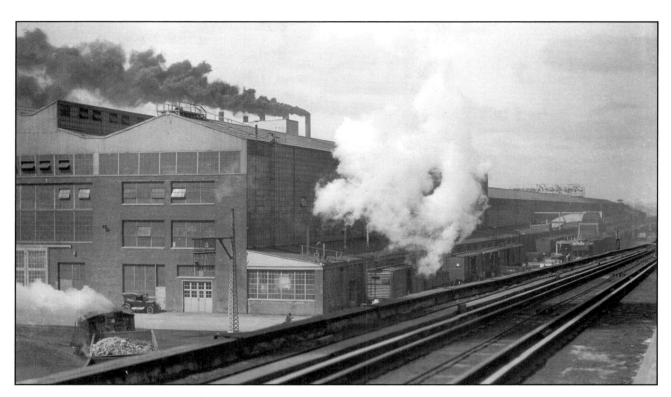

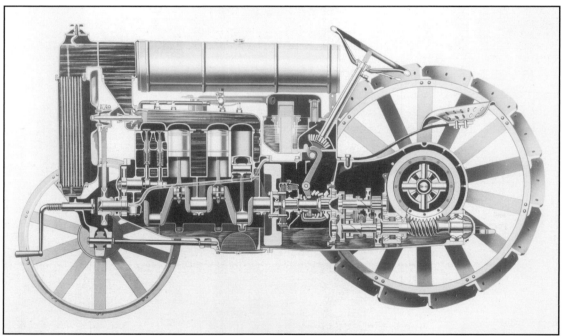

Top: The River Rouge B Building as it appeared in March 1924 photographed from the north end of the railroad highline. Following completion of Eagle boat assembly in 1920, assembly of Fordson tractors began in this same building. Although Model T parts, especially castings, were manufactured for several years at River Rouge, Model T cars were never fully assembled at the Rouge.

Bottom: A drawing of mechanical aspects of the Fordson tractor. The four-cylinder engine produces 21.4 horsepower at 1000 rpm. Driving wheels are 42 inches high and 12 inches wide. The three gear speeds at 1000 rpm are 1.50, 2.75, and 6.75 miles per hour. For plowing, the 2.75 ratio is usually used. (833.52482)

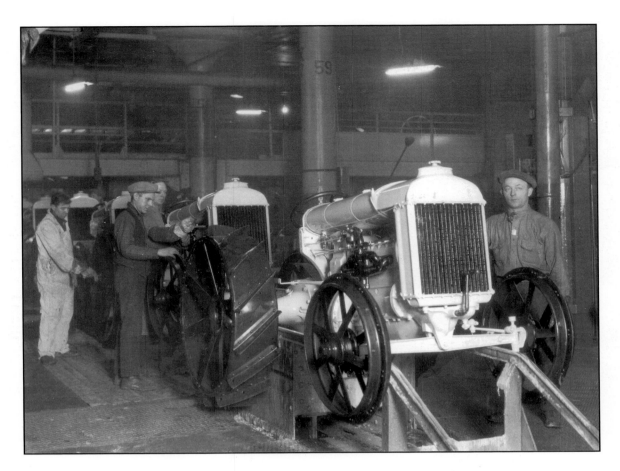

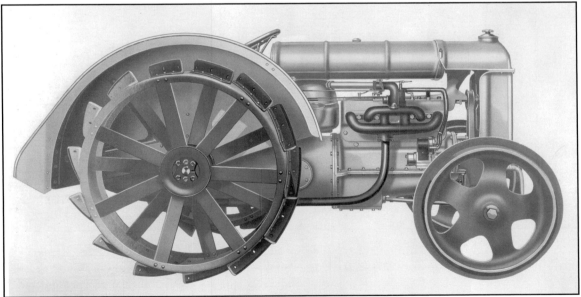

Top: Fordson tractors come off the final assembly line at the Fordson Plant on January 16, 1926. That year, 99,101 Fordson tractors would be built. (833.45138)

Bottom: This drawing of a Fordson tractor shows a fender over the rear wheel. Under certain conditions, when the rear wheel could not turn, the front end of the tractor would rise from the ground and roll backward onto the driver of the tractor. In 1922, the rear fender was designed to prevent the front end from rising too far, and the safety fender eventually became standard equipment. (833.52848)

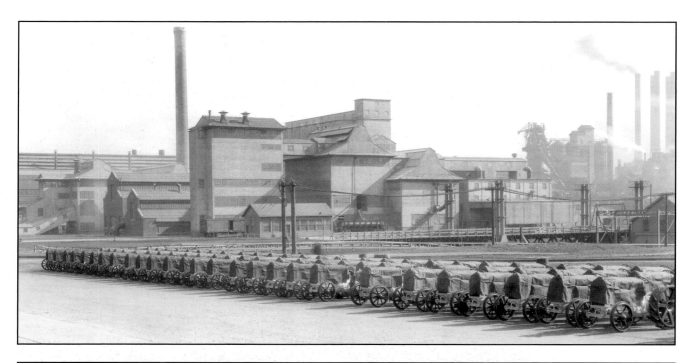

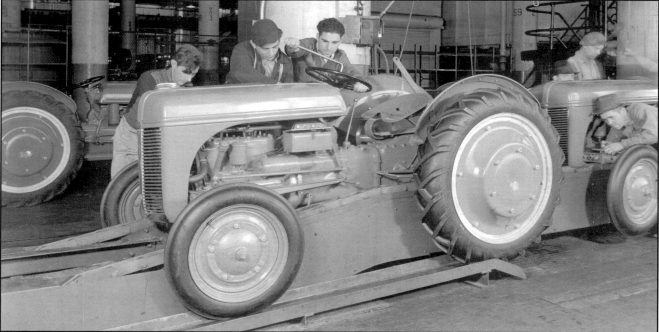

Top: Fordson tractors line up in front of the B building ready for shipment in February 1927. In the background is the cement plant, and to the far right are the blast furnaces and the powerhouse. This was the last full year of Fordson tractor production in the United States. A total of 93,972 Fordsons were produced that year, with the Rouge Plant manufacturing essentially all the parts and assembling about 100 tractors per day, while other Ford assembly plants in Des Moines, St. Louis, and Kearny, New Jersey, assembled the balance of the tractors. (833.48504)

Bottom: Final adjustments are made as this Model 9-N Ford-Ferguson tractor is lowered for the first time onto its own wheels. The date is November 16, 1939, and the assembly line is in the B building at the Rouge. That year, 10,233 Ford-Ferguson tractors were produced. (833.72697)

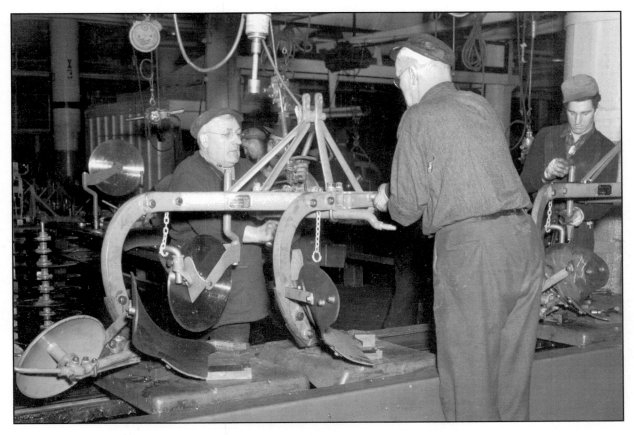

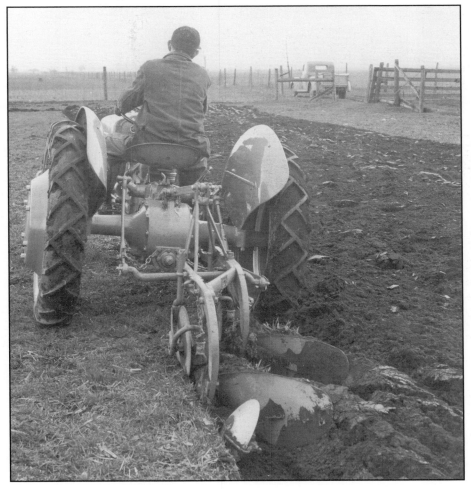

Above: Men assemble the double-bottom plow, which is an integral part of the Ford-Ferguson system. Implements attached to the tractor are controlled almost effortlessly by means of hydraulic linkages. The photo was taken February 14, 1940, in the B building. (833.73166)

Left: A Ford-Ferguson tractor plows a field using the hydraulically activated double-bottom plow capable of being raised or lowered by simple finger control. (833.73703-F)

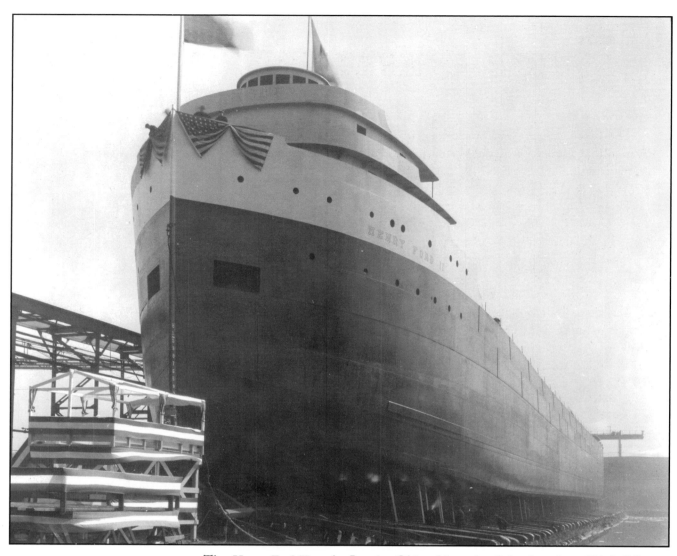

The *Henry Ford II* at the Lorain, Ohio, shipyards of the American Shipbuilding Company at the time of its launching on March 1, 1924. The next month, an almost identical ship, the *Benson Ford* will be launched by the Great Lakes Engineering Works at Ecorse, Michigan. Both ships are 600 feet long and equipped with 3000-horsepower four-cylinder diesel engines, which provide a speed of about 14 miles per hour. These two ships ply waters primarily between the Rouge Plant and the ore docks at Duluth, Superior, and Marquette on Lake Superior. (833.36778)

12
MARINE OPERATIONS

The River Rouge Plant was located in 1917 on the banks of the Rouge River so that Henry Ford could bring his raw materials in by boat and ship his manufactured products out by boat. The dredging of the river channel and boat slip by the U.S. government made that possible. In addition to the manufacture of Eagle boats, Ford had in mind especially his tractors. It was rumored as early as October 1919 that he planned a steamship line to deliver tractors to Ireland. At the termination of the Eagle contract, Ford announced he would manufacture barges at the Rouge location, and in August 1921, he announced plans to run freight barges on the Erie Canal to carry products between Detroit and New York. In time, he would do all of these things.

The first steam freighter is said to have docked at the Rouge in July 1923. About this same time, Ford was ordering two mammoth cargo carriers with which to supply his blast furnaces with iron ore from the Lake Superior region. These were the almost identical *Henry Ford II* and *Benson Ford.* To deliver manufactured goods worldwide, Ford was limited by the small dimensions of the St. Lawrence Seaway and the Erie Canal. To ply the Atlantic, he purchased two small ocean freighters, *Oneida* and *Onondaga,* which, by late 1924, were headed for southern Atlantic ports. A larger ocean vessel purchased in 1925 from the government was the *East Indian,* the pride of the Ford ocean fleet, which plied waters between New York and European, African, and Asian ports.

The largest group of ships to enter the Rouge were the 199 "Lakers," built at Great Lakes ports for Atlantic shipping during World War I and in 1925 part of the government's "Moth Ball" fleet. These were purchased by Ford at various Atlantic seaports at scrap prices and hauled by tug to the Rouge for salvage. Very few were saved for use as vessels.

A large amount of automobile freight was carried by canal barges between the Rouge and the East Coast seaports of Chester, Pennsylvania; Edgewater, New Jersey; Green Island, New York; and Norfolk, Virginia. The barges *Chester* and *Edgewater* were added to the fleet in 1931. They were at that time the largest cargo ships using the New York State Barge Canal. In 1937, the barges *Green Island* and *Norfolk* were added. These canal barges had retractable pilot houses, folding masts, and funnels that could be lowered to pass under bridges.

In all, the Ford fleet headquartered at the Rouge reached a total of twenty-nine vessels — thirteen barges, four towing tugs, one harbor tug, four canal boats, five oceangoing ships, and two ore carriers.

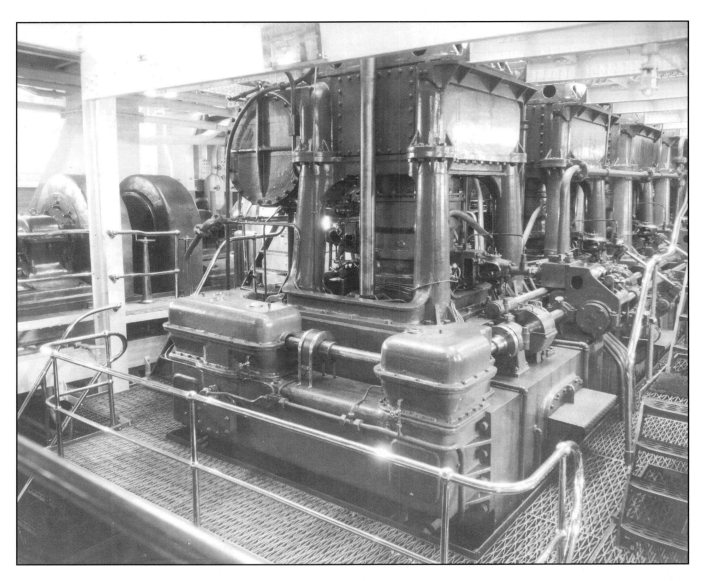

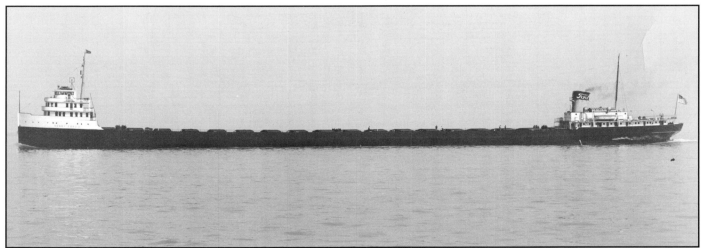

Top: The engine room of the *Henry Ford II*. (833.41652)

Bottom: The *Henry Ford II* in calm open water on the Great Lakes during October 1928. The ship carries a crew of thirty-four men including eight officers. (833.53159)

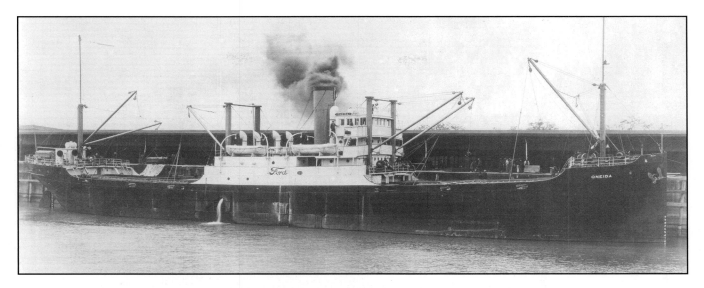

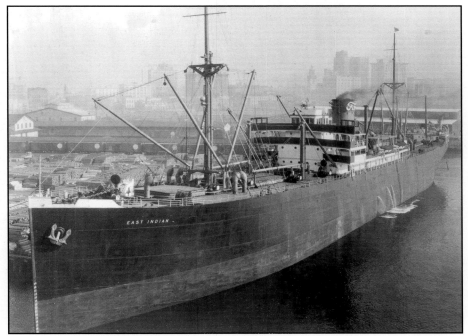

Above: The *Oneida*, built by the Detroit Shipbuilding Company in 1920 and acquired by Henry Ford in 1923. At 261 feet in length, it is barely able to pass through the Canadian canals and locks, but by the fall of 1924, after hauling lumber on the Great Lakes, both the *Oneida* and a sister ship, the *Onondaga*, will be based on the Atlantic coast and ply waters between Jacksonville, New Orleans, Houston, and as far south as Buenos Aires. The *Oneida* was sunk by a German submarine off the eastern tip of Cuba on July 13, 1942. Six of the crew lost their lives. (833.54276)

The *East Indian* never visited the Rouge but is shown here at Jacksonville, Florida, on February 6, 1935. Its 461-foot length is 200 feet too long to traverse the inland waterways. This 8200-ton ship was purchased by Ford in 1925 for $80,000 as a coal-fired steamer and converted to diesel power to provide a speed of 16.5 knots. Its purpose was to carry Ford freight to and from overseas ports. One load, for example, included 500 cars in wooden boxes together with 8000 engines, delivering them to dealers in Trieste, Barcelona, Copenhagen, and Antwerp. The *East Indian*, however, was one of the casualties of World War II. Chartered by the government, it was sunk by Nazi submarine U-181 on November 3, 1942, in the Indian Ocean, 300 miles from Capetown, South Africa. Of the crew, twenty-three went down with the ship, and fifty-one survived using a lifeboat and life rafts. (833.61999)

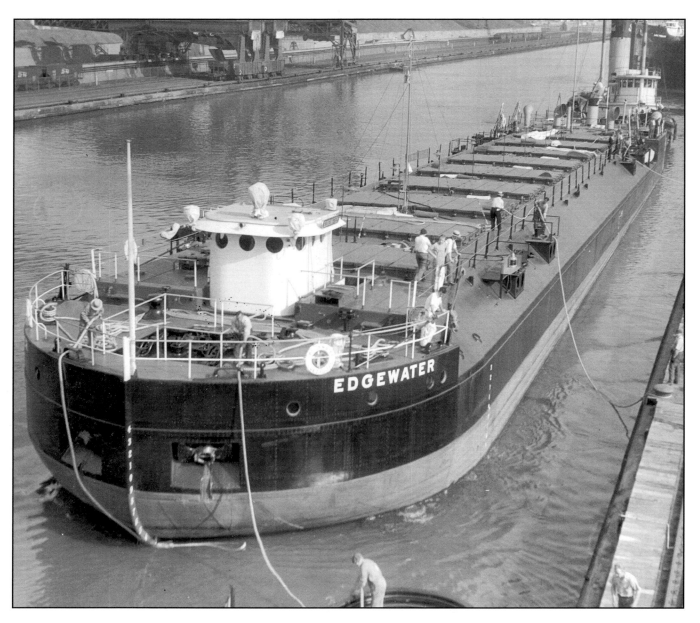

Above: The new canal barge *Edgewater* in the Rouge boat slip on August 10, 1931. This ship and its sister ship, the *Chester*, were added to the Ford fleet that year. The two ships were built by the Great Lakes Engineering Works at a cost approximating $593,000 each. With a length of 300 feet and capacity of 2800 tons, they are driven by 1600-horsepower steam engines and manned by crews of twenty-two men. The two ships' routine duties involve primarily carrying automotive material between the Rouge and Ford operations on the East Coast. (833. 56393-1)

Opposite, top: Entering the turning basin at the south end of the Rouge Plant is the *Henry Ford II* pulled by the tugboat *J. C. Morse*. (833.62768)

Opposite, bottom: There were as many as eleven tugs employed at the Rouge at one time or another. This one, the *Barrallton*, is one of seven almost identical tugs built in 1919 and purchased by Ford Motor Company from the government in 1925 to haul World War I freighters from eastern and southern Atlantic ports for salvage. Two or three tugboats are usually stationed at the Rouge to help pull or push the larger ships as necessary. (833.45792)

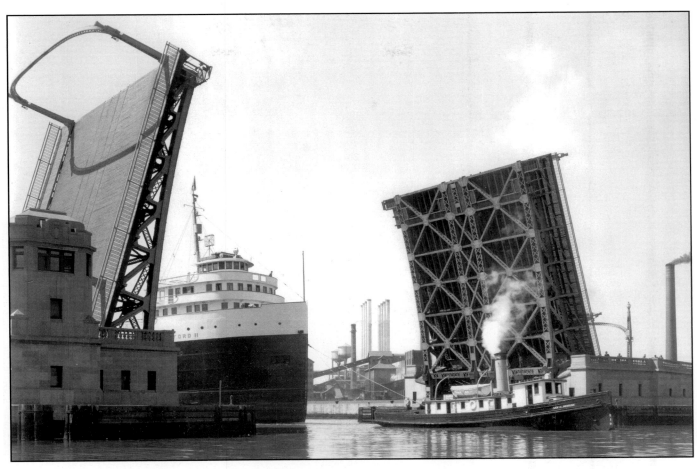

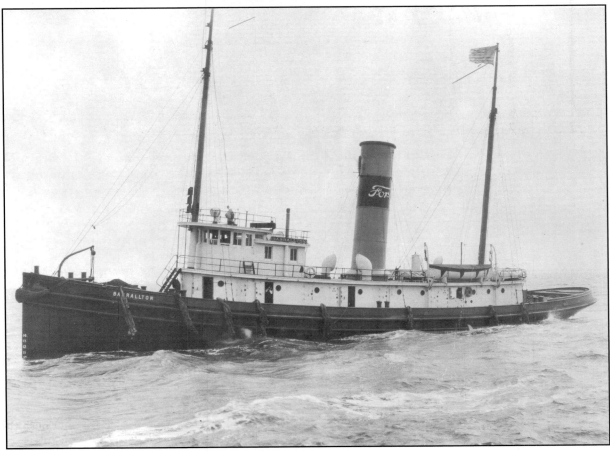

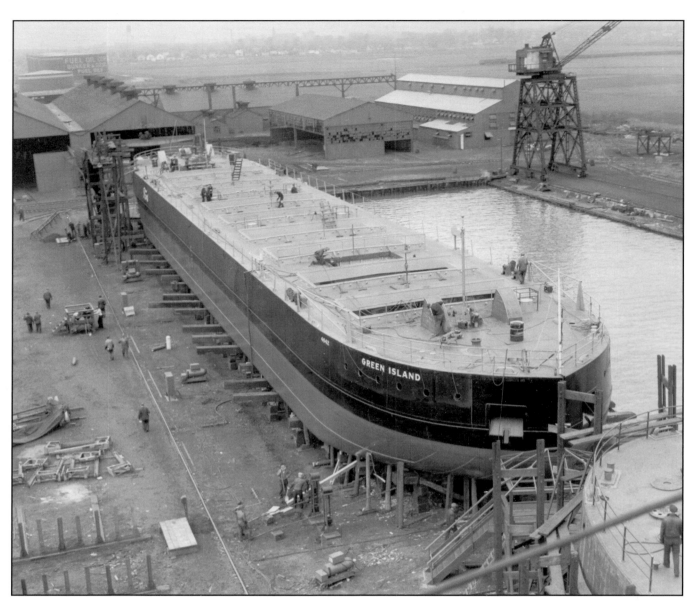

The *Green Island* nearing completion on May 14, 1937, at the Great Lakes Engineering Works, River Rouge, Michigan. The stern of the *Norfolk* is also visible at lower right. Each of these duplicate 300-foot vessels is powered by two 600-horse-power V-8 engines providing a speed of 12 knots. (833.68045-D)

13
DOCK OPERATIONS

The mile-long docks at the Rouge were just one of the many ports of call provided to Ford ships as they carried goods from place to place around the world. Smaller dock facilities were provided at several Great Lakes locations, coastal cities in the United States, and Ford manufacturing sites on five other continents. Rouge dock facilities were most complete, however, and methods of handling automotive freight were most advanced. From the bulk handling of raw materials to the delivery of the finished vehicle and its parts, the simplest, most efficient, and most dependable procedures were adopted. During the time these expensive vessels were in port, they were not working, and neither were most of their crews. Expenses were high; unloading and loading time was precious. Every device possible was applied to shorten a ship's time at dock.

One detrimental feature of the Rouge location was its climate. From about mid-November until mid-March, navigation on the Great Lakes and the St. Lawrence Seaway was hindered by ice, making it necessary to complete as much shipping by water as possible during the ice-free season.

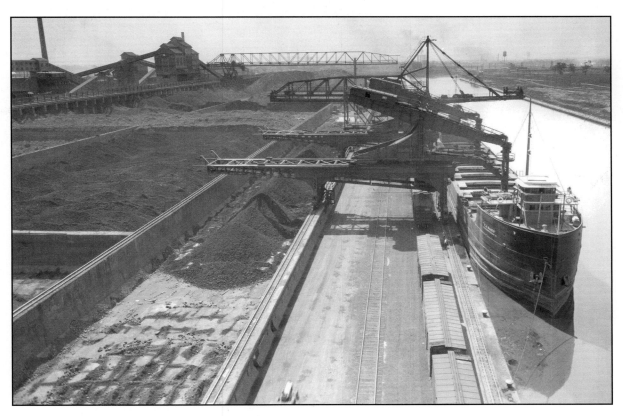

Looking south from the top of the B building, one of the Great Lakes freighters is seen bringing iron ore from the Lake Superior mines to the Rouge dock in August 1923. Hulett unloaders are at work lifting ore from the holds of the ship. Bare land is still on the west side of the boat slip. (833.35057)

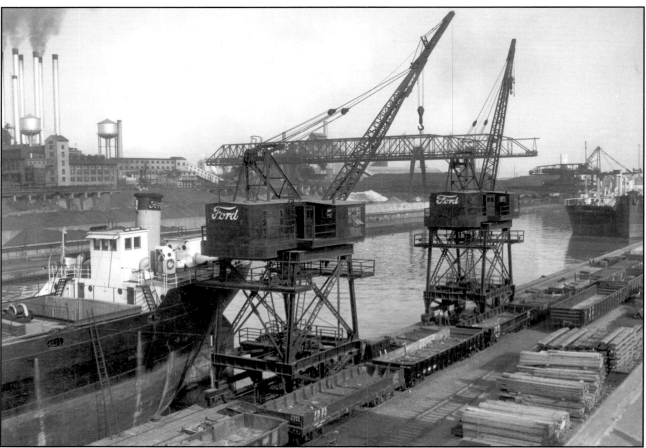

Top: Down inside one of the holds of this ore boat are two men working. One sits inside the arm of the Hulett unloader, opening and closing its mammoth jaws before it travels upward out of the ship, while the other man drives a Fordson tractor scraping residual ore toward the unloader's wide-open jaws. The photograph was taken on October 7, 1924. (833.38892)

Bottom: In August 1937, both sides of the boat slip are active with stout cranes to lift material onto and off ships. Several ships can be accommodated simultaneously. (833.68680)

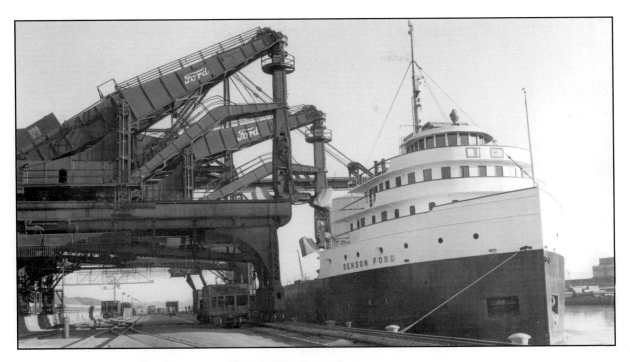

Above: The cargo carrier *Benson Ford* with Hulett unloaders on the east docks of the Rouge Plant. Later, to make certain these large bulk carriers could unload their cargo immediately upon reaching any port, self-unloading equipment would be installed on their decks. (833.72435-A)

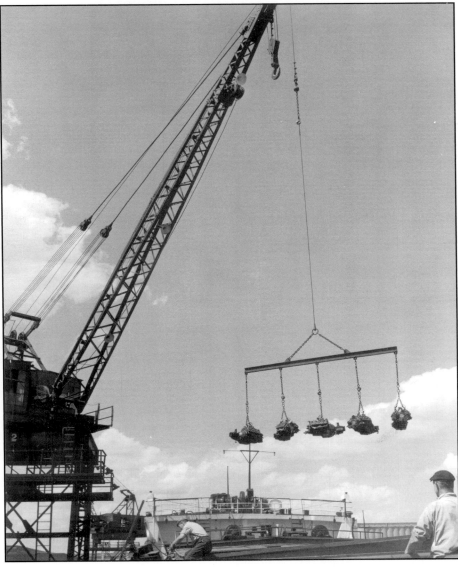

Left: The Ford method of loading V-8 engines together with transmissions onto ships by means of the railroad cranes at dockside. Five (sometimes ten) of these engine-transmission units are swung together into the holds of the ships. (833.74081-D)

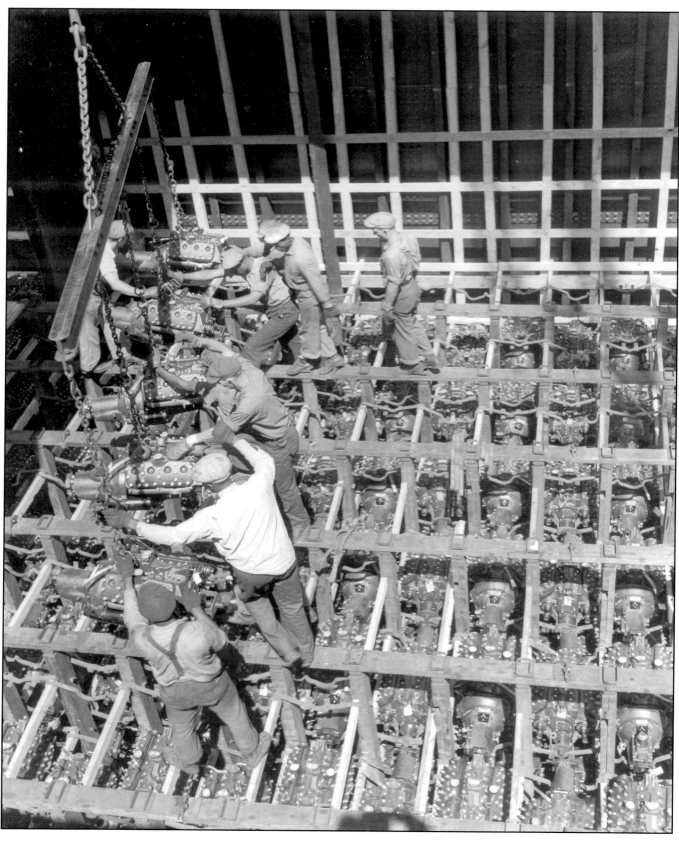

Engine-transmission units stacked in layers in the hold of a barge going to the East Coast in August 1940. (833.74081-F)

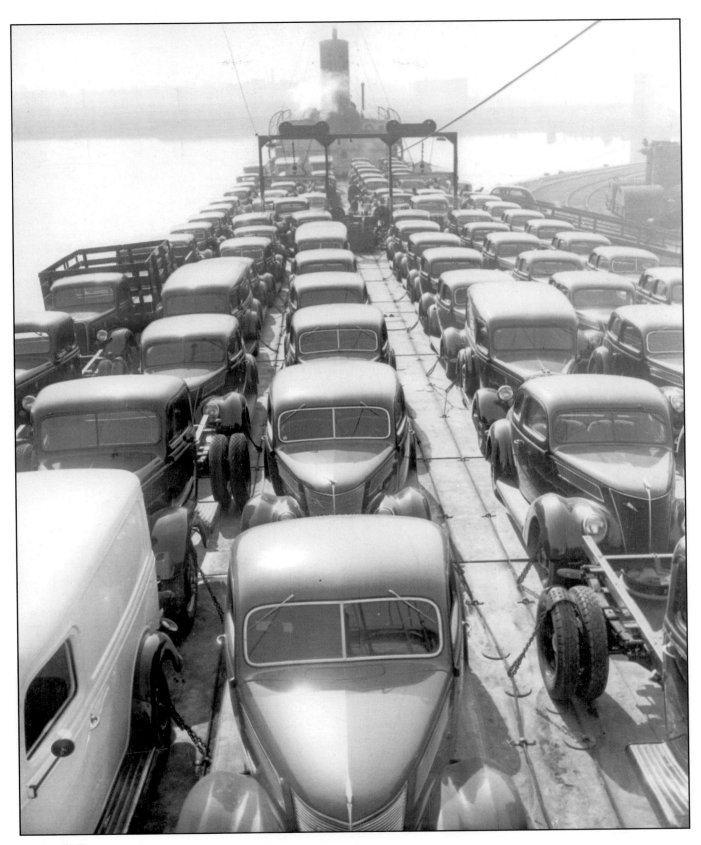

A March 3 shipment of new 1937 cars and trucks manufactured at the Rouge Plant are loaded onto a barge for shipment to the East Coast. At this early date, the shipment is probably the first of the season. Chains fasten the wheels of the vehicles to the deck of the ship. The barge is docked at the far south end of the west dock near the turning basin. (833.67992)

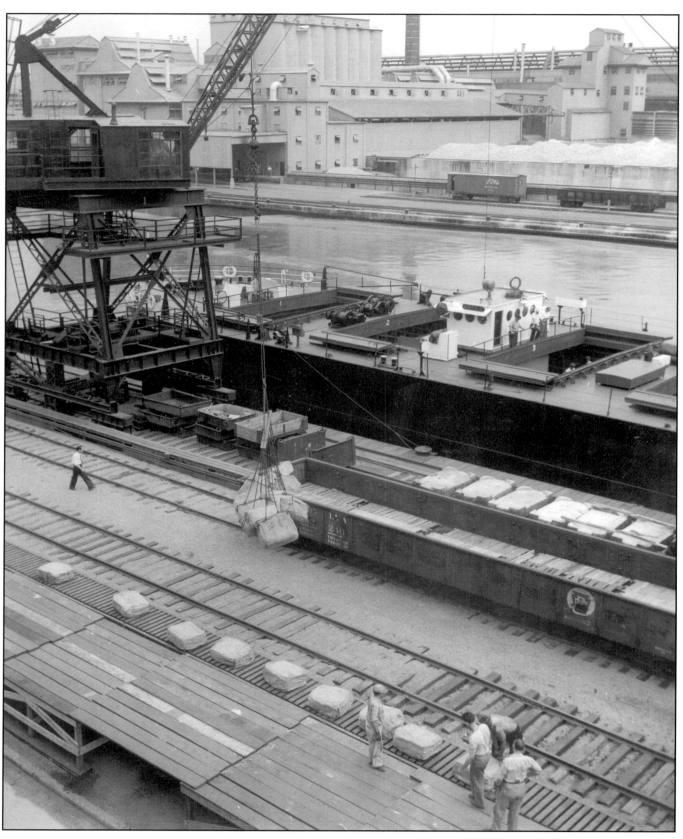

A shipment of rubber is delivered to the Rouge Plant by the Ford barge *Norfolk*. This is in 1939, when the tire plant is operating and rubber imported from the Far East is transshipped from the East Coast of the United States. The conveyor at the bottom of the photograph carries the baled rubber directly into the adjoining tire plant.
(833.72140-B)

14
SHIP SALVAGE

In negotiating for the ocean freighters *Oneida* and *Onondaga,* Henry Ford became aware of hundreds of surplus World War I merchant ships, most of them built on the Great Lakes and called Lakers. In August 1925, Ford purchased 199 of these 1500-ton surplus ships for an average price of $8530 in their "as is, where is" condition. Towing was to be from various Atlantic coastal ports to the Rouge by way of the St. Lawrence and Canadian locks from as far away as Orange, Texas, a distance of 4332 miles. Towing to the Rouge was at Ford's expense, and the dismantled parts were to be used solely by Ford Motor Company. However, any one of the ships could be restored upon payment of $16,470 to the government, Ford bearing the restoration expense of about $22,000. Along with the ships, seven seagoing steel tugs were also purchased from the Shipping Board.

Because of their size, about fifty ships larger than Lakers were scrapped on the Atlantic coast and hauled in pieces to the Rouge on the smaller Lakers. The first salvage ship to reach Fordson was the *Lake Fondulac,* arriving on November 15, 1925, from Kearny, New Jersey, towed by the tug *Barlow.* Scrapping of this first ship was completed on June 15, 1926. A crew of 1500 workers, by means of a ten-station disassembly line along the west bank of the ship canal at the Rouge, completely dismantled seventy-six derelict vessels during 1926. During 1927, about 1000 employees continued working at the docks, and sixty more vessels had been either dismantled or converted to barges. The last of the salvage vessels to arrive at Fordson was the *Lake Annette* in August 1927. Three of the ships were converted for ocean use and five for use as freshwater barges.

The major material recovered from the ships at the Rouge docks was steel, amounting to 144,532 tons. Much of the steel was cut into scrap and fed into open-hearth furnaces. Large pieces were hauled to the pig-cast building, where each piece was slowly dunked in a vast ladle of molten blast-furnace iron prior to being pigged. Engines and boilers were reconditioned. Miles of pipe and electrical conduit were utilized for plant construction and maintenance, as were thousands of small hardware items. Almost all of the ship salvage materials had been used in one way or another by 1929.

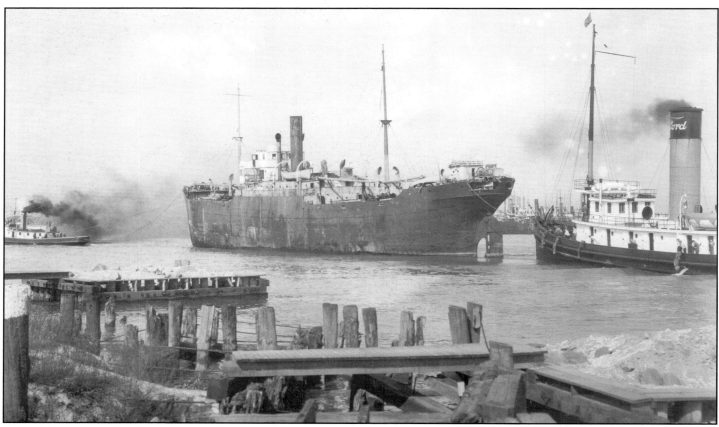

Top: A tug with a strong hawser tows four Lakers in a line on calm waters during August 1926. Each Laker can supply its own steam for steering and auxiliary equipment but not for propulsion. (833.47446)

Bottom: A Laker is pulled along the Rouge River toward the Ford docks by Ford tugs on October 4, 1926. (833.47617)

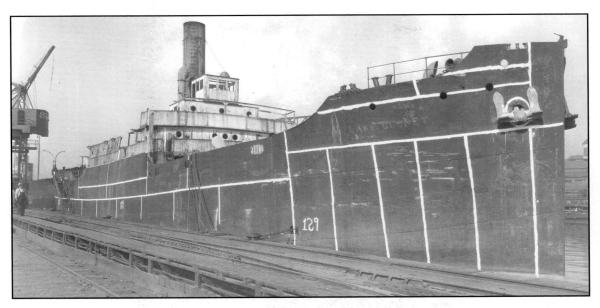

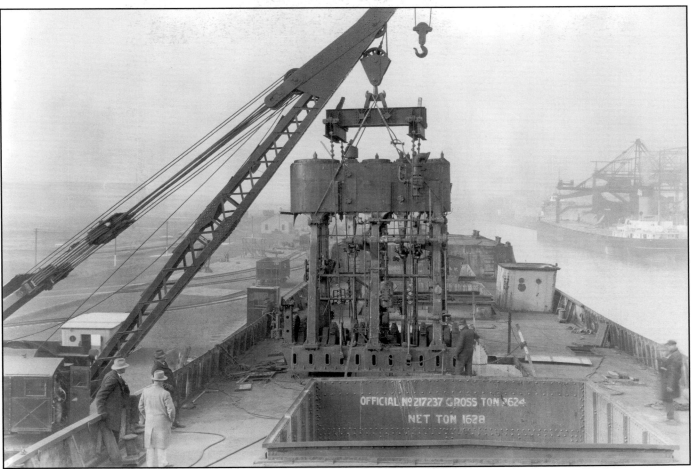

Top: The *Lake Copley*, tied to the dismantling dock at the Rouge boat slip on October 25, 1927. Markings on the ship's hull indicate where the giant shears and cutting torches will do their cutting. (833.50088)

Bottom: Carefully lifting the ship's valuable engine out of the hull. These engines have had little use and will be put back into working condition for powering various Ford operations. (833.50386)

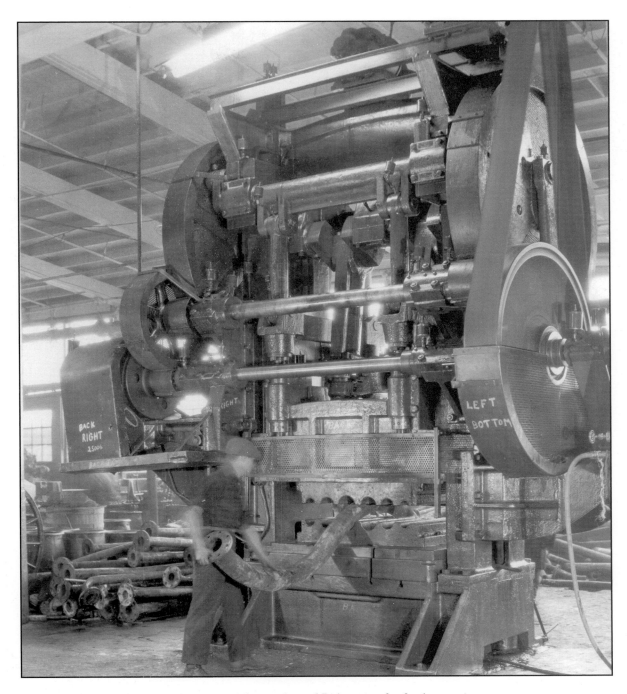

A worker operating a giant press to straighten salvaged Laker pipe for further use in Ford factories. The photograph is dated December 1926. (833.48036)

Opposite, top: Rows of engines (left) and boilers (right) stored temporarily at the Rouge Plant in November 1926. These will all be put to use later. (833.47981)

Opposite, bottom: A grand mixture of small items, including piping, fittings, valves, and other hardware, is accumulated near dockside to be hauled to repair stations elsewhere at the Rouge. (833.47806)

15
GLASS PLANT

The Ford Motor Company pioneered the manufacture of automotive plate glass. Following World War I, when sedans were becoming popular, Henry Ford noticed distortion in the purchased glass used in his Model T sedans. His solution was to manufacture his own glass. At the Highland Park Plant in 1921, after trying the customary procedure of making batches of molten glass that were poured into pots, lifted by cranes, and then repoured onto fixed tables, a new continuous process was devised. This new process, whereby the furnace operated continuously and poured continuously onto moving tables, was the method adopted by the Rouge glass plant, which began production on August 11, 1923. Over the years, Rouge glass furnaces were enlarged and operated continuously for months at a time, producing as much as a mile of plate glass before being relined. Also in constant operation were the overhead grinders and polishers that produced the perfectly flat surface as the glass passed beneath them on the endless line of tables.

The Rouge glass plant was the largest of Ford's three such plants. In February 1923, because of the popularity of closed cars, Ford purchased the Allegheny Plate Glass Company's plant at Glassmere, Pennsylvania. In 1926, because of the high-quality sand beneath the Twin Cities, Minnesota, assembly plant, glass production was undertaken at that location. By 1930, the three plants were producing 20 million feet of glass annually, of which the Rouge produced half. And by that date, the need to produce both laminated and tempered safety glass for automobiles brought numerous additional technical challenges.

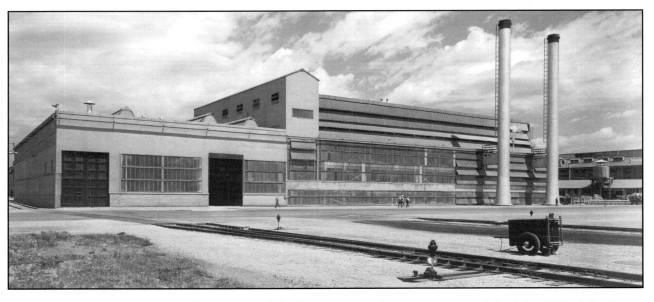

A front view of the Rouge glass plant as it appeared in July 1936, following installation of new and more efficient equipment. There are now two much larger furnaces rather than the previous four smaller ones built in 1923. Grinding and polishing lines move faster, and laminated safety glass becomes a standard product. The one-story building at the left is the Rouge fire station. (833.66411)

At the charging end of one of the two glass furnaces, this worker, guarding his eyes from the glare, is stirring the molten glass and will extract a small sample to be sent to the laboratory for analysis. Fuel for heating the furnaces is Rouge coke-oven gas. (833.65267)

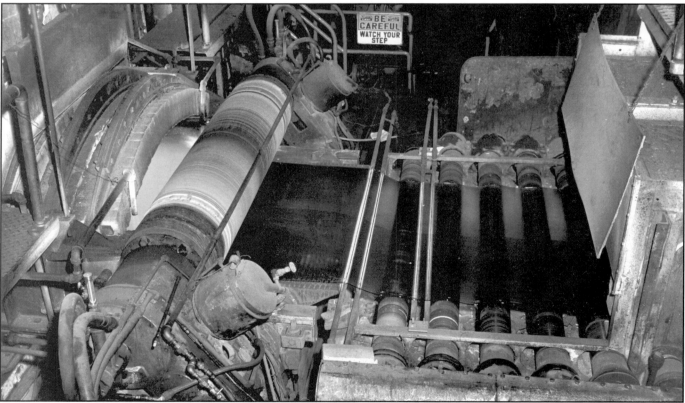

Top: Inside one of the large glass furnaces when drained of glass in May 1938, after sixteen months of continuous service. Inside dimensions of the tank are 117 feet long and 22 feet wide. In operation, the tank contains 5 feet of molten glass weighing 900 tons held at a pouring temperature of 2250 degrees Fahrenheit. (833.70267-A)

Bottom: Molten glass, at left, is flowing from the furnace and between two water-cooled rolls controlling the 3/16-inch thickness and 53-inch width of the glass sheet. At the right, the endless sheet of glass enters a 440-foot annealing lehr, where the temperature is gradually lowered until the glass is cool enough to handle. (833.03297-7)

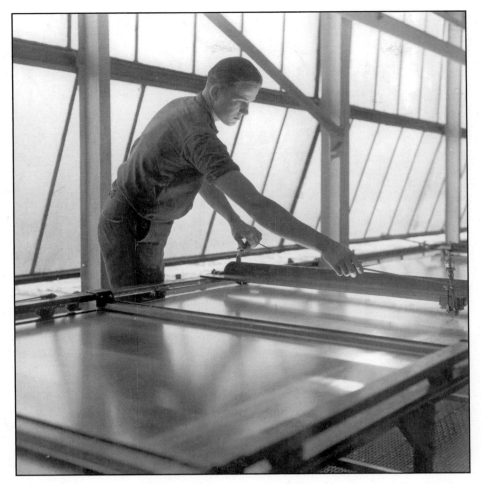

Left: This photograph was taken on August 15, 1936 the very month the new manufacturing equipment was put to use. This man operates the glass-cutting machine at the cool end of the annealing lehr. The continuous line of glass, moving at the rate of 160 inches per minute, is cut into large sheets whose surfaces are still rough. Grinding and polishing are yet to come. (833.65276)

Below: A rare view of a motionless line of thirty grinders in the newly equipped Rouge glass plant. Usually, these grinding wheels are whirling at a good clip driven by the electric motors mounted above. A wet-sand abrasive, accurately graded from coarse to very fine particles, provides the necessary grinding action. (833.64348)

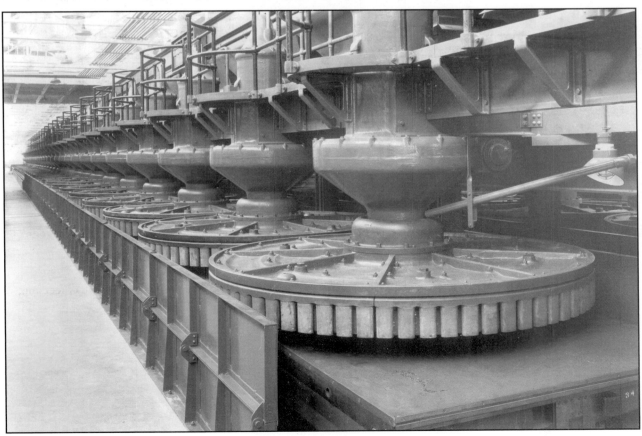

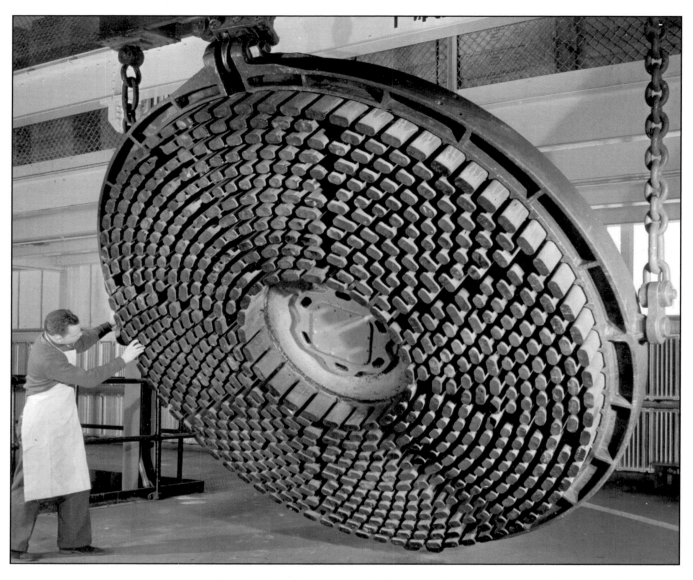

One of the thirty giant grinding wheels is inspected on December 29, 1937. (833.69633-0)

Opposite, top: The line of polishing wheels, either standing idle or photographed with split-second exposure in the Rouge glass plant on April 9, 1938. On the polishing line, the sand is replaced by red ferric oxide (rouge) to obtain the finest polish possible. (833.70081-A)

Opposite, bottom: One of the multiple polishing wheels is examined on December 29, 1937, after more than one year of use. (833.69633-M)

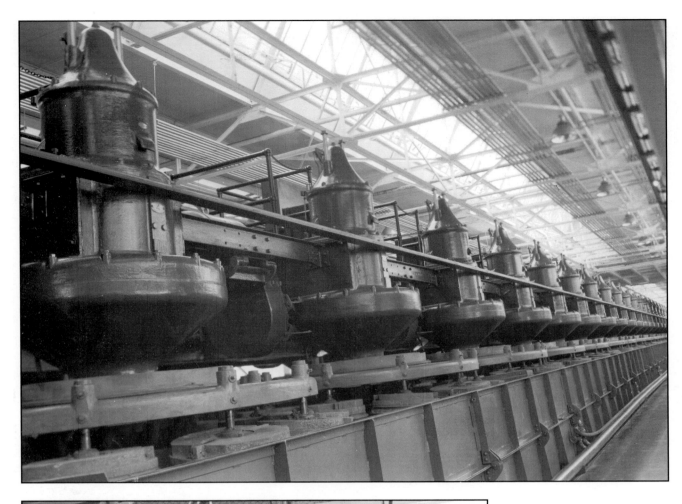

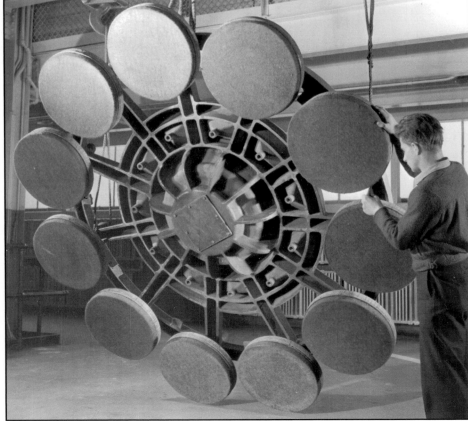

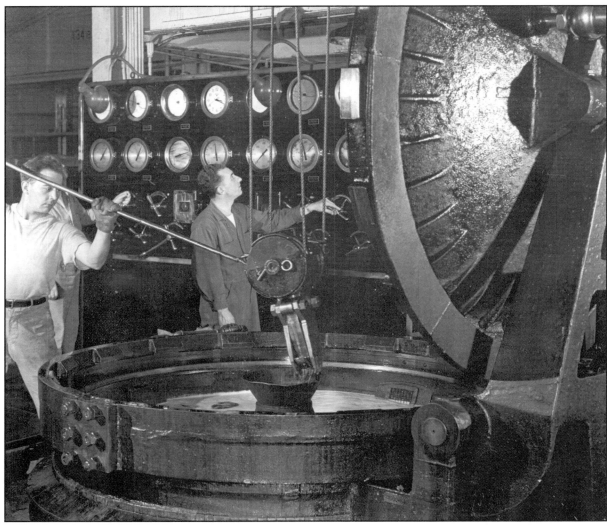

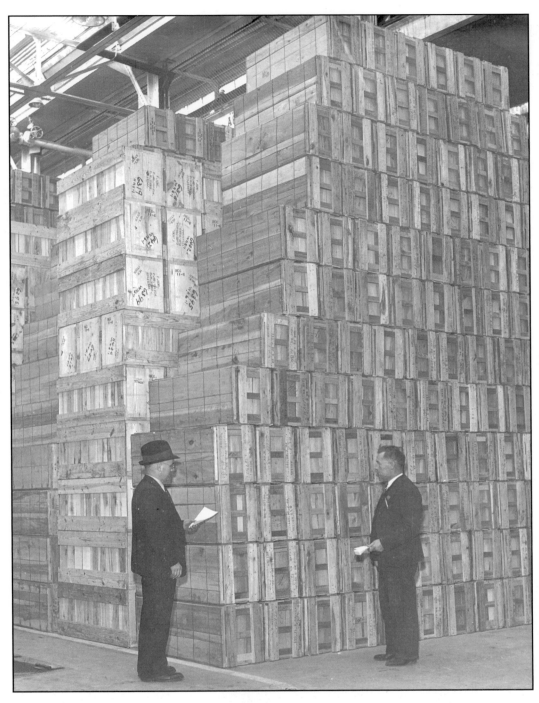

Crated automotive safety glass is ready to be shipped to Ford assembly plants and parts distribution centers. (833.64504-J)

Opposite, top: Men assemble or "sandwich" laminated automobile window glass by placing a sheet of polyvinyl resin between two thin sheets of plate glass. Cleanliness is paramount at this stage, where a bit of lint or dandruff can result in a visible defect in the final product. Laminating rooms are rigidly temperature- and humidity-controlled. (833.67118)

Opposite, bottom: The laminating process is completed in this huge autoclave, or pressure cooker. Stacks of glass sandwiches are submerged in oil with heat and pressure applied. The heating is done while hydraulic pressure of 225 pounds per square inch is applied at a starting temperature of 150 degrees, raised to 275 degrees, and maintained for five minutes. Under this extreme heat and pressure, the actual lamination takes place. (N- 4694)

16
CEMENT PLANT

The composition of Portland cement was patented in 1824 and named after the stone quarried on the Isle of Portland on the east coast of England. In 1890, the introduction of the rotary kiln completely revolutionized the manufacture of Portland cement, making its preparation a continuous rather than a batch process.

Although Henry Ford purchased Portland cement by the trainload from Thomas Edison in the initial building of the Rouge, after his blast furnaces were operating, he had the great advantage of making Portland cement for himself from blast-furnace slag. Along with smaller portions of silica, alumina, iron oxide, and magnesia, Portland cement is composed primarily of lime. Lime is a useful ingredient in the purification of iron during reduction from iron ore in the blast furnace but is then skimmed off the molten iron as a by-product. Whereas Portland cement was usually made by using a dry mixing process, Ford slag cement utilized a cleaner wet process. Ford not only sold Portland cement to the public, but he also lavishly utilized cement wherever it was desirable.

The first kiln in the Rouge cement plant was lighted in April 1924, the second kiln in August 1925. Cement manufacture at this Rouge site continued for at least twenty years at a rate of more than 2000 barrels a day. During the 1940s, the United States was producing annually approximately 200 million barrels of cement.

Opposite, top: An August 1932 view of the Rouge cement plant looking east from the top of a gantry crane next to the boat slip. To the left is the B building. Ore bins and blast furnaces are out of sight immediately to the right of the cement plant. Silos in the background belong to the cement plant, as does the tall stack. The stack does not emit the customary fine dust particles because special filters collect particulates that are reprocessed into about 250 barrels of additional cement each day. (833.68625)

Opposite, bottom: The mechanism for crushing coarse blast-furnace slag into fine particles for use in the manufacture of Portland cement. Hidden by the wooden structure at top right is the conveyor belt that brings the slag to the crushing machine below. To the right is the guarded motor drive, and to the left is the guarded blower, both recently replaced. The blower can send the powdered slag either to storage or to the rotary kilns. (833.79068-2)

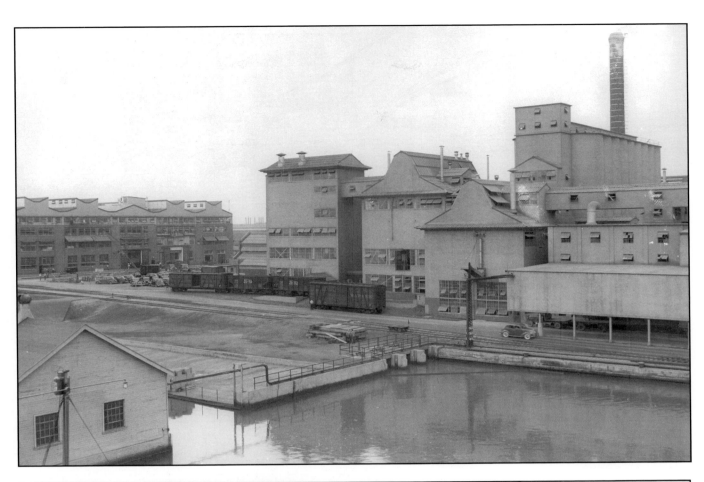

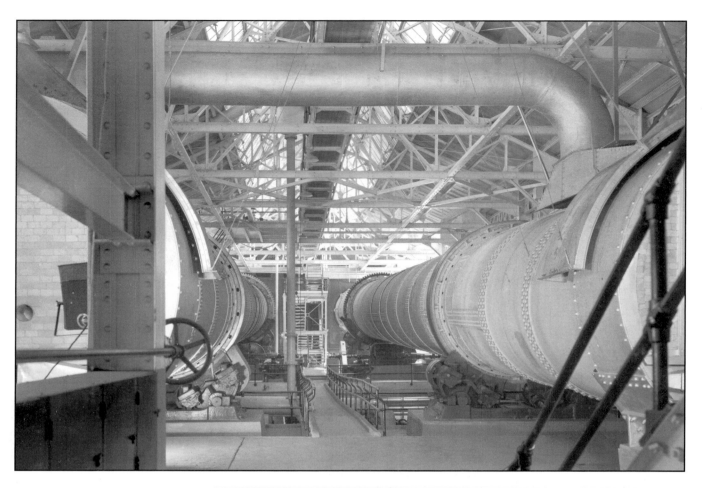

Above: The heart of the cement plant equipment is these two giant kilns, as they appeared on February 29, 1936. These long steel cylinders lined with fire brick have an internal diameter of 10 feet and a length of 150 feet. Both are inclined slightly downward, with the finished cement emitted at the lower far end. Powdered coal used as fuel produces a temperature within the kilns of 2700 degrees Fahrenheit. The place is surprisingly clean; Henry Ford would not tolerate a dirty, dusty factory. (833.65311-A)

Right: The hot end of the kiln where raw materials, made up of about 40 percent slag and 60 percent limestone, are fed continuously as a slurry, with pulverized coal added as a fuel. 833. 65311)

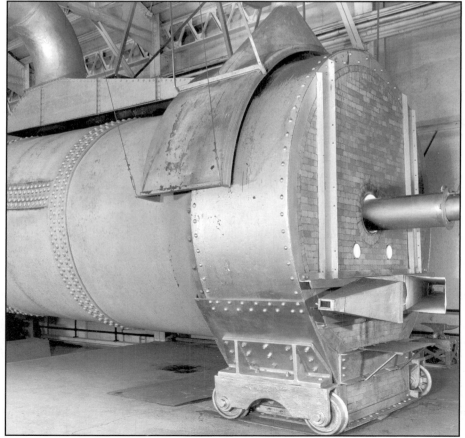

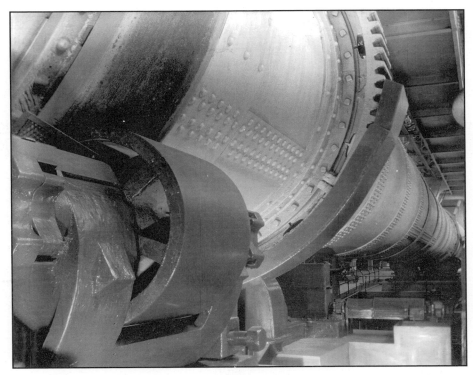

Left: The relatively cool end of the cement-making kiln, where rotation of the kiln is provided by an electric motor driving a gear surrounding the circumference of the kiln. More than an hour is required for the slurry to travel the length of the kiln. (833.62902-A)

Below: Filters that employ vacuum and air currents to remove the last traces of moisture from the cement before bagging. (833.62919-A)

Bagging and weighing Ford Portland cement in April 1937. A scale automatically controls filling of the bags, each containing exactly one cubic foot or 94 pounds. (833.68158)

17
BY-PRODUCTS

Henry Ford abhorred waste. Wherever there was scrap, he found a use for it. Whenever his manufacturing operations resulted in a by-product, he found a market for it. Surplus electrical power generated at the Rouge was diverted for use at the Highland Park Plant. Blast-furnace exhaust gases containing considerable carbon monoxide helped fuel the powerplant boilers. Slag from the blast furnaces was converted to cement, and tons of scrap sheet steel from the stamping plant were remelted in the foundry, electric, and open-hearth furnaces.

Shortly after 1920, as an experiment, Ford utilized steam at his No. 3 powerhouse for the daily reduction of about 40 tons of garbage. By fermentation and distillation of the garbage, useful products such as alcohol, soap, drawing compound, soluble oil, Benzol, tars, and residual coke were produced and put to use elsewhere in the Rouge Plant.

Exceptionally valuable were the Rouge coke-oven by-products. Using low-grade bituminous coal from Ford's West Virginia and Kentucky mines, the coke ovens produced not only the coke necessary for the blast furnaces but also abundant amounts of energy-rich hydrogen-methane coke-oven gas to fuel the open-hearth furnaces. As additional by-products of the coke ovens, Ford marketed large quantities of liquid Benzol as an automotive fuel additive and tons of granular ammonium sulfate as an agricultural fertilizer.

Surplus Rouge coke was sold and delivered at very low cost directly to the homes of employees of the Rouge, Highland Park, and Lincoln plants of Ford Motor Company. Ammonium sulfate fertilizer was sold through Ford automobile and tractor dealers and the Ford commissaries. Ford Benzol motor fuel was sold at a number of gas stations throughout the Detroit area. Ford Portland cement was distributed through dealers in construction materials.

A wholesale distributor's display using slag concrete blocks to promote Ford Portland cement. (833.65254)

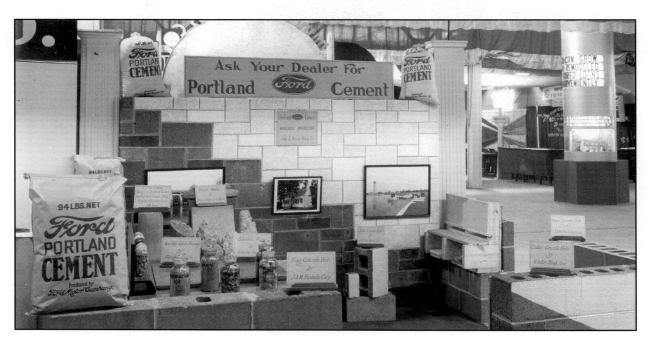

A diagram of the many products of bituminous coal. The Rouge coke ovens, besides providing residual coke for the blast furnaces and gaseous fuel for the open hearths, release hundreds of chemicals that are not separated from one another but are instead sold by Ford to various chemical companies as impure tars and oils. (833.62890)

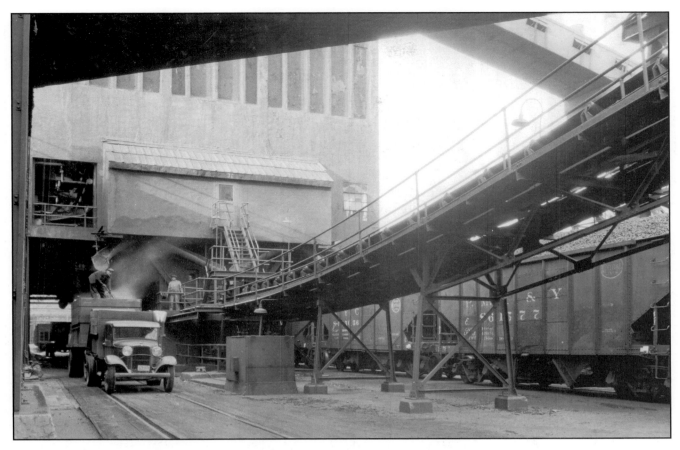

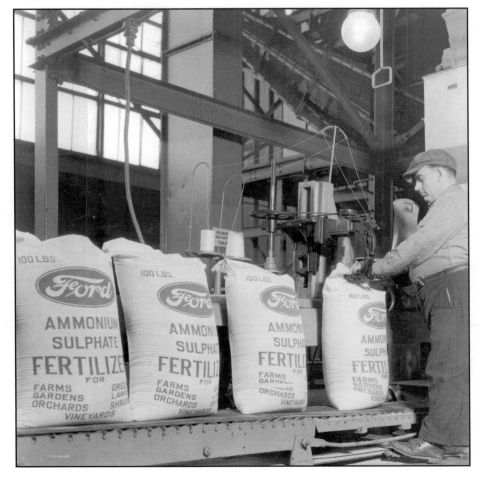

Above: A Ford truck being loaded with Ford coke to be delivered to a local address. The coke, considerably lighter in weight than coal, requires an unusually high box on the truck to carry a two-ton load. (833.58066)

Left: Weighing and bagging Ford ammonium sulfate fertilizer at the Rouge coke-oven by-product plant. Ammonium sulfate, a high-nitrogen fertilizer, is produced at the rate of 95,000 pounds a day. (833.71247-A)

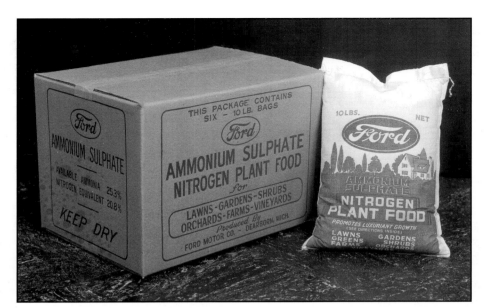

As sold to city and suburban gardeners, Ford ammonium sulfate is packaged in 10-pound rather than 100-pound sacks. (833.75023)

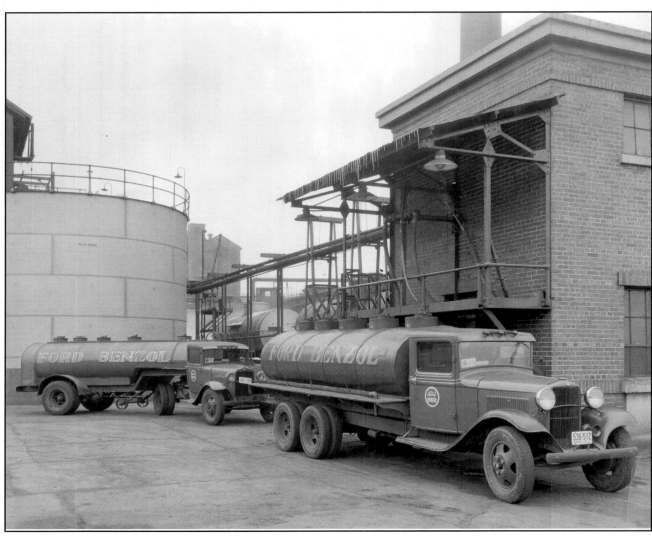

Ford Benzol trucks at the coke-oven by-products plant to be filled for deliveries of Benzol to Detroit gas stations. Ford Benzol consists of one part of coke-oven light oil and three parts of regular gasoline. Production at the Rouge is 42,000 gallons a day. (833. 58065)

A 1937 Ford Tudor at a curbside Ford Benzol pump in front of a Ford dealership.
Ford Benzol, a high-octane fuel, competes with the heavily leaded ethyl gasoline.
Benzol, however, contains no toxic lead. (833.67410)

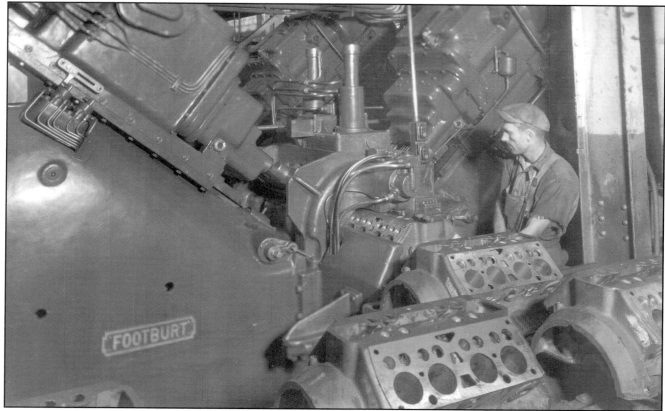

18
MOTOR BUILDING

In the design of automobiles, Henry Ford's talents lay predominantly in engines. As early as 1901, his reputation was established as a racing-engine engineer. The four-cylinder Model T motor, introduced in 1908, was still being manufactured at Highland Park and elsewhere at the rate of about 10,000 per day as the Rouge Plant was being constructed. The first Model T motor built in the new Rouge motor building was stamped with serial number 10,566,001 on September 30, 1924. Assembly procedures developed at Highland Park were similarly applied at the Rouge — conveyors bringing parts to the workers and workers in fixed positions each accomplishing his small portion of the total assembly process. Model T engine number 12,000,000 was built at the Rouge Plant on August 20, 1925, number 15,000,000 on June 26, 1927.

Model T engines were produced in quantity at the Rouge until mid-1927, when the Model A engine, an improved four-cylinder engine, was introduced. The 25-horsepower Model T motor, which had for nineteen years provided a speed of 40 miles per hour, was replaced by the Model A motor producing 40 horsepower and a speed of 60 miles per hour.

In 1932, in order to counter the Great Depression, Henry Ford decided to equip Ford cars with V-8 engines. This engine, of radical design, employed an engine block cast all in one piece. For a while, one could buy a Ford with either a four-cylinder or a V-8 engine. Both were manufactured at the Rouge. The single-block V-8 casting was very troublesome at the start but became a winner over the years. By 1939, 3600 V-8 motors were being built daily at the Rouge, each requiring only 3.25 hours.

Opposite, top: Castings large and small on their way to the motor assembly building. Clearly visible in the foreground are engine blocks, heads, manifolds, flywheels, and crankcases. This photograph was taken in June 1932, when both four- and eight-cylinder Ford motors are being built. Mercurys have not yet been introduced. (833. 57060)

Opposite, bottom: A Footburt eight-spindle boring machine boring sixteen valve and pushrod holes simultaneously in a 1935 Ford V-8 cylinder block. (833. 62054)

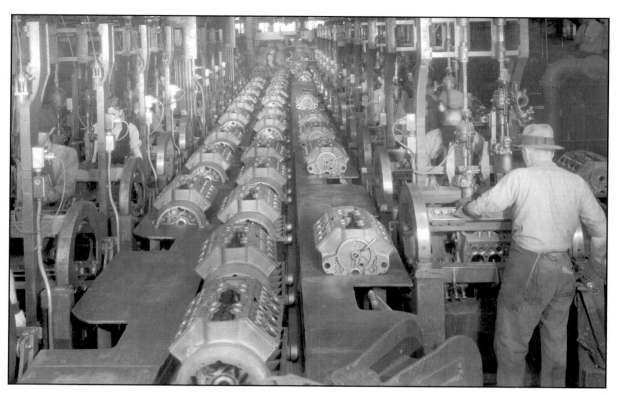

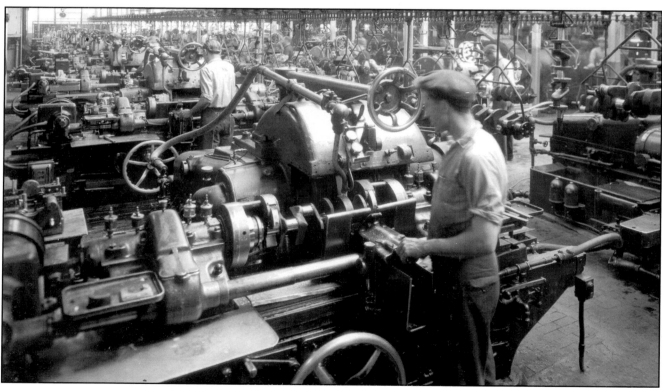

Top: Long rows of Hall Grindovac machines, with operators grinding valve-seat inserts in Ford V-8 engine blocks on February 19, 1935. (833. 62239-A)

Bottom: The crankshaft department in June 1933, where fifty-eight separate milling, grinding, and checking operations are performed. A continuous overhead conveyor system brings the unmachined crankshafts to the machines and takes the machined crankshafts away. (833. 57557-1)

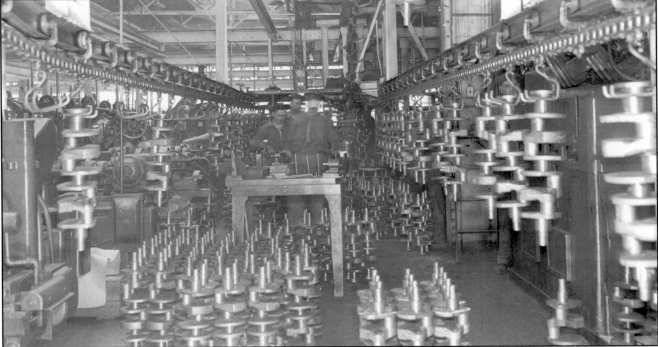

Top: The Snyder crankshaft drilling machine. This special-purpose machine drills the entire oil system in an automobile crankshaft in one continuous operation. (833.95085-2)

Bottom: An inspection station for Ford V-8 crankshafts on May 1, 1936. Bearing surfaces need to be accurate to 0.0001 inch. (833. 65896)

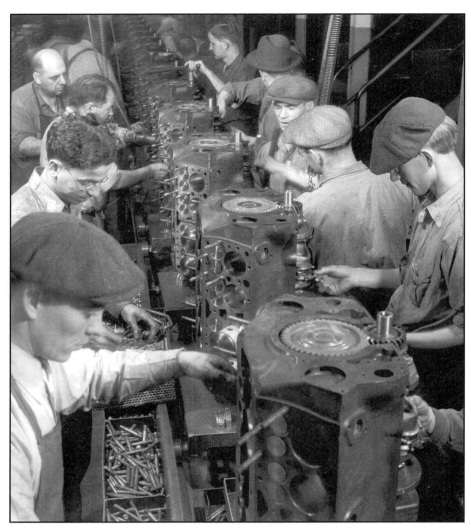

Right: Assembling 1937 Ford V-8 engines on December 18, 1936. Men on the left are inserting pushrods, while men on the right are installing crankshaft-bearing retaining bolts. (833.67507)

Below: The engine break-in room, normally filled with dozens of workers. Not every station would have an engine. Each newly assembled engine block, together with transmission, is connected to water and oil lines and coupled to an electric motor. The motor spins the engine until the engine's mechanical friction is reduced to a value acceptable for use in a vehicle. The same operation allows detection of engine oil or water leaks. (833.65142)

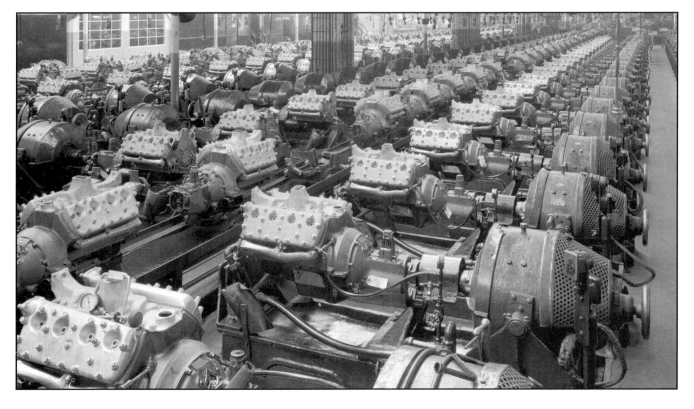

19
PRESSED STEEL

The first pressed-steel building at the Rouge was erected during 1924 opposite the north end of the steel mill. The first automotive parts were produced there in June 1925. Using railroad tracks within the building, 2500 tons of milled steel was supplied daily to the plant, and approximately 112 carloads of finished parts were produced. Parts were made from both sheet and bar stock, including automotive frames, fenders, and body panels. With a 1937 expansion, there were more than 4000 presses in operation every day, making more than 2000 different parts. Some of the dies weighed as much as 30 tons, and presses weighing 450 tons exerted pressures of 800 tons. In the building were nine 10-ton cranes to facilitate handling of material, and four miles of conveyors permitted continual movement of stock from place to place. Body panels used for automotive assembly at the Rouge were carried by long conveyor from the pressed-steel building to the B building. Most pressed-steel production, however, was shipped by rail to Ford assembly plants elsewhere. Henry Ford's insistence on preventing waste required that steel trimmings, of which there were 250 tons daily, be used to provide smaller automotive parts, and any further residual scrap was to be remelted for further use.

Ten thousand men were employed in the pressed-steel building. Of these, 1200 were highly trained mechanics needed to keep the machinery in good condition. For the comfort of employees, there were eight large soundproof lunch rooms with tables and benches capable of seating 3200 men at one time. The building was also equipped with shower and locker rooms.

The pressed-steel building, with its clock, in 1941.
(833.76318)

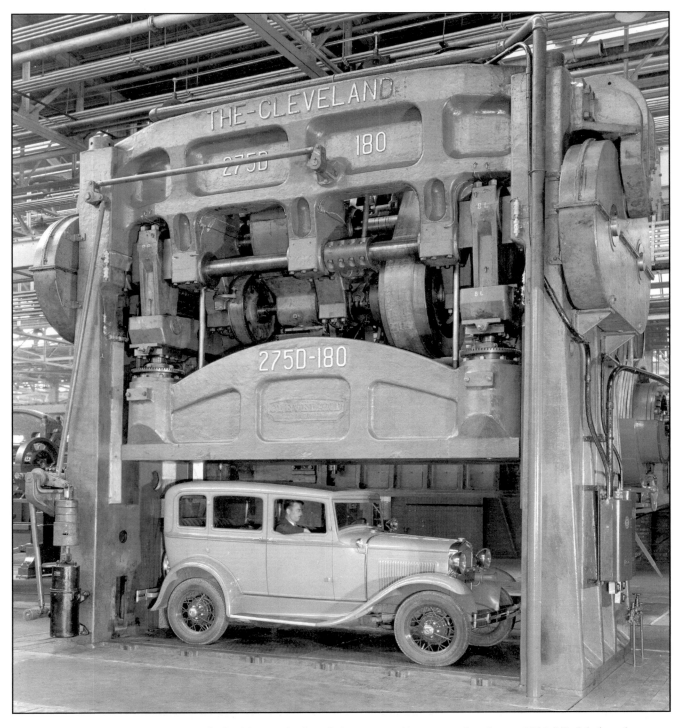

A double-crank, four-joint suspension press, showing a 1931 Model A sedan to emphasize the size of the press. (833.56463-1)

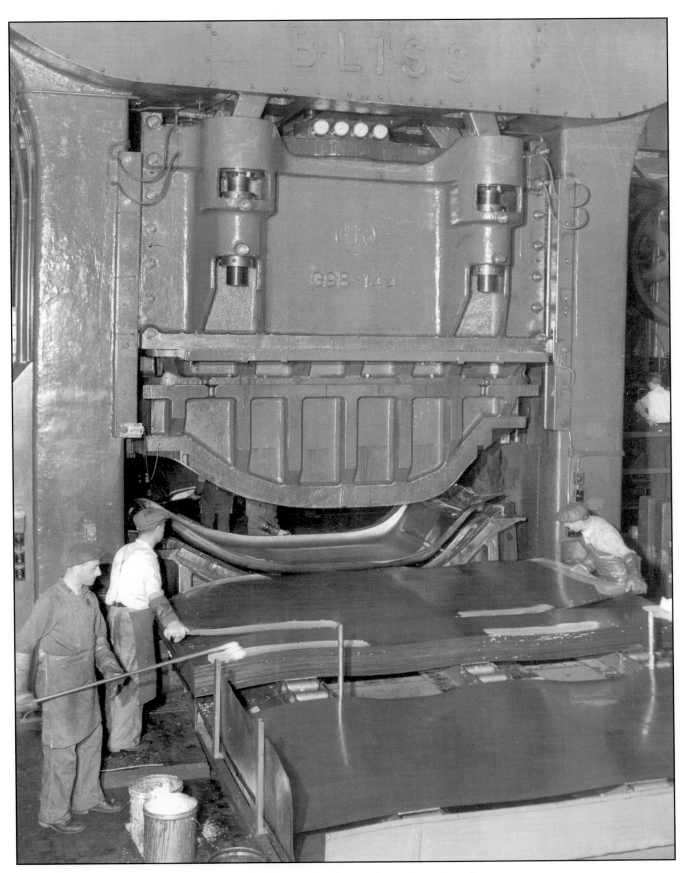

Feeding large flat sheets of steel into a Bliss press that forms the roof section of a 1939 Ford. Note the man at the far left with a mop applying a lubricant that prevents tearing of the metal in areas of deep draw. (833.71979-M)

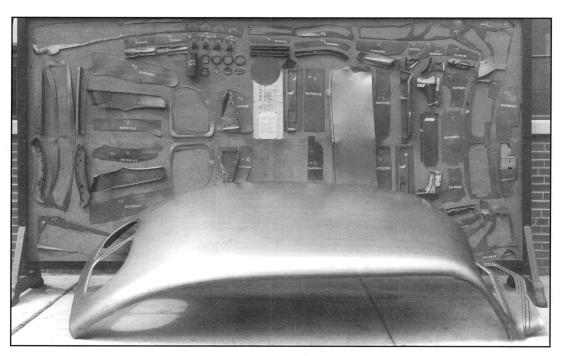

Above: A 1939 Ford sedan roof in the foreground, with an array of additional parts stamped from the trimmings remaining from the original top stamping. (833.71979-1)

Right: Men unload 1939 Ford rear quarter-panels from a Bliss press. Flat steel sheets are being loaded by men on the opposite side of the press. (833.71226-A)

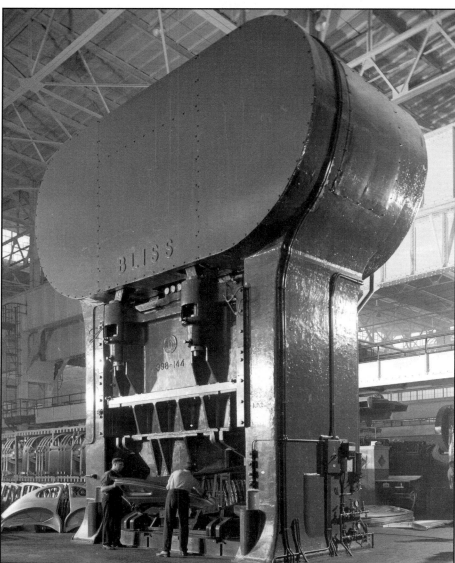

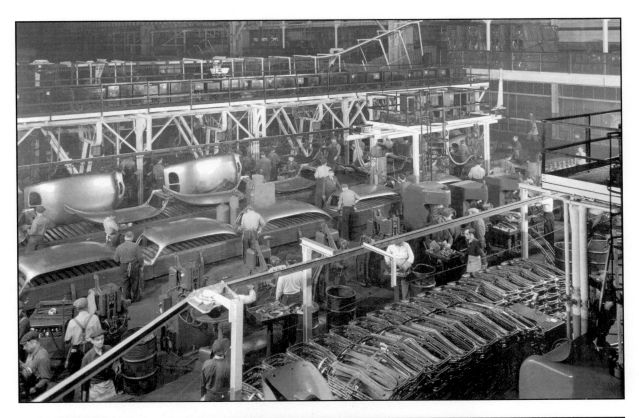

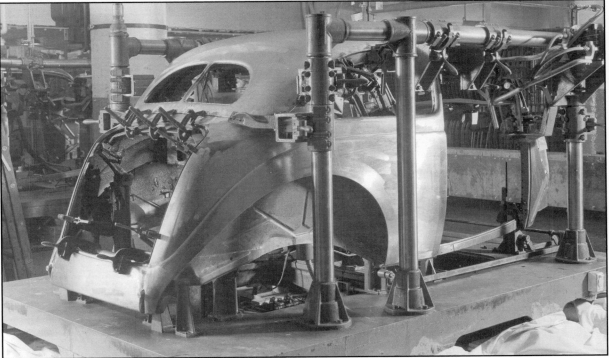

Top: An interior view of the press shop in February 1940, showing electrically powered conveyor systems carrying body stampings to the body assembly area. (833.73086)

Bottom: Known as a body buck, this 1937 Ford Tudor framing fixture is designed to clamp body panels together while they are being welded. Most body panels produced at the Rouge pressed-steel plant are shipped to the several Ford assembly plants, where body bucks identical to this one are used for body assembly. (833.67045-D)

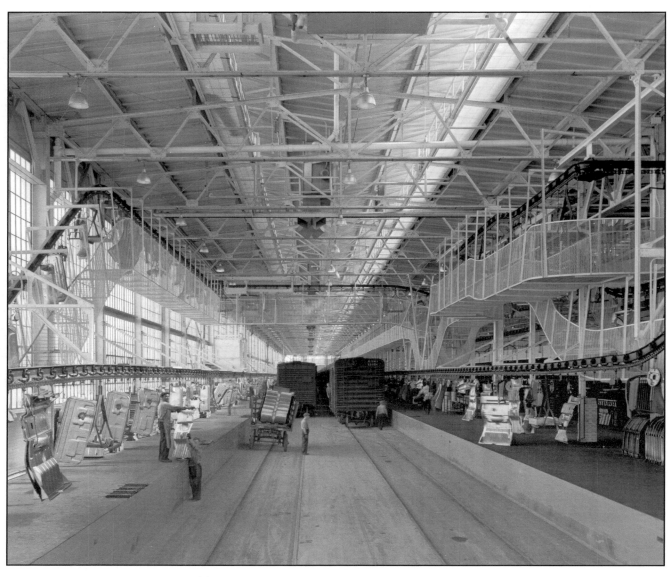

The shipping area of the pressed-steel shop on September 12, 1939. Most of the Rouge-produced stampings are shipped by rail to Ford assembly plants elsewhere. (833.72378)

20
OPEN HEARTH

Although the Model T automobile contained an inordinate number of iron castings through the ingenuity of Charles E. Sorensen ("Cast Iron Charlie"), it was steel that was necessary for the bulk of the Ford car. In fact, no fewer than fifty-six different steel compositions were used. To produce high-quality steel in those days, open-hearth furnaces were required. Raw material for the furnaces included either molten or pig iron, which was supplied by the Rouge blast furnaces, large quantities of scrap iron, and a variety of ferro-alloys to provide each steel with its desired physical properties.

The open-hearth building held ten large furnaces in a long row through the length of the building, each furnace with the capacity of at least 180 tons. On the west side was the charging floor, from which the furnaces were fed, and on the east side was the teeming floor, from which the furnaces were tapped and steel ingots were poured. Powerful 125-ton cranes ran the length of the building to handle the huge ladles of molten metal. Steel production began in Rouge open-hearth furnaces in June 1926. Daily fuel for operation of the furnaces consisted of about 70,000 gallons of oil and 5 million cubic feet of Rouge coke-oven gas. Daily production of steel was approximately 2000 tons.

Henry Ford, it is said, liked to visit the open hearth's twenty-four-hour operations by day or night and would sometimes arrive unannounced and inspect the premises. He had a penchant for neatness, and the open-hearth building was one of the cleanest at the Rouge.

The open-hearth building looking northwest and viewing the south end. The building has a width of 238 feet and a length of 1066 feet. It is very well lighted and ventilated, and its ten stacks in a row indicate the relative positions of its ten furnaces. Rows of ingot molds line the railroad tracks at the side of the building. (833.66867)

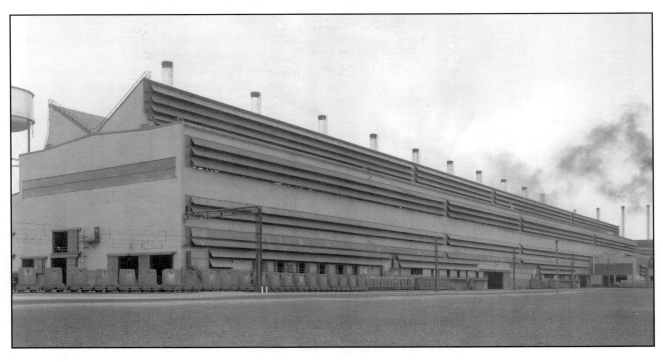

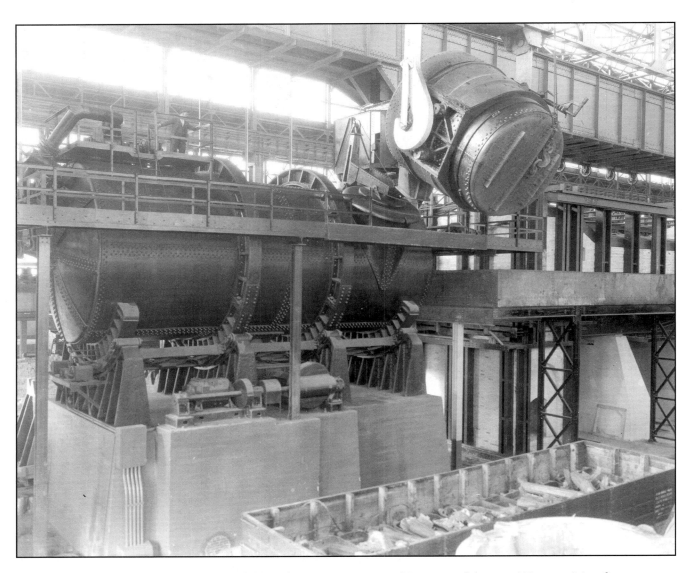

Molten blast-furnace iron is poured into one of the two 600-ton mixing furnaces at the south end of the building. These giant mixing furnaces, each holding metal at 2100 degrees Fahrenheit, have a mechanism that allows them to tilt toward the charging to receive blast-furnace metal and tilt toward the teeming floor to fill ladles used for filling ingot molds. (833.50159)

Opposite: Molten iron from a Rouge blast furnace is transferred from its 75-ton ladle directly into an open-hearth furnace on the charging floor. (833.59468)

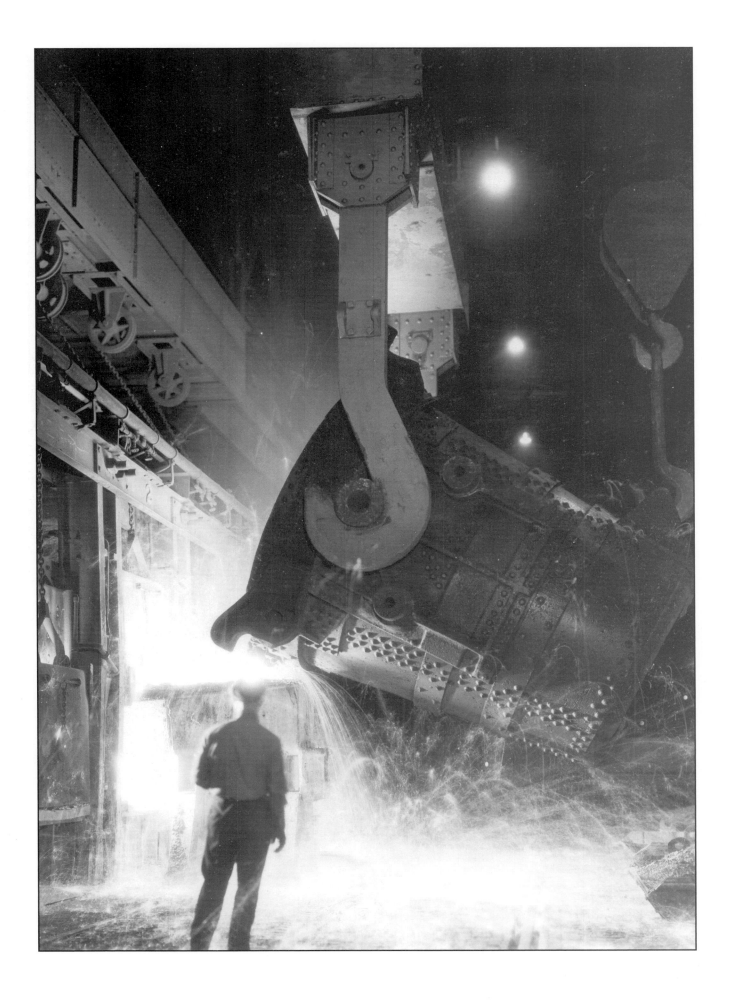

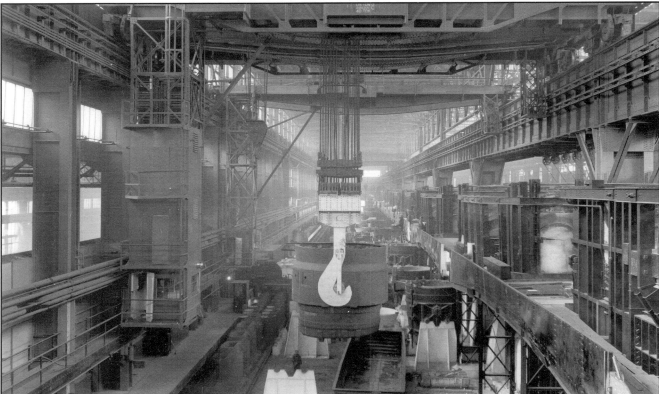

Top: Another way of charging an open-hearth furnace. One of the five small doors of the furnace is opened, and the 5-ton charger, which can move on rails from furnace to furnace, pushes materials such as scrap metals into the furnace. (833.62736)

Bottom: A 1938 view looking south on the teeming (pouring) side of the open-hearth building. In the foreground is a 175-ton crane holding a 75-ton ladle together, supported on overhead rails running the entire length of the building. The crane can easily transport 75 tons of molten steel to the south end of the building, where the steel is poured into ingot molds. (833.69825)

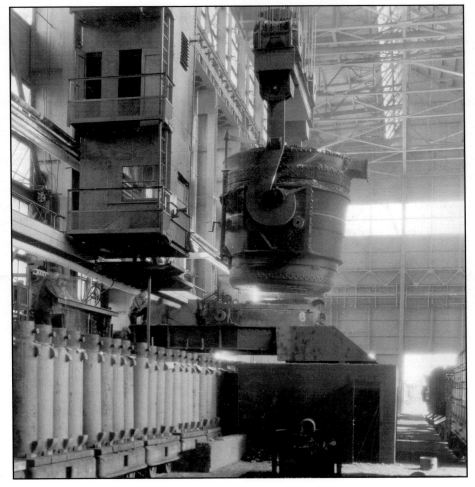

Above: A close-up of the teeming side of just one of the ten open-hearth furnaces. The typical open-hearth furnace is 18 feet wide, 35 feet long, and 13 feet deep. Constructed of 800,000 fire bricks, most have a capacity of 180 tons. Some of the brick construction is visible, and the bottom of the furnace stack can be seen at the upper right. Preparing a heat of steel requires about twelve hours. (833.56148)

Left: At the south end of the open-hearth building, a large ladle of molten steel is released through the bottom of the ladle into a device designed to fill four ingot molds at a time. These ingots, the chief product of the open-hearth furnaces, will later be removed from their molds and sent to the blooming mill in preparation for being rolled into various forms suitable for car parts. (833.47637)

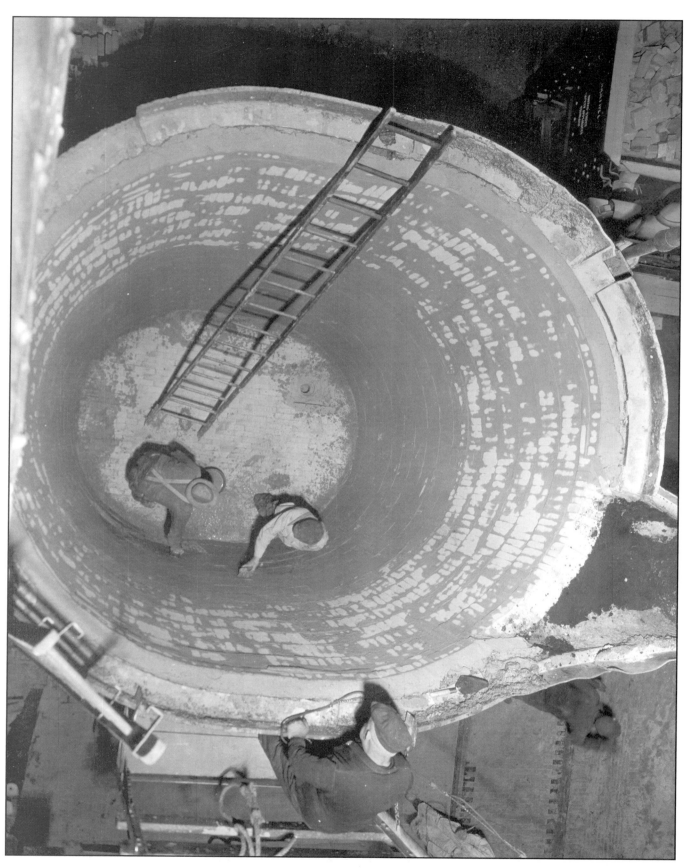

A large open-hearth ladle is relined with brick. The furnaces themselves require relining to the extent that two of the ten furnaces are down for repairs most of the time. (833.75218)

21
ROLLING MILLS

One of the largest buildings in the Rouge, the rolling mill (460 by 1500 feet), was attached directly to the open-hearth building in order to receive hot steel ingots produced by the open-hearth furnaces. Steel rolling operations were begun in 1926 but were much improved from time to time. Especially during the Depression years of 1935 to 1936, Ford invested $35 million in modernizing Rouge operations, including more than $10 million for rolling-mill improvements.

As standard procedure, hot ingots from the open-hearth furnaces were first put through the blooming mill to provide billets of a shape suitable for rolling into a variety of rods, bars, or sheets needed for the many parts of the automobile. Exact control of the final rolled dimensions was particularly important. Delicate adjustment of thickness of the sheet products was particularly critical inasmuch as gauge and drawing properties of steel determine its usefulness for such parts as automotive fenders and deep-drawn body parts.

Public tours of the Rouge Plant, which began during the summer of 1924, were much enhanced by the inclusion of the rolling mills along with the automotive assembly plant. The terrific noise, together with the scurrying white-hot steel ribbons, not only drew visitors' attention but also caused them to grasp the hand rail of the high and narrow catwalk from which they were allowed to view the scene. The rolling mills became, indeed, the most spectacular sight in the Rouge.

The exterior of the steel rolling mill under construction on August 6, 1925. It will not be in operation for more than another year. (833.43115)

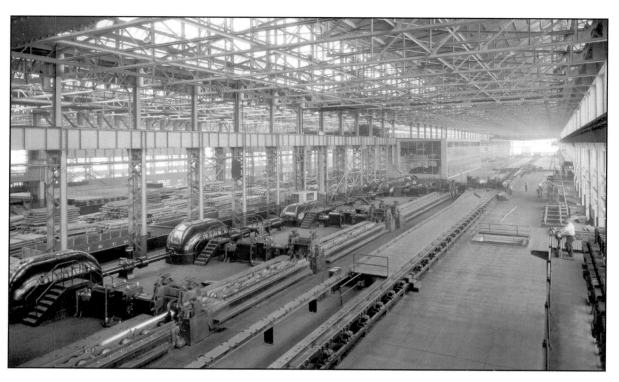

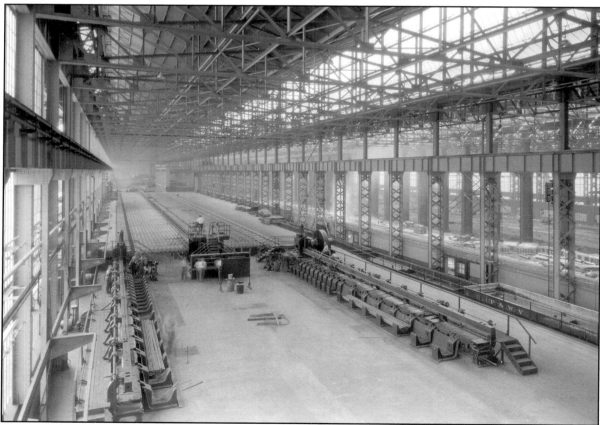

Top: Interior of the steel rolling mill under construction on August 12, 1926, looking north from an overhead crane. (833. 47390)

Bottom: Interior of the steel rolling mill under construction on August 12, 1926, looking south from the same overhead crane. (833.47392)

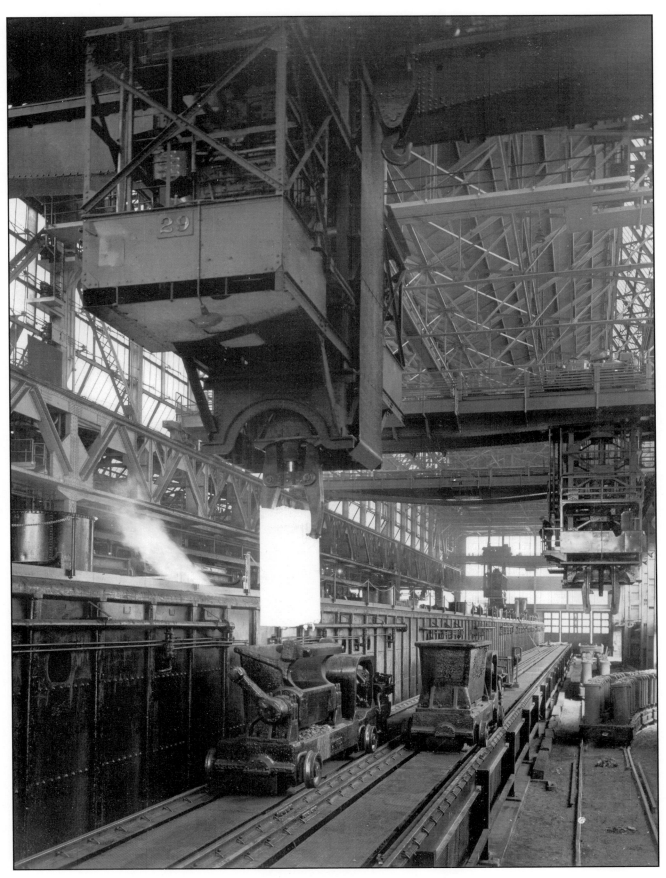

A 10-ton ingot at white heat is transferred from the soaking pit to a buggy which takes it to the blooming mill. (833. 65662)

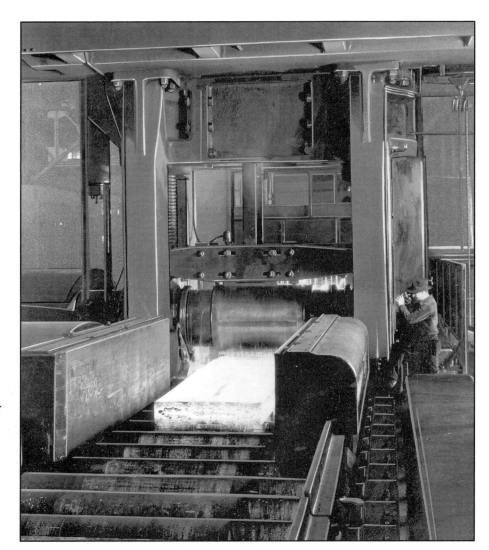

Right: A white-hot billet made from a 10-ton ingot emerges from the blooming mill. The man is reading the temperature of the billet by means of an optical pyrometer. (833.65394)

Below: A hot strip mill to roll 56-inch steel sheet. This mill was added in 1935 to provide sheet wide enough to press from it the new turret top for all-steel automobile bodies. (833.64414)

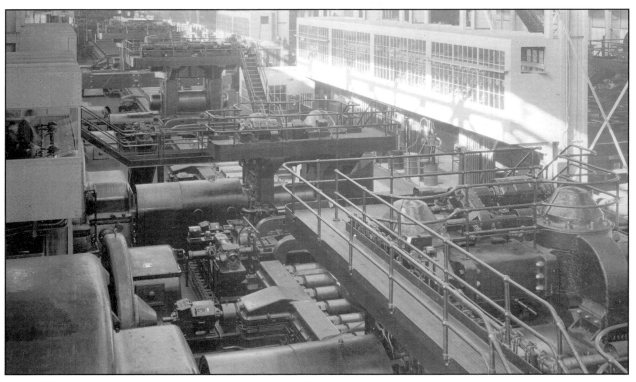

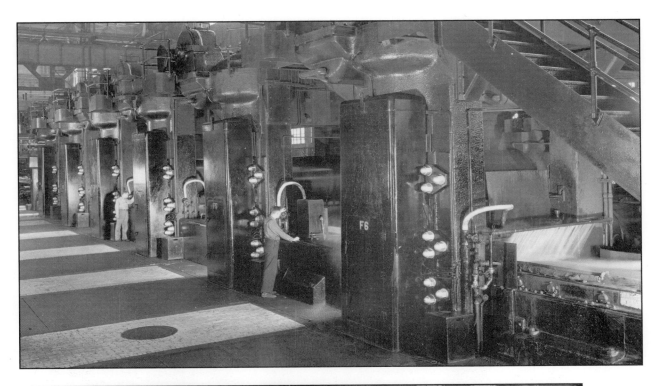

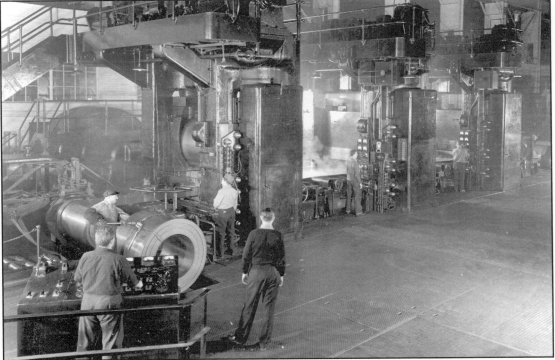

Top: One of the hot-strip rolling mills using six sets of rolls to lower the thickness of the metal gradually to the gauge required. Standard gauge no. 30 is 0.0125 inch in thickness. Ford mills can easily produce sheet twice that thickness or more, or half that thickness or less, as called for. (833.72298-A)

Bottom: This three-stand tandem cold finishing mill is winding its long, smoothly finished sheet onto a mandrel from which the coil of sheet is removed and bound with steel tape. The steel sheet has been cooled to 1200 degrees, coiling speed is about 20 miles an hour, and length of the coiled strip is about 400 feet. (833.73008-A)

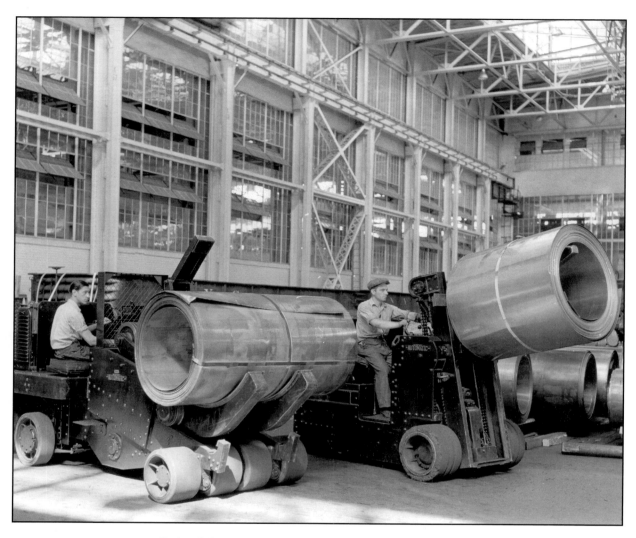

Coils of sheet steel can be delivered directly to the adjoining pressed-steel building at the Rouge, stored for later use, or shipped to Ford press shops elsewhere. In every case, the open-hearth heat number, the gauge number, and the width of the sheet are attached to each coil. Other forms than sheet, such as bar stock and wire of various dimensions, are also produced by the Rouge rolling mill. (833.66615)

22
SPRING AND UPSET

The spring-and-upset building of the Rouge Plant was about the same size as the pressed-steel building and was attached to its north end. The upper floors of the two buildings together formed a bridge over Road 4 of the plant. The spring-and-upset building was noted for being the greatest electrical heat-treat furnace installation in the world. By the 1930s, the drop-forge department and the spring department each had more than eighty electric furnaces. All of these furnaces were pyrometrically controlled, and in many of the furnaces the automotive parts were automatically fed and discharged. Many small automotive parts were conveyed to the furnaces in baskets on conveyors to be heat-treated and annealed.

Drop forging was used to shape such parts as connecting rods and front axles. Leaf springs in the early days had to be heat-treated leaf by leaf in order to temper the steel and allow the leaves to be pressed into the proper shape. Machines were developed, however, to shape and temper in one operation. As in the pressed-steel building, an overhead conveyor moved finished parts directly from the spring-and-upset building to the B building for assembly into vehicles or to loading docks for shipment elsewhere.

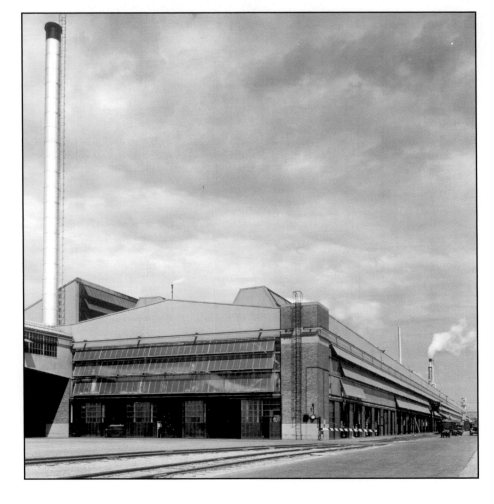

The spring-and-upset building along the east side of the pressed-steel building on July 23, 1936. (833.66516)

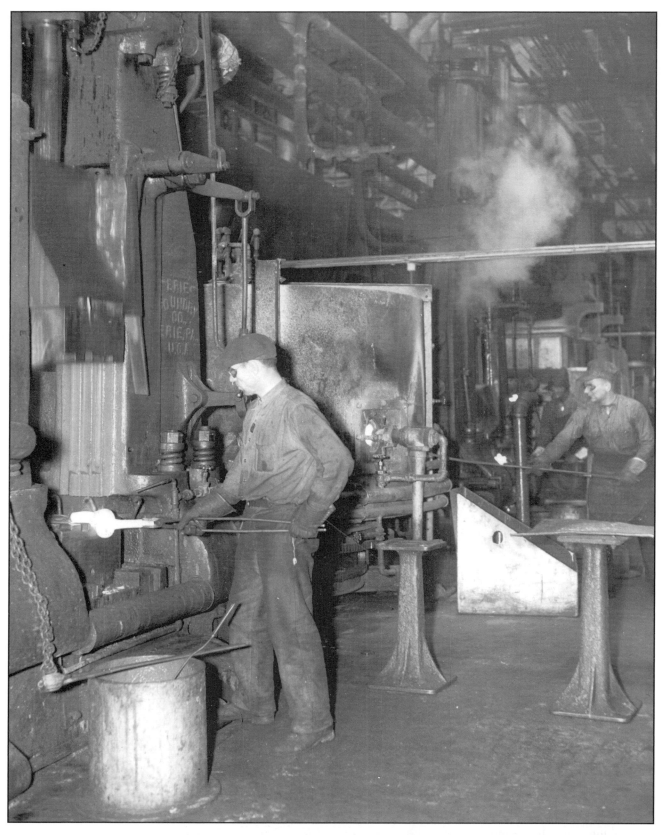

Men operate drop hammers forging automotive connecting rods in March 1936.
(833. 65507)

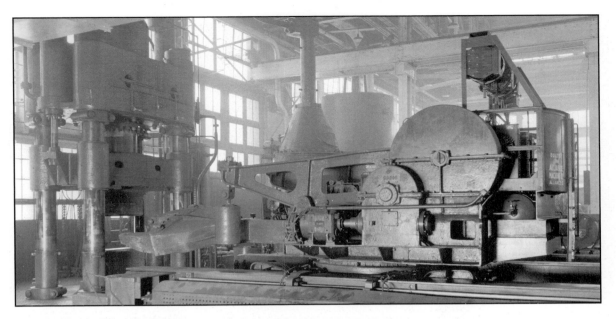

Above: In 1937, the forging press (far left) is equipped with giant servo manipulating controls to grip and hold a large piece of steel while it is being forged. (833.69548)

Left: Drop-forging front axles for Ford cars in May 1938. (833.70131-B)

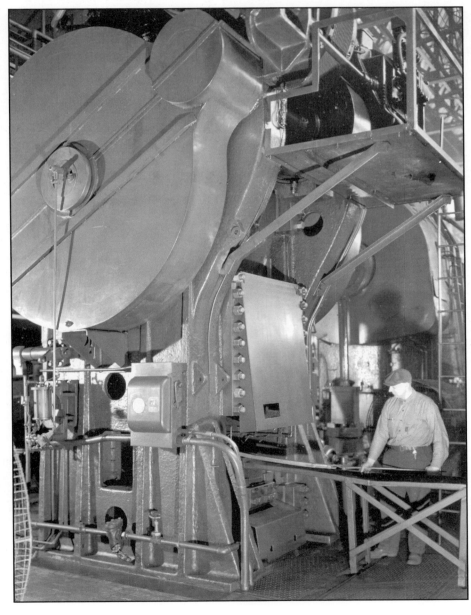

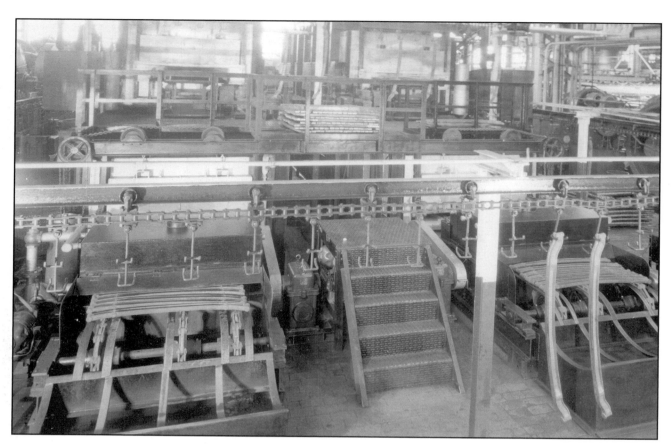

Above: Dick electric furnaces used for heat-treating front axles in 1932. As the axles leave the furnaces, they are hung by hand on the passing conveyor. (833.56767-7)

Right: A battery of drill presses drill holes through Ford 1934 front axles. Each worker keeps several presses in operation. The steel turnings are saved and melted as scrap. (833.59369)

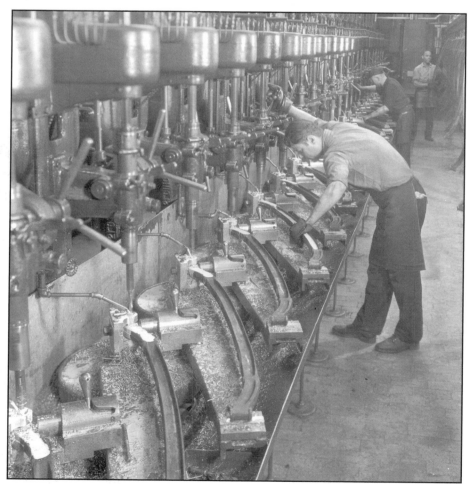

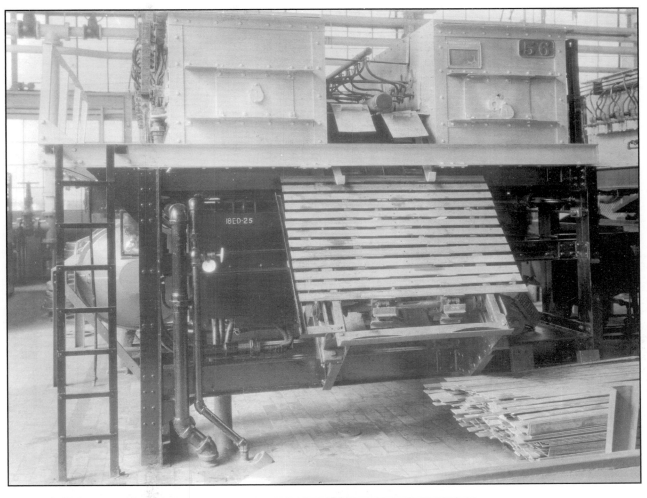

Above: One of several
electric furnaces used to
heat-treat leaf-spring steel.
(833.56101)

Left: Machine for bending
leaves for Model A leaf
springs in April 1931.
(833.56101-4)

23
ELECTRIC FURNACES

To prepare many of the specialty steels needed for the manufacture of automobiles and tractors, electric furnaces were best. They were used especially for the production of high-grade alloy steels in which the impurities had to be held to a minimum. By providing exceptionally high temperatures using electricity rather than oxygen and sulfur-bearing fuels, a relatively pure iron could be produced to which exact additions could be made to provide the specific steel desired. Sixty-five or more different types of steel were employed by Ford Motor Company.

Typically, Rouge electric furnaces were charged with cold pig iron from the blast furnaces, low-alloy steel scrap from Rouge stamping operations, and small amounts of iron ore and limestone. A typical large electric furnace was lined with silica brick, had a capacity of about 10 tons, and was heated by means of electricity passing through the metal between a giant positive carbon electrode and a similar negative carbon electrode. The smaller electric furnaces using single-phase current employed only two electrodes, but the larger furnaces using three-phase current required three electrodes. Although the electrical current was costly, the high value of the resulting metal made the process worthwhile. Electric furnaces were particularly adapted to reclaiming valuable alloys in high-alloy scrap steel.

The largest of the electric furnaces were located in the electric furnace building, where 20-ton basic furnaces poured special steels into ingot molds of various sizes. From 70 to 80 tons of special steel were poured daily. Other electric furnaces were scattered throughout the Rouge, especially in the jobbing foundry, the production foundry, and the spring-and-upset building.

Opposite, top: The electric furnace building, in which 70 to 80 tons of specialty steels are poured daily. This photograph, taken in 1938, shows the south end of the building. The large 10-ton electric furnaces are located on the second floor at a height even with the railroad high-line visible at the far left. Furnace-charging material arrives by rail. (833.69826-A)

Opposite, bottom: Chemical specifications of the various steels prepared and used by Ford Motor Company at its Rouge Plant.

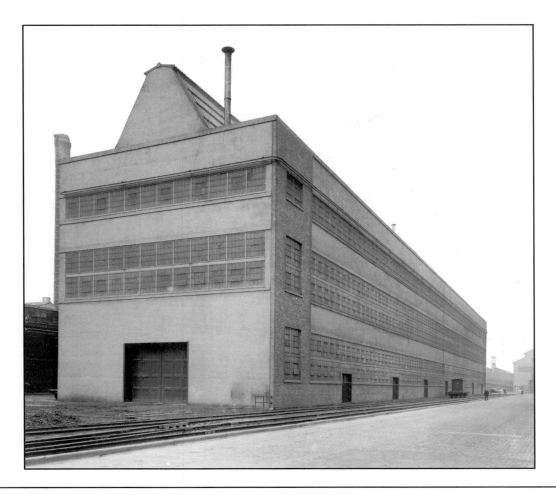

STEEL ANALYSIS CHART

TYPE OF STEEL	CARBON	MANGANESE	CHROMIUM		SILICON	PHOSPHORUS	SULPHUR	ENDS PAINTED
A	.20-.25	.60-.75	.65-.80	VANADIUM .12-.15	.10-.15	.03 Max.	.04 Max.	*
AX	.18-.22	.50-.65	.75-.90		.10-.20	.03 Max.	.04 Max.	White & Black
AA	.26-.29	.65-.80	.80-1.00		.10-.20	.03 Max.	.04 Max.	Red & Black
AAA	.30-.35	.65-.75	.90-1.10		.10-.20	.03 Max.	.04 Max.	Red & White
AAAH	.35-.38	.65-.75	.90-1.10		.10-.20	.03 Max.	.04 Max.	Red, White & Blue
AAAAL	.38-.42	.65-.75	.90-1.10		.10-.20	.03 Max.	.04 Max.	Red, Green & Yellow
AAAA	.42-.47	.65-.75	.90-1.10		.10-.20	.03 Max.	.04 Max.	Red & Green
AAAAA	.48-.52	.65-.75	.90-1.10		.10-.20	.03 Max.	.04 Max.	Blue & White
AA Select	.28-.32	.65-.80	.80-1.00		.10-.20	.03 Max.	.04 Max.	T-498 All Elements
AAA Select	.32-.35	.65-.80	.90-1.10		.10-.20	.03 Max.	.04 Max.	T-12Well within limits
Armature Steel	.05 Max.	.40 Max.			.12-.20	.03 Max.	.04 Max.	
B	.95-1.05	.20-.30	.40-.50		.20-.30	.03 Max.	.04 Max.	
BB	.95-1.05	.20-.30	.90-1.10		.20-.30	.03 Max.	.04 Max.	
BBB	.95-1.05	.20-.40	1.25-1.50		.20-.30	.03 Max.	.04 Max.	Blue & Red
Bessemer #1	.09-.15	.70-.90				.09-.15	.10-.20	Aluminum
C Key Stock (S.A.E. 1035)	.30-.40	.50-.80			.10-.20	.05 Max.	.05 Max.	
C Pure Iron	.03 Max.	.12 Max.		COPPER OPTIONAL		.01 Max.	.04 Max.	
Chrome Non-Shrink	1.45-1.60	.25-.35	11.00-12.00	V .20-.25 No .70-.90	.20-.40	.03 Max.	.04 Max.	
CC	.44-.50	.40-.55	.70-.90	TUNGSTEN 1.00-1.20	.15-.25			
D	.45-.52	.80-.95	1.00-1.20		.10-.20	.03 Max.	.04 Max.	Green with White Stripe
DD	.48-.52	.80-.95	1.00-1.20		.10-.20	.03 Max.	.04 Max.	Green
Die Block Ajax	.60-.75	.30-.40	3.25-3.75		.10-.20	.03 Max.	.04 Max.	
Die Block Hammer	.47-.55	.50-.60	.60-.75	NICKEL 1.50-1.75	.10-.20	.05 Max.	.04 Max.	
E	.27-.30	.70-.90			.07-.15	.04 Max.	.05 Max	Red
EE	.27-.30	.70-.90			.07-.15	.04 Max.	.05 Max	Yellow
EEE	.40-.45	.70-.90			.07-.15	.03 Max.	.05 Max	Red & Yellow
EEEE	.46-.53	.80-.95			.10-.20	.03 Max.	.05 Max	Red - Yellow-White
Electrical Steel	.05 Max.	.30 Max.			.90-1.20	.04 Max.	.03 Max	
F	.08-.12	.80-.99			.10-.20	.04 Max.	.06-.12	Black with White Stripe
FF	.15-.20	.80-.99			.10-.20	.04 Max.	.10-.15	Brown with White Stripe
FFF	.24-.30	.80-.99			.10-.20	.04 Max.	.10-.15	Yellow with White Stripe
FFFF	.45-.50	.80-.99			.10-.20	.04 Max.	.10-.15	Blue with White Stripe
Ford High Spd.(Taps & Drills)	.65-.72	.25-.35	3.75-4.25	V 1.00-1.25 W 17.0-18.	.20-.50	.03 Max.	.04 Max.	Red & Green with White Stripe
Ford Hot Work Steel	.18-.23	.40-.60	1.40-1.60	MOLYBDENUM .45-.55	.15-.25	.03 Max.	.04 Max.	Mo. .50-.80
Ford Spec. High Speed	.78-.84	.25-.35	4.00-4.50	V2.00-2.25 W 18.0-19.0	.20-.50	.03 Max.	.04 Max.	
G	.09-.15	.30-.45			.07-.15		.05 Max.	Black
GG	.15-.20	.30-.45			.07-.15		.05 Max.	Black
H	.27-.34	.45-.60			.07-.15	.04 Max.	.05 Max.	Blue
Key Stock (S.A.E. 2330)	.25-.35	.50-.80		NICKEL 3.25-3.75		.04 Max.	.045 Max.	
I	.43-.50	.35-.50				.04 Max.	.05 Max.	Green & Blue
Low Carbon, Open Hearth	.03-.08	.35-.50				.04 Max.	.05 Max.	Black with Yellow Stripe
Machine Steel	.08-.20	.35-.50			.10-.20	.04 Max.	.05 Max.	Black
Magnet	.82-.90	.30-.45	2.25-2.60		.25-.40	.03 Max.	.04 Max.	Alum. when C is .85 or over
N	.12-.16	.35-.45	.30-.40		.10-.20	.03 Max.	.04 Max.	Green & Black
R	.70-.80	.20-.35	.10 Max.	NICKEL - NONE	.15-.25	.025 Max.	.03 Max.	
RR	.95-1.05	.20-.35	.10 Max.	NICKEL -NONE	.15-.25	.025 Max.	.03 Max.	Brown
RRR	1.20-1.30	.20-.35			.15-.25	.025 Max.	.03 Max.	
Rustless Steel #1	.05-.12	.10-.15	16.0-18.0	NICKEL - 7.0-9.0	.15-.30	.04 Max.	.05 Max.	
Rustless Steel #2	.05-.10	.10-.15	16.0-18.0		.50 Max.	.04 Max.	.05 Max.	
Rustless Steel #3	.10-.40	.15-3.00	15.50-17.50	NICKEL 5.50-8.50	.70-1.60	.020 Max.	.030 Max.	Not Less Than 24% Alloying Elements.
Rustless Type II	.20-.35	.25-.40	12.0-14.0		.70-1.60	.04 Max.	.04 Max.	
S	.60-.70	.70-.85			.15-.20	.03 Max.	.04 Max.	
SS	.70-.85	.70-.85			.10-.20	.03 Max.	.04 Max.	Blue & Yellow
Tap Steel (Under 1" Dia.)	1.20-1.30	.25-.40	.35-.45	V.15-.25 W 1.25 1.50	.30-.45	.025 Max.	.025 Max.	
V	.35-.45	.25-.40	1.85-2.50		3.60-4.20	.03 Max.	.02 Max.	
Welding Wire	.10 Max.	.20 Max.					.03 Max.	
Insert Die Steel	.55-.60	.45-.60	.70-.80	Mo .75-.80 Ni.2.25-2.45		.03 Max.	.04 Max.	
Vanadium Tool Steel	.95-1.05	.30-.35	.40 Max.	V.40-.50 Ni. None	.15-.25	.025 Max.	.03 Max.	Red with White Stripe
S.A.E. #4620	.18-.23	.50-.70	.25 Max.	Mo.20-.30 Ni.- 1.80	.15-.30	.04 Max.	.05 Max.	
Deep Drawing Steel	.05 -.08	.25-.35	.04 Max.	COPPER .10 Max.		.03 Max.	.04 Max.	
FFF	.20-.25	.80-.99			.10-.20	.04 Max.	.10-.15	
Hot Punch & Die Steel	.30-.35	.25-.35	4.8-5.1	Tung. 1.25-1.50 Mo.-- -1.6-1.8	.85-1.00			
XR Steel	.90-1.00	.20-.35	.10 Max.		.15-.25	.025 Max.	.03 Max.	Brown - Yellow stripe. (Must Be cross-rolled or forged - Must be select part of ingot).

*(WHITE IF ON LOW SIDE OF ANALYSIS AND WHITE WITH GREEN STRIPE IF ON HIGH SIDE)

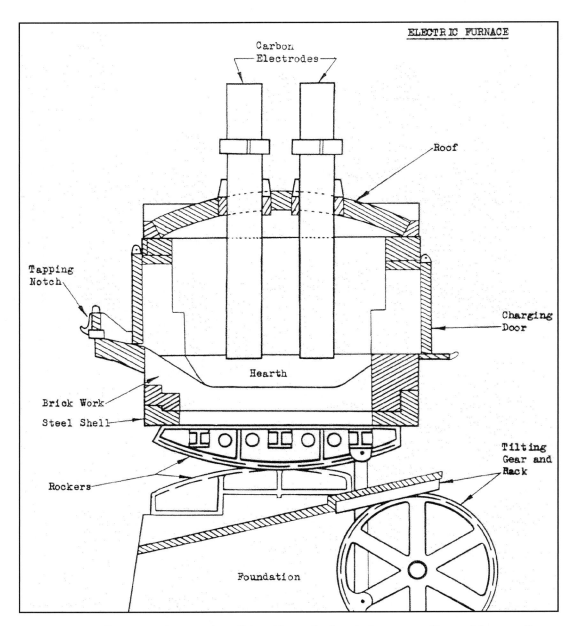

Carbon
Electrodes

Roof

Tapping
Notch

Charging
Door

Hearth

Brick Work

Steel Shell

Tilting
Gear and
Rack

Rockers

Foundation

Diagram of a typical small two-electrode electric furnace used in teaching metallurgy to students of Henry Ford Trade School.

Opposite, top: Piles of pig iron stored in the open at the northwest corner of the Rouge Plant near Gate 6. Pigged from molten blast-furnace iron, it is available for charging not only electric furnaces but open-hearth furnaces as well. (833. 68611)

Opposite, bottom: An early 3-ton, three-electrode electric furnace with its switchboard operated in Rouge production in 1920. The vertical framework is used to control the height of the electrodes. (833.31736)

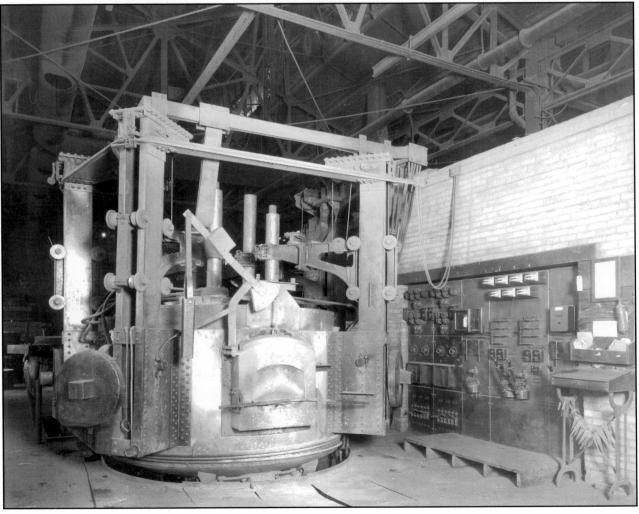

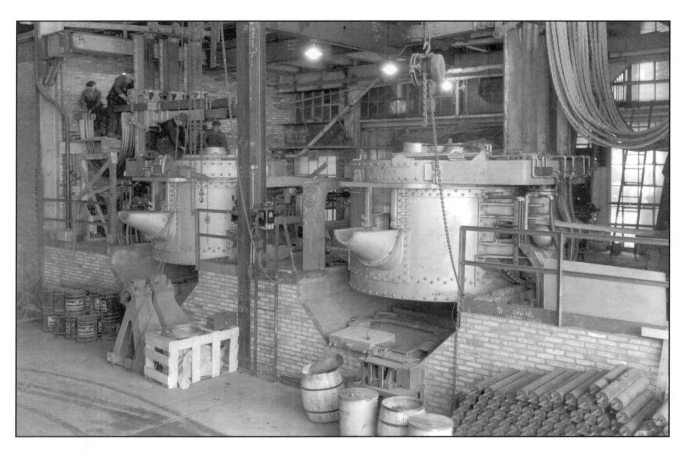

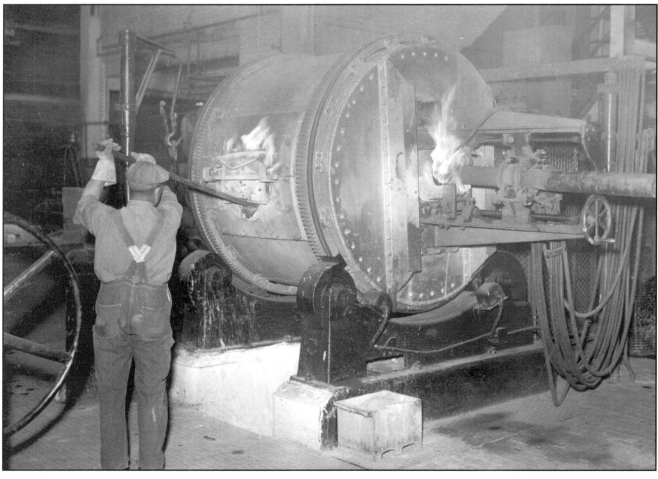

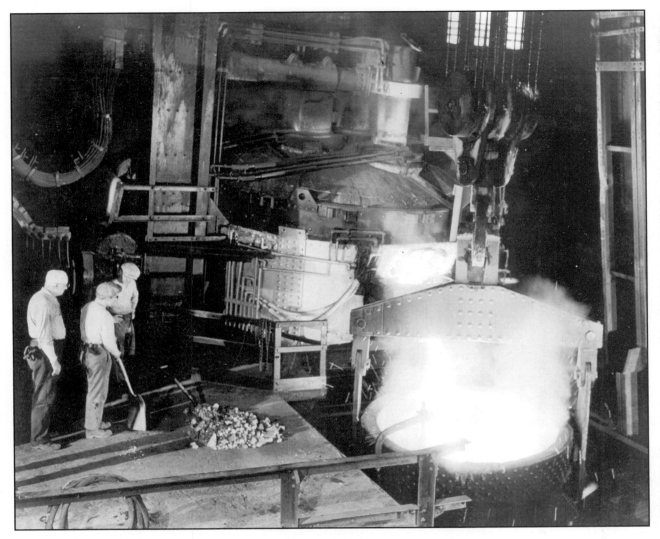

A large electric furnace with three 1-foot-diameter electrodes pours its metal into a ladle held in place by means of a crane. In operation, a transformer of 4000 kilovolt-amperes provides current in steps ranging from 9300 to 15,000 amperes. The neat little pile of material on the floor is not waste; it is likely a ferro-alloy perhaps rich in manganese, copper, chromium, or nickel, ready to be added to the melt if necessary to meet chemical specifications. The photograph is dated November 27, 1939. (833.72748-14)

Opposite, top: Installation of a pair of large electric furnaces in the northwest corner of the production foundry in February 1936. (833.62242)

Opposite, bottom: A 1.5-ton Detroit electric furnace with horizontal electrodes operating in the jobbing foundry building on June 30, 1938. (833.70402)

24
MATERIALS TESTING

From raw materials to finished vehicles, high-quality specifications were applied. Whether it was coal from Kentucky, iron ore from Minnesota, or latex from Indonesia, strict chemical specification limits were established. Purchased shipments were routinely analyzed chemically upon arrival. Although suppliers furnished test data, Ford Motor Company ran tests to verify the vendors' test data before accepting the material.

At each step during manufacturing processes, additional testing was done to determine whether the process was advancing properly. Sometimes these tests would be chemical, and sometimes they would be physical. During the making of a heat of cupola iron, for example, two or three "preliminary" chemical analyses were made before the "final" analysis was made and approved. During the manufacture of engine, transmission, and axle parts, the size, weight, and surface finish were measured many times. The Model A crankshaft, for example, was subject to 174 separate tests before being installed in an engine.

Much of the testing during manufacturing was of the continuous monitoring type, such as the measurement and control of temperature, pressure, viscosity, flow, thickness, size, and weight of materials being processed. A separate department at the Rouge was devoted to the maintenance and repair of such measuring equipment.

The Rouge main chemistry laboratory on Miller Road near Gate 4, adjacent to the production foundry and blast furnaces. Here chemical analyses are performed routinely on cast irons, steels, lubricants, fuels, and paints. Several other specialty chemical laboratories are operated at locations such as the coke ovens, open hearth, glass plant, and rubber plant. Rouge Plant laboratories operate twenty-four hours a day controlling the quality of manufactured products. (833.65717)

Left: A photographic plate on which are four atomic spectra of steels. By measuring the optical density of chosen lines in each spectrum, the exact quantities of certain elements, such as silicon, manganese, chromium, nickel, and molybdenum, can be quickly determined. This spectrographic procedure requires less time than wet chemical methods. (833.71240-J)

Below: X-ray radiography is employed to examine metal parts for internal flaws such as cracks and voids. Shown is a crankshaft positioned over an encapsulated photographic film. After adjusting the position of the X-ray tube, the operator leaves the room while the exposure takes place. The film is then removed from its capsule and developed. (833.73314-A)

Metallurgists align a million-volt X-ray machine capable of penetrating steel in heavy sections. (833.76586)

A radiograph of five connecting rods is examined for imperfections by a metallurgist. In automotive manufacturing, radiography is employed whenever there is suspicion of defects in castings, forgings, welds, and so on. Contract work for the U.S. Defense Department, however, often requires radiographic examination of every part manufactured. (833.71703)

Examining a specimen of steel by X-ray diffraction to determine its crystalline structure. The diffraction pattern is recorded on photographic film placed on the circular drum. The physical properties of metals are related to their crystalline structure as well as to their chemical composition. (833.74933)

A machine for determining the tensile strength of cloth and leather upholstery materials. (833.74460-F)

Left: Wear test results on four different upholstery samples. (833. 68066-M)

Below: Testing fabrics and paint samples in the laboratory using "color fade meters." Excessive fading of paint and fabric is considered detrimental. Samples of paint are also regularly tested on racks facing the sun on roofs of buildings in Florida. (833.74982-B)

Two identical machines for measuring the wearing qualities of upholstery materials by holding samples against a revolving drum with an abrasive surface. (833.68066-C)

25
CHASSIS ASSEMBLY

The automotive chassis assembly line, operating on the ground floor of the B building, was the beginning portion of the Rouge final assembly line. Parts manufactured in the pressed-steel building, the spring-and-upset building, and the motor building, as well as from outside suppliers, were all transferred to the B building automotive assembly line by means of conveyors. By 1930, an endless chain conveyor of suspended hook type, more than three miles long, brought parts from Rouge manufacturing areas not only to the B building but also to the Rouge loading docks for shipment to dozens of Ford assembly plants throughout the United States and the world. On the other hand, many items such as tires, batteries, and headlights, not manufactured at the Rouge, were carried from the railroad docks to the B building by the same conveyor system. The chassis assembly line moved forward constantly at the same rate as the final assembly line. Each worker had only a minute or so to perform the one repetitive task to which he was assigned. Along with the regular workers, especially trained relief men could, when necessary, assume any one of the many assembly tasks for a short time. The assembly line was not to stop.

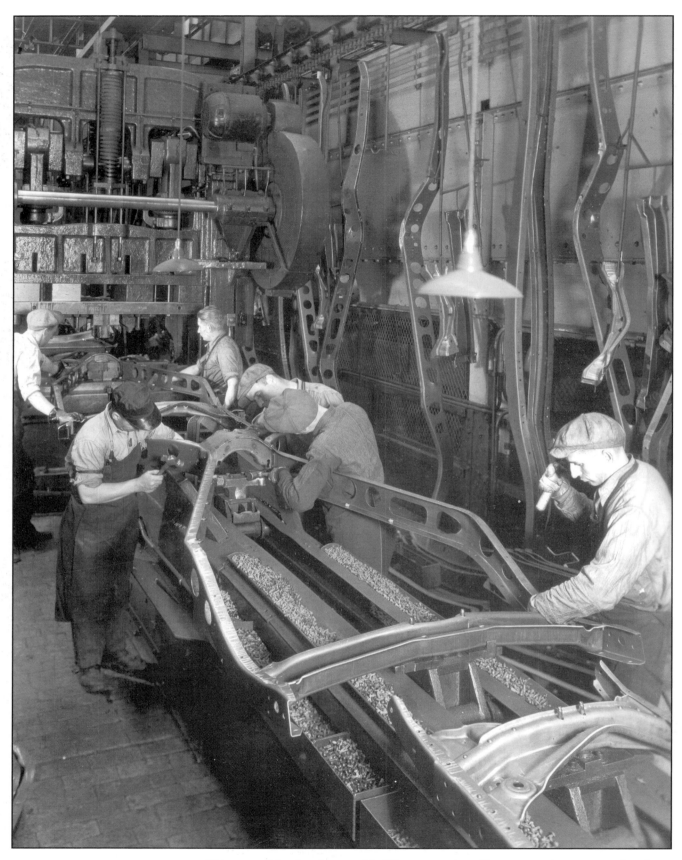

The start of the chassis assembly. The men are installing copper rivets connecting the cross members of automotive frames prior to cold-press operations. (833.59364)

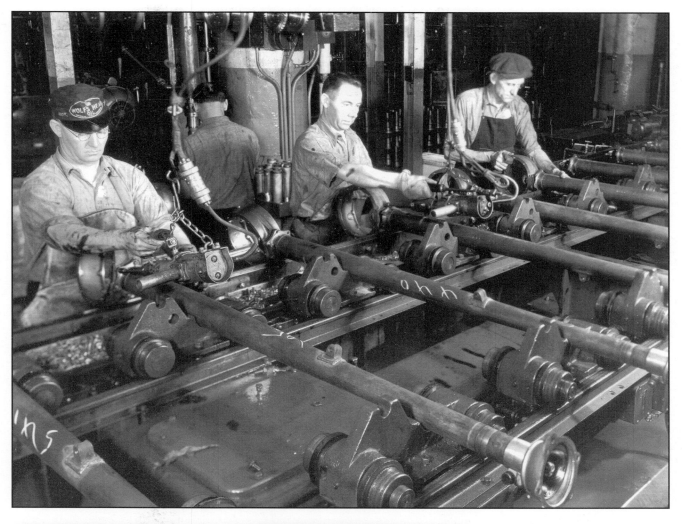

Above: Attaching rear axle gear housings to torque-tube driveshafts. (833.59622)

Left: Men bolt rear axle tubes to axle gear housings. (833.62883)

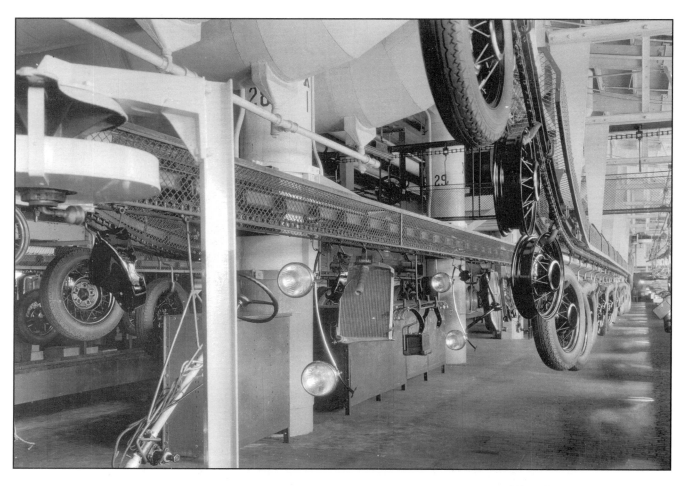

Above: On endless suspended hook conveyors, automotive components from various manufacturing sources reach the chassis assembly lines in the B building. Batteries, headlights, radiators, steering columns, and wheels with or without tires are all available for assembly on a 1932 Ford chassis. (833.57060-16)

Right: A typical Ford chassis assembly line on June 28, 1932. (833.57060)

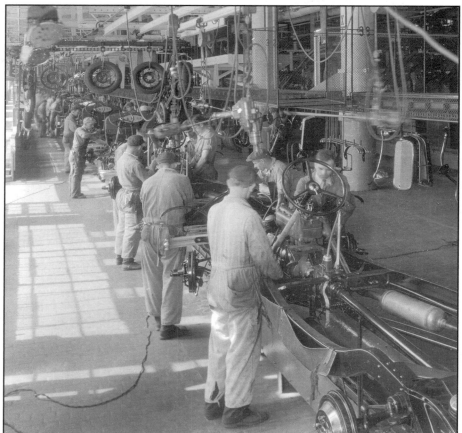

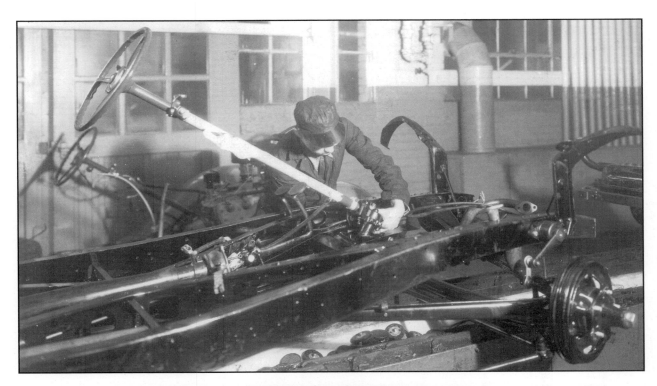

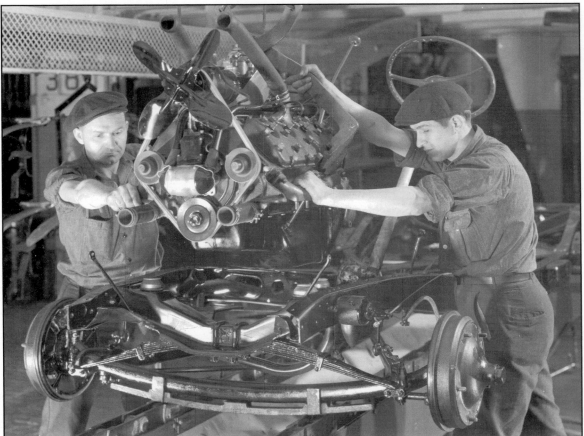

Top: Installing the steering column as the chassis moves along the line. (833.61997)

Bottom: Lowering the V-8 engine with transmission attached into the chassis as the chassis continues to move along steadily. (833. 65235)

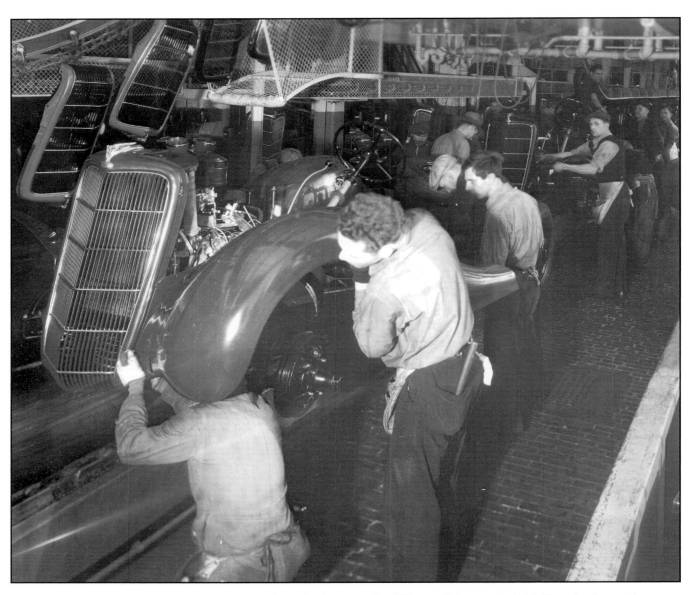

Installing front fenders on a Ford V-8 on February 6, 1935. Rear fenders will come already attached to the body prior to the "body drop." (833.61995)

26
BODY ASSEMBLY

Wooden body frames for Ford cars gradually disappeared with late Model Ts. At the Rouge Plant, automotive body structures were assembled primarily from steel stampings. Throughout the 1930s, when sedans were more popular than open cars and Tudors the most popular of the sedans, the Rouge Plant concentrated on assembling Tudor sedans. There was a saying in the plant, "There is nothing too good for the Tudor," meaning that the very best equipment would be installed to expedite its manufacture. Several of the more deluxe bodies were purchased by Ford from vendors such as Murray Corporation and Briggs Manufacturing Company.

Rouge body assembly operations were on the second floor of the B building. To assemble the Ford Tudor sedan, the floorpan, cowl, side quarter-panels, door frames, and balloon back were all arc-welded together to form the body. In 1937, the turret all-steel top was added to the structure, making the body one of "all steel." Interior upholstery trim and hardware were installed before the body was sent to the final assembly line on the first floor of the B building. Ford Motor Company purchased its upholstery and trim materials from a number of producers and conducted numerous tests on them to evaluate their quality.

During the Depression year of 1935, when one million Ford cars were built, it was predicted that Ford automotive upholstery would require wool from 800,000 sheep, hair from 87,500 goats, and cotton from 433,000 acres. About this time, in Henry Ford's soybean research laboratory, soybean fibers were being blended with wool (35 percent soy and 65 percent wool) to form an upholstery cloth. The strength of the soy cloth, however, was found to be only 85 percent that of wool and was never used as automotive upholstery. For personal use, Ford liked his automobile seat upholstered in leather, preferring to slide easily into and out of the car. He disliked mohair upholstery in particular.

The south end of the quarter-mile-long B building in October 1920, when Eagle boats are finished and Fordson tractors are about to be assembled. The B building will be the Rouge vehicle assembly building throughout the rest of the twentieth century. (833.1237)

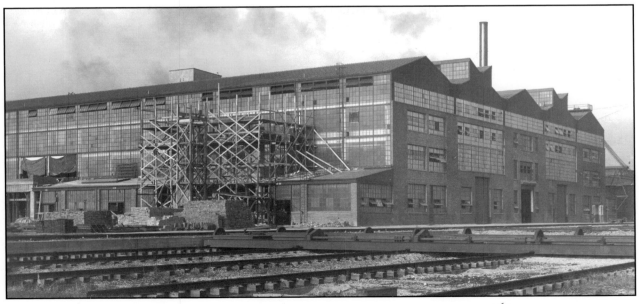

Sheetmetal stampings spot-welded together to form the floorboard of a 1935 Ford body. (833.63445)

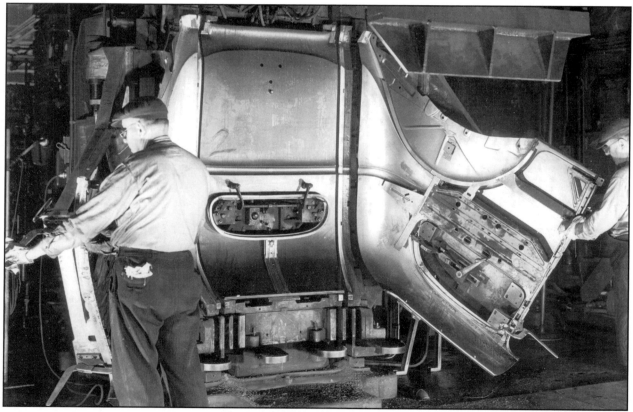

Right and left body quarter-panels on either side of a "balloon back" are here in a "body buck" attached to a huge automatic spot-welding machine ready for simultaneous welding in a multitude of spots. (833.64682-B)

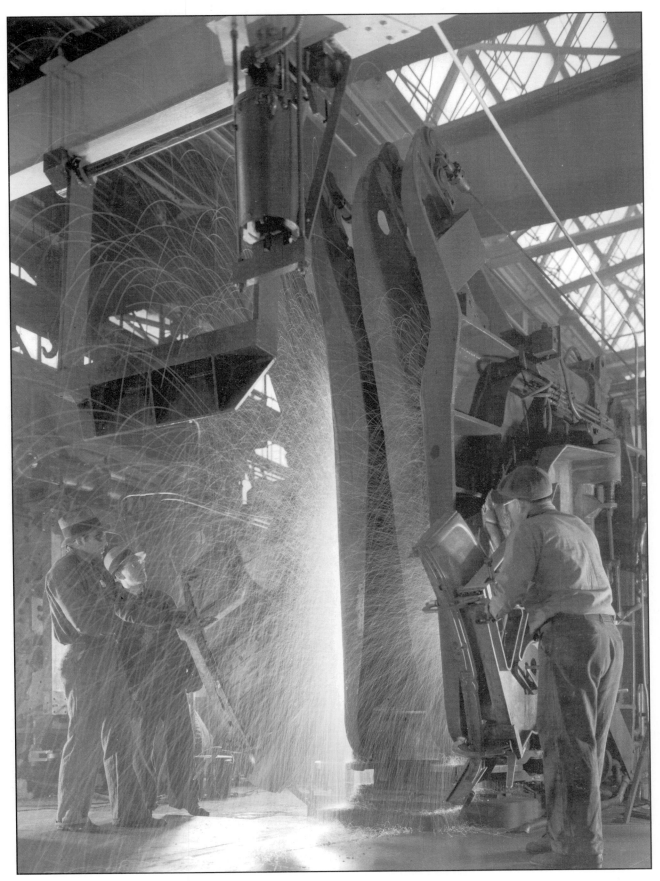

Sparks fly as the welding of the three large body panels takes place in an instant.
(833. 65253)

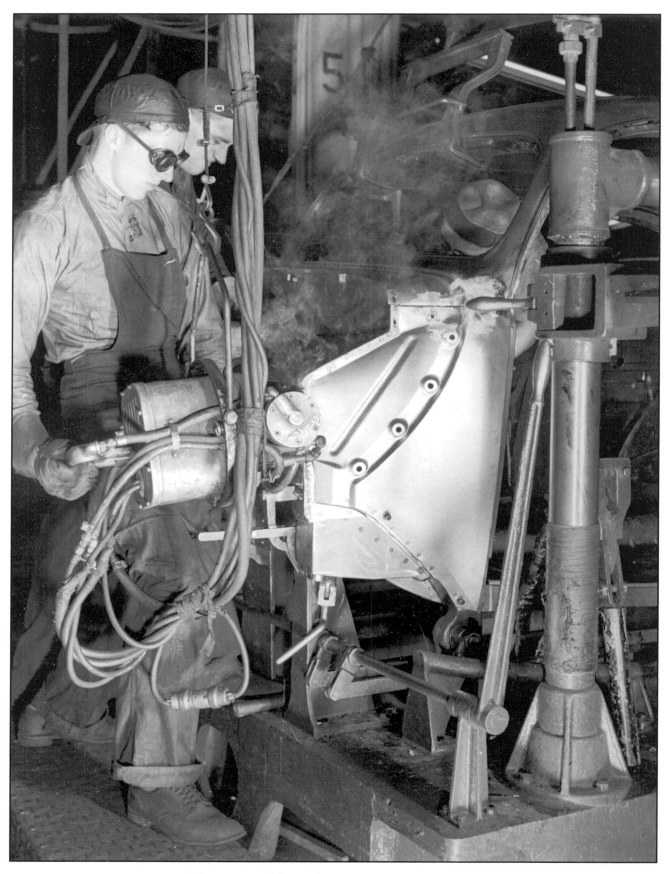

The seam welding of an automotive cowl while held in a small body buck.
(833.67634-C)

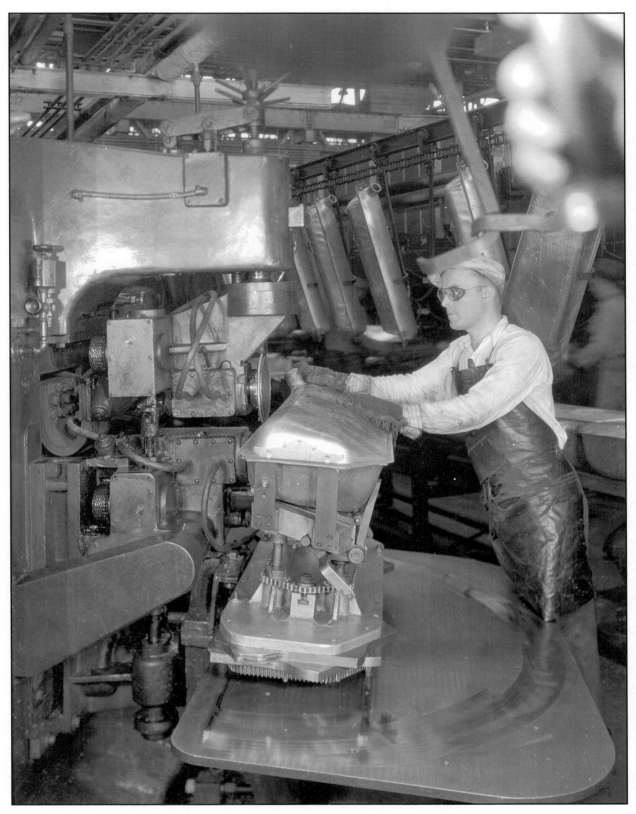

Gasoline tanks are fabricated by seam welding the top and bottom stampings. A mechanism of gears and chains automatically maneuvers the tank to its proper position under the welding wheel. (833. 9693)

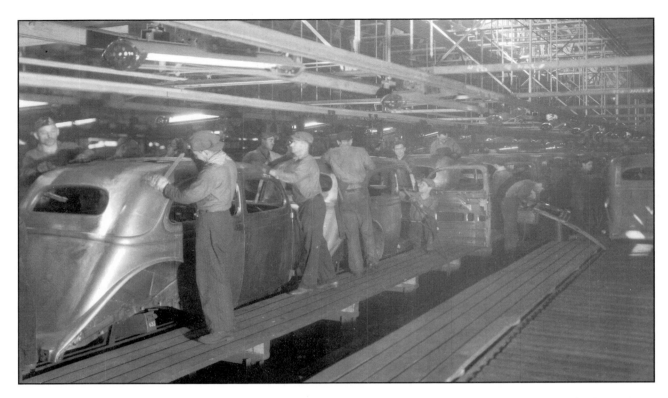

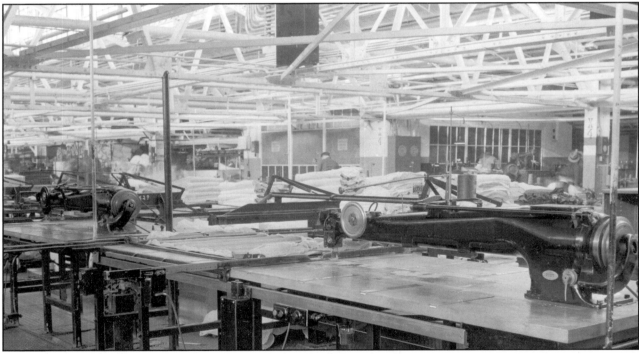

Top: Standard Tudor bodies undergo metal finishing as they move along toward the paint shop and then the interior trim department. Installation of window glass, upholstery, hardware, instrument panel, and other final trim requires another two hours of assembly time. (833.61986)

Bottom: A general view of the sewing room in the B building. In the foreground are two 50-inch sewing machines. In the background, piles of white padding are in sight, and to the left in the distance are conveyors loaded with completed automobile seats. (833.69805-B)

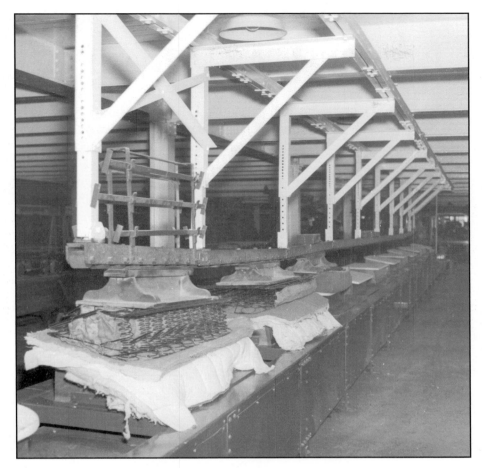

Left: The starting end of the seat-cushion assembly line. When the line is in operation, men will be busily working on both sides. On individual trucks, each cushion is assembled upside-down, with upholstery on the bottom, padding above the upholstery, and steel spring frame on top. As the trucks move along, pressure is applied from above so that the fabric materials easily reach around the springs and can be fastened together. (833.69054-A)

Below: The end of the seat-cushion assembly line. After the fabrics have been firmly fastened around the springs and the trucks move toward the end of the line, pressure from the top is released, and the cushion is removed from the line. Other lines prepare the seat backs that can be seen stored in the background. (833.62889-A)

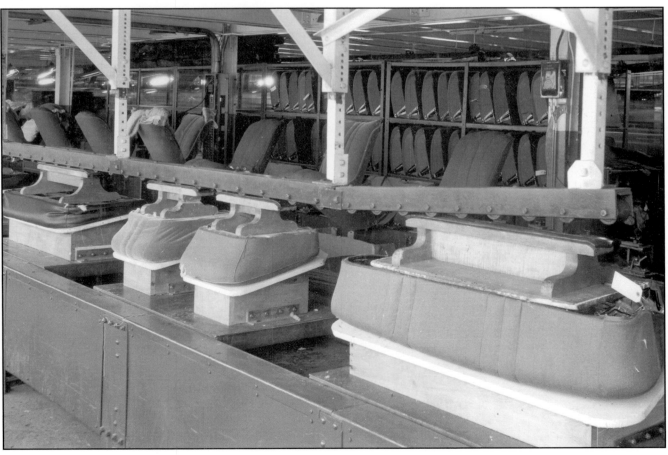

27
PAINTING AND PLATING

Ford Motor Company was in the automotive painting business very early. The color black, for which Ford was famous, was formulated to provide durability together with speed of application. Paint manufacturing was centered at the Highland Park Plant. At the Rouge Plant, where paints were tested and applied to vehicles, synthetic resin enamels took the place of the early varnishes and lacquers, and an endless variety of colors was possible.

During the mid-1930s at the Rouge, Ford introduced his famous soybean paint utilizing soybean oil. There were rumors that Chrysler Corporation exchanged its well-developed automotive hydraulic brake system to Ford for the use of Ford's soybean paint formula. Another Ford development during the 1930s was the utilization of infrared light to bake wet painted surfaces such as on automotive bodies. Instead of hours of drying time, paints could be dried in minutes.

To provide plated surfaces, electrolytic plating baths were scattered about the Rouge. Copper, nickel, and chromium were applied in layers to ornamental parts, while nuts and bolts were plated with cadmium. A surface treatment used extensively by Ford to protect steel surfaces from rusting was known as "bonderizing." This was a thin zinc phosphate coating applied to wheels, fenders, splash pans, and other sheetmetal parts prior to painting them black.

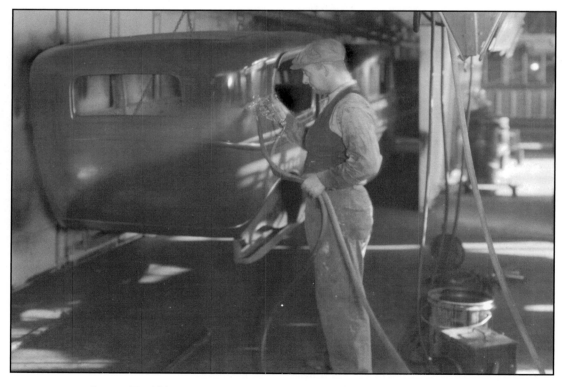

A 1932 Ford Tudor body being carried on an overhead conveyor and spraypainted by a worker not wearing face protection. This work is a high-paying but hazardous occupation in most automobile factories. (833.57209-6)

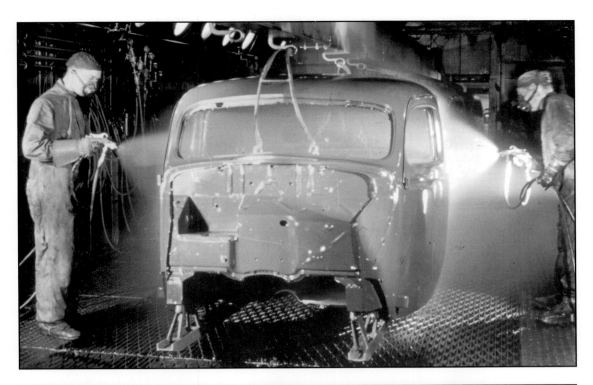

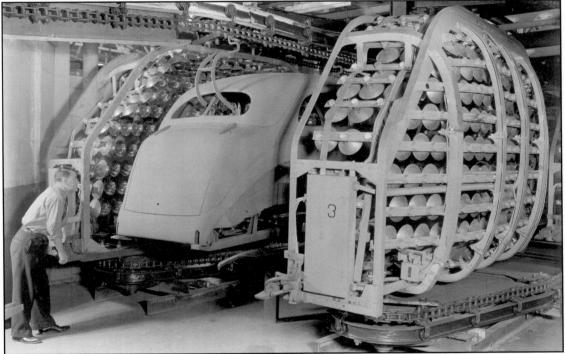

Top: A 1938 Ford Tudor body is sprayed by workers wearing protective breathing masks. Approximately 3000 gallons of paint flow daily through 46,800 feet of welded steel pipelines to the spray booths. Air pollution is not considered a serious threat to health. (833.69803-G)

Bottom: Again carried on an overhead conveyor, this freshly painted 1937 Ford body is entering an infra-red drying oven, which closes in on the car body and moves along with the body for several minutes until the paint is fully baked. Metal temperature is maintained at 300 to 325 degrees Fahrenheit during the baking. (833.67545-D)

Right: A 1938 fender is dipped in black paint over a bonderized steel surface. (833.69803-R)

Below: Black 1935 Ford Tudor bodies on their way from the paint shop. (833.62686)

Opposite, top: Chrome plating of 1935 Ford radiator shells. Moved from tank to tank by means of an overhead conveyor, the shells are cleaned, plated, and rinsed. (833.63500-A)

Opposite, bottom: A Ford 1937 radiator grille repair station. Men are inspecting and repairing plated grilles taken from the conveyor on their way to the final assembly line. (833.68539-A)

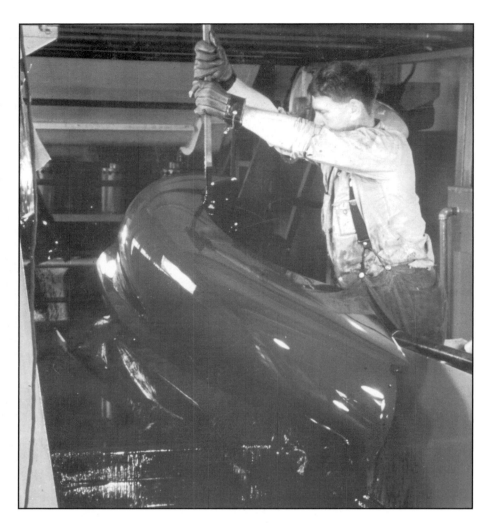

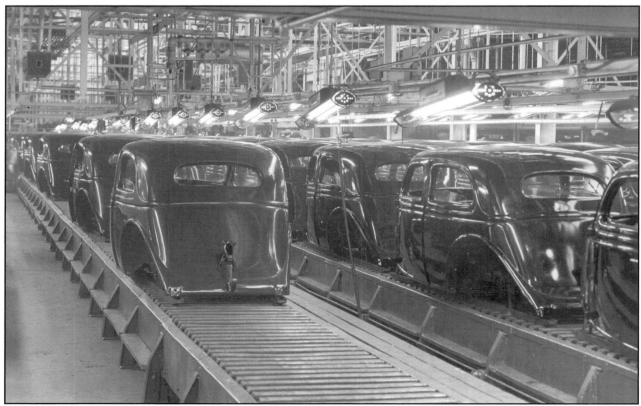

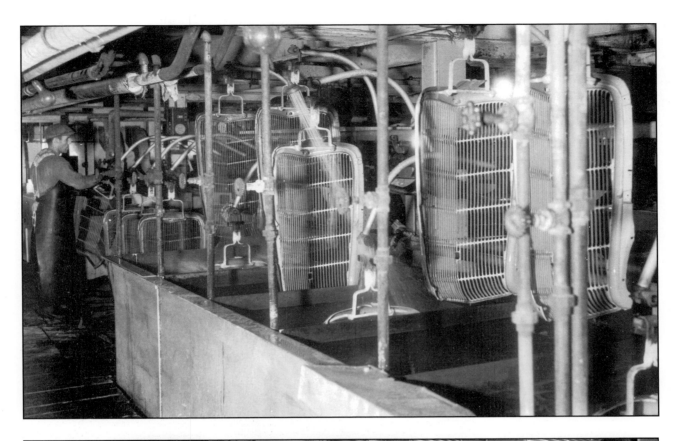

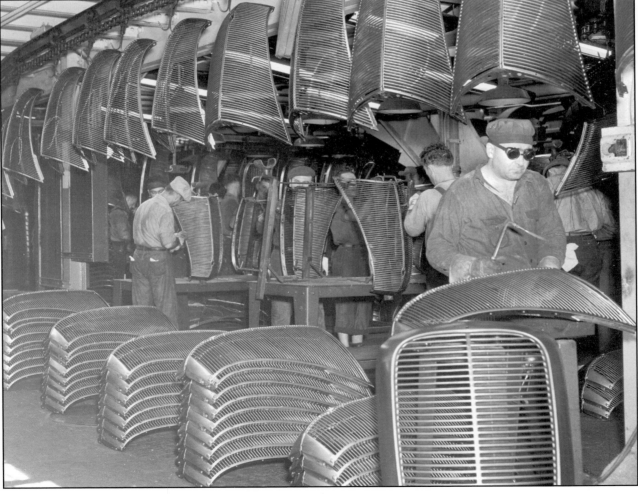

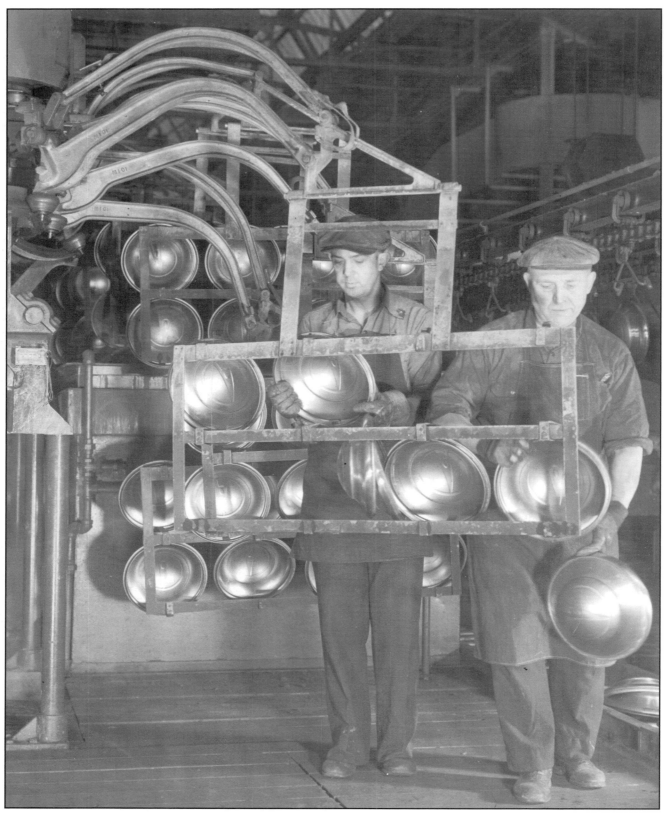

Ford 1937 steel hubcaps being rustproofed by means of a dipping process known as "granodizing."

28
FINAL ASSEMBLY

The logistics of moving assembly lines had already been well developed by Ford at Highland Park and other assembly plants through the building of 15 million Model Ts by 1927. Rouge Plant assembly procedures incorporated all that previous experience together with modifications such as much more extensive conveyor systems and fewer men employed as stock chasers.

Thousands of visitors to the Rouge enjoyed watching new Ford cars being assembled and driven off the end of the final assembly line. Occasionally, a customer would be allowed to witness his own car being assembled. Some customers insisted that the car they ordered not be assembled on either Friday or Monday — days when assembly-line workers might not be at their best.

At times, the Rouge drive-away garage would be filled with newly assembled cars needing minor mechanical adjustment of some sort. Some of these ailments were corrected at the Rouge, and some were passed off to the local dealer to be included in preparation charges. In the new-car sales room, the delicate combination of odors emanating from the paints, upholstery, rubber, adhesives, and gasoline added up to that "new-car smell," the aroma that tends to anesthetize the customer to whatever automotive ailments might exist.

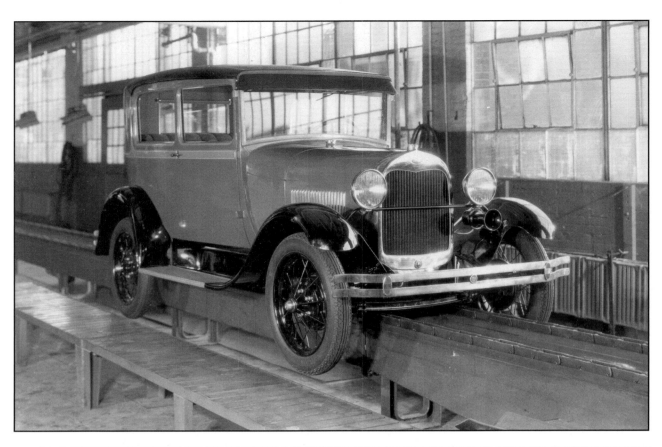

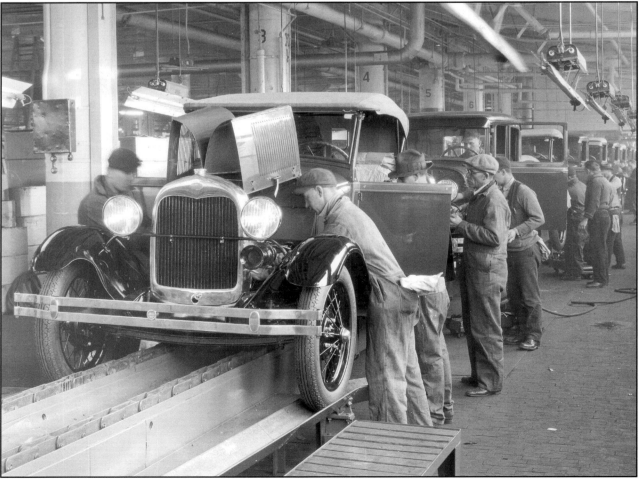

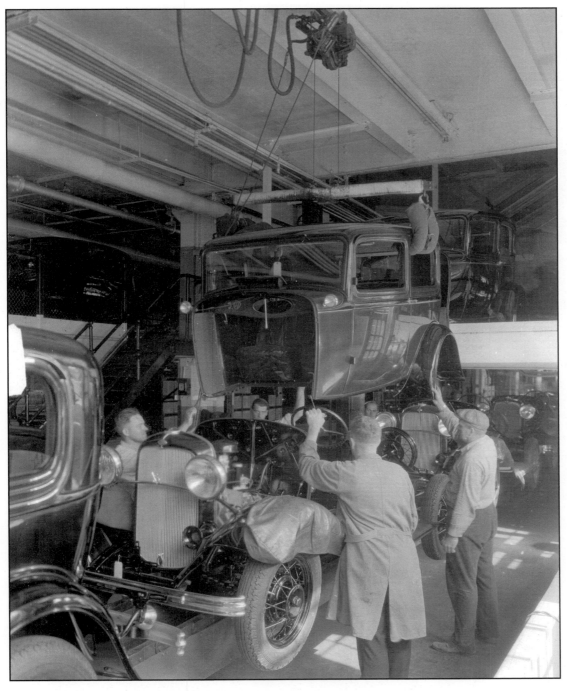

A Tudor body is lowered onto a Ford V-8 chassis in June 1932. (833.57060-9)

Opposite, top: A Model A Tudor, perhaps the first automobile assembled at the Rouge Plant. The Rouge had produced millions of Model T parts and assembled thousands of Fordson tractors, but the Model A was the first automobile assembled. Model Ts had not been assembled at the Rouge. Officially, Model A production started on November 1, 1927, but this photograph is dated October 21, 1927. (833.50034)

Opposite, bottom: Early Model A vehicles are assembled on December 9, 1927, for a very anxious public. Close to 5 million Model As were built between 1928 and 1932, of which 100,000 are said still to exist. These 1928-model roadsters and sedans at the end of the final assembly line go next to the drive-away garage. (833.50425)

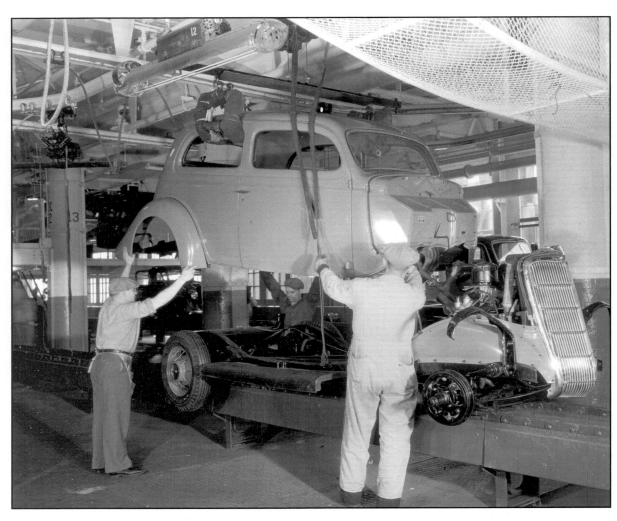
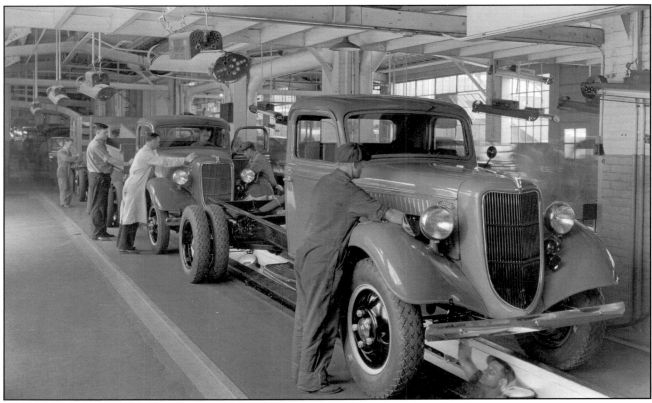

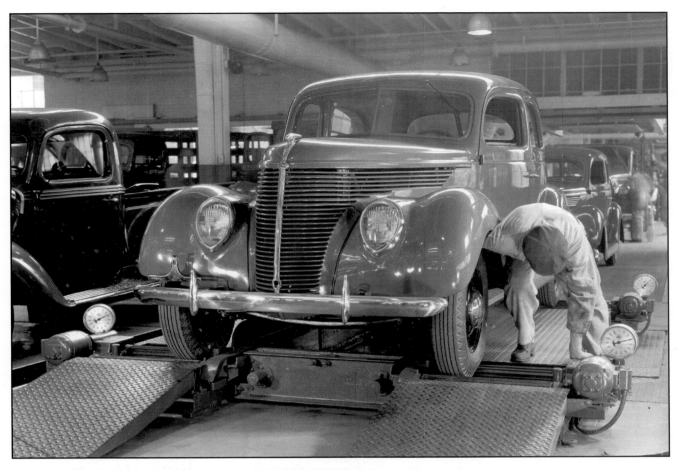

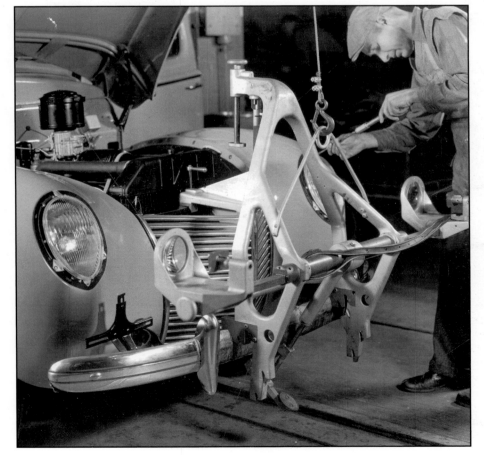

Above: Adjusting brakes on a standard 1938 Ford. (833.69215)

Left: Adjusting headlights on a 1939 Mercury. (833.71108-6)

Opposite, top: Body drop of a Tudor body onto a 1935 Ford V-8 chassis on December 1, 1934. (833.61119)

Opposite, bottom: Ford V-8 final assembly line in July 1936. Note the worker in the trench beneath the truck. (833.66401)

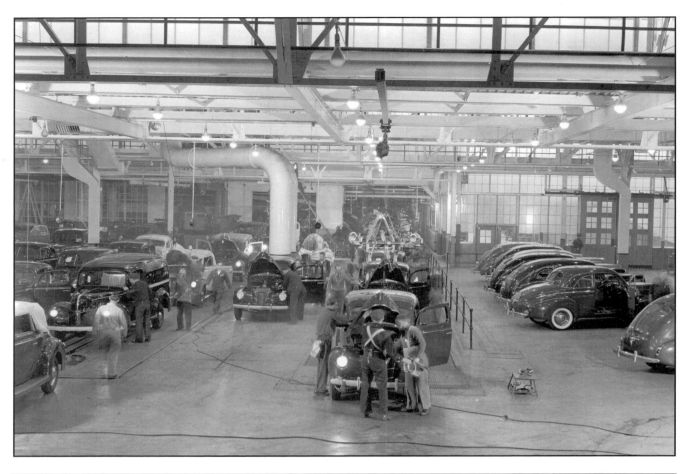

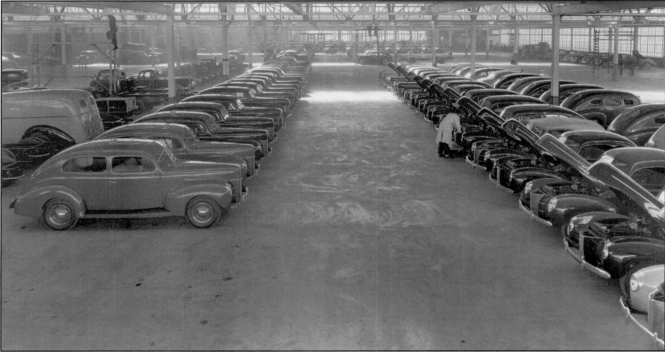

Top: The end of one of the Ford Rouge final assembly lines, where 1940 model Fords are being inspected on December 28, 1939. (833.72878-B)

Bottom: The Rouge drive-away garage in October 1939. (833.72557-A)

29
ENGINE RECONDITIONING

There was no separate building for engine-rebuilding operations; the work was accomplished in a special area of the motor building. Approximately 35,000 engines per month were reconditioned at the Rouge during the Depression period of the 1930s. Henry Ford was not only addicted to salvaging any and all materials that could be salvaged, but he was also finding as many ways as possible to keep his workers employed during these years of severe unemployment.

Some of these worn-out engines came from used cars being reconditioned on a Ford used-car reassembly line at the Highland Park Plant, and some came directly from Ford dealers to the Rouge motor building for reconditioning. In spite of the cost of all the new parts and the transportation charges to and from the factory, this new service required less time and cost the customer less than when overhauled at a dealer's service station. Most Ford dealers maintained a stock of factory-reconditioned engines that sold for about $40 in exchange for the used engine.

In the reconditioning process, approximately 25 percent of the engines were given new blocks, and 50 percent were given new camshafts. Very few new crankshafts or connecting rods were necessary. Factory-rebuilt parts such as distributors, carburetors, and fuel pumps were reconditioned and supplied to dealers separately. Engine reconditioning at the Rouge started on May 1, 1933; by December 22, 1937, one million had been completed.

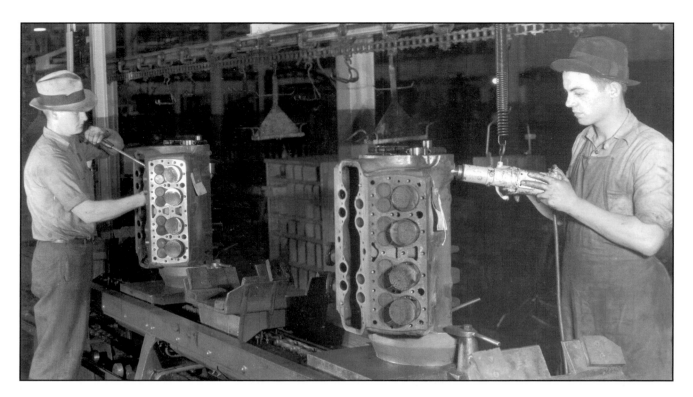

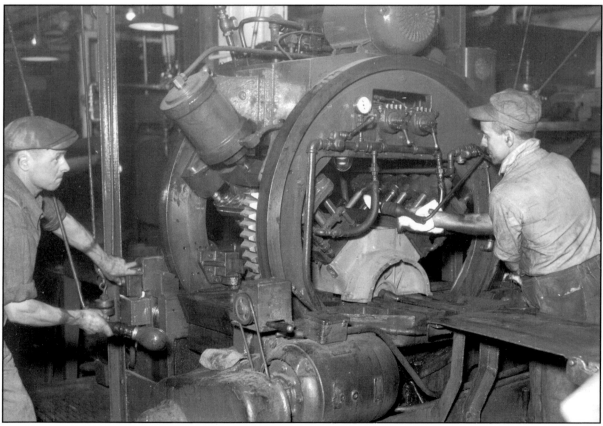

Top: Dismantling used Ford V-8 engines in preparation for reconditioning. The photograph was taken on December 1, 1934. (833.60794)

Bottom: Blow-testing and reconditioning a used Ford V-8 engine block on November 25, 1936. (833.67279)

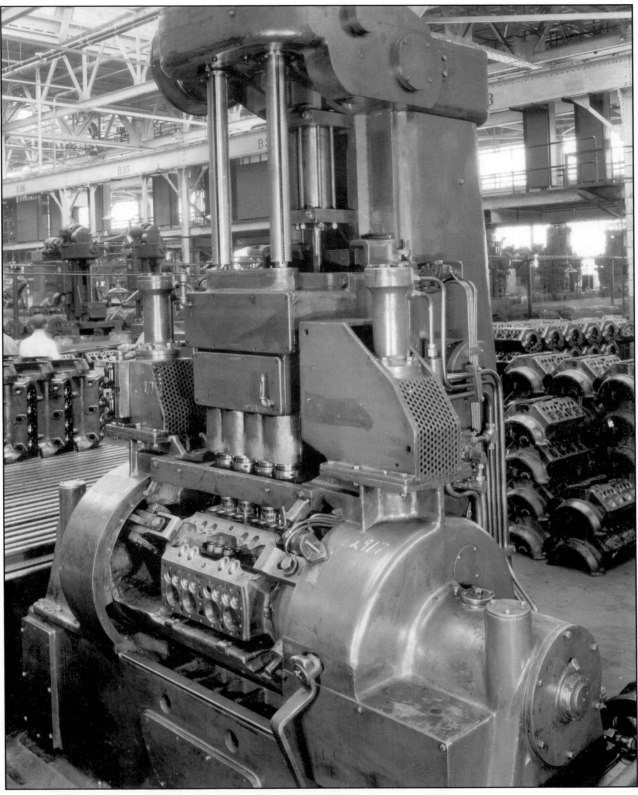

Reconditioning a used engine block by reboring the cylinder walls preparatory to honing. Stacks of reconditioned blocks are seen at the far right. (833.59892)

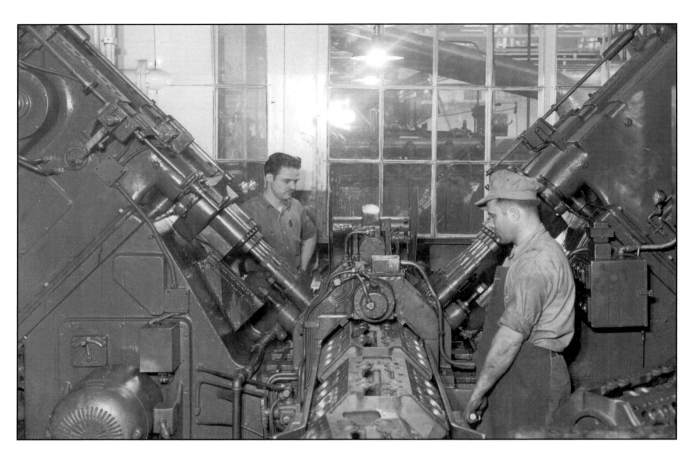

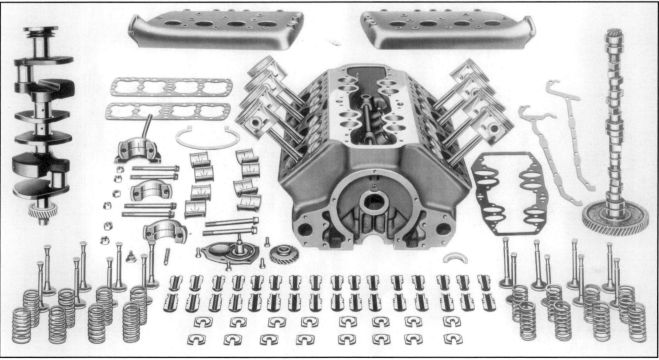

Top: Precision honing machine used to hone cylinder walls in the V-8 engine blocks. (833.67528)

Bottom: The many parts of a 1934 Ford V-8 truck engine that will be either restored or replaced with new parts in the engine-reconditioning process. (833.59125)

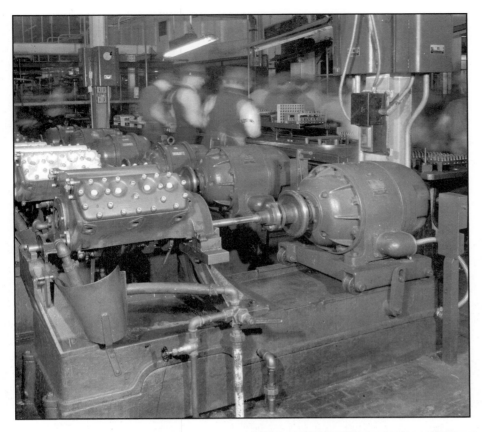

Left: Running-in stands at the end of the V-8 engine-reconditioning line in February 1935. (833.62238)

Below: A Ford Motor Company advertisement displayed in 1933. (833.57934)

30
PRODUCT SHIPPING

Efficient shipment of fully assembled cars and parts from the Rouge Plant was an ongoing challenge. The bulk of manufactured automotive parts had to be shipped either by rail or by water to other assembly plants, while the relatively small number of vehicles assembled at the Rouge could be either driven or hauled by highway truck to nearby dealerships. Local dealers often would take delivery of their vehicles at the drive-away garage in the B building and sometimes would pass along transportation savings to the customer.

Much ingenuity was used in methods of shipping both body and chassis parts to domestic assembly plants by rail without excessive damage. For maximum efficiency, constantly moving conveyors brought automotive parts directly from Rouge manufacturing areas to inside railroad sidings. Body parts were particularly bulky and awkward to fit compactly into standard 36-by-10-foot boxcars, whereas chassis parts were much more amenable to systematic packing within the standard railroad cars. Railroad cars and trucks designed to carry completed vehicles safely later became quite commonplace.

Shipment by water was employed for moving both cars and parts to Atlantic and Gulf Coast assembly plants in the United States and to foreign assembly plants which in nearly every case were located on water where ocean freighters could dock.

Fully assembled Model A cars, one above the other, are shipped in railroad boxcars in October 1929. Because of height limitations, wheels and tires have been removed and fastened to the walls of the boxcars. (833.54046)

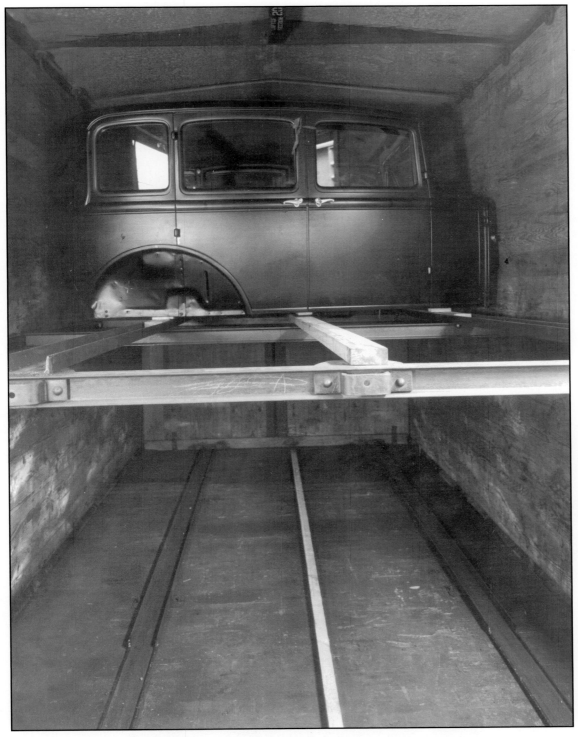

A 1931 Model A Fordor sedan body fits neatly within the 9-foot-6-inch width of the standard railroad boxcar. (833.56127)

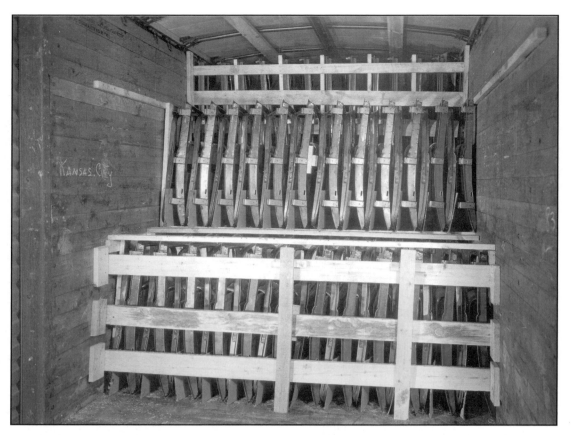

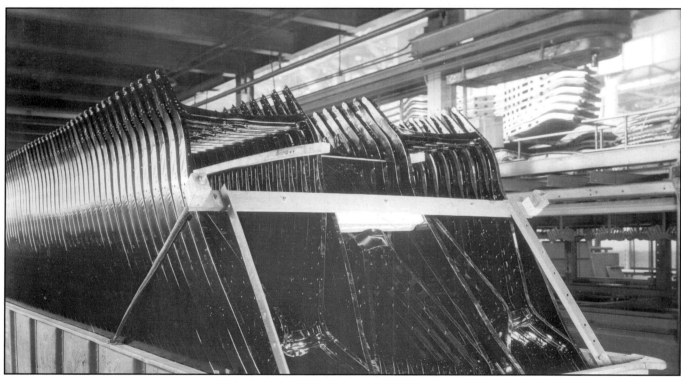

Top: Doors of Ford 1934 automobile bodies are packed in the end of a railroad boxcar for shipment to Ford Motor Company's Kansas City assembly plant. (833.60062)

Bottom: A railroad carload of 1934 automotive frames ready for shipment to an assembly plant. Note that the railroad car was loaded inside the factory. (833.60051-1)

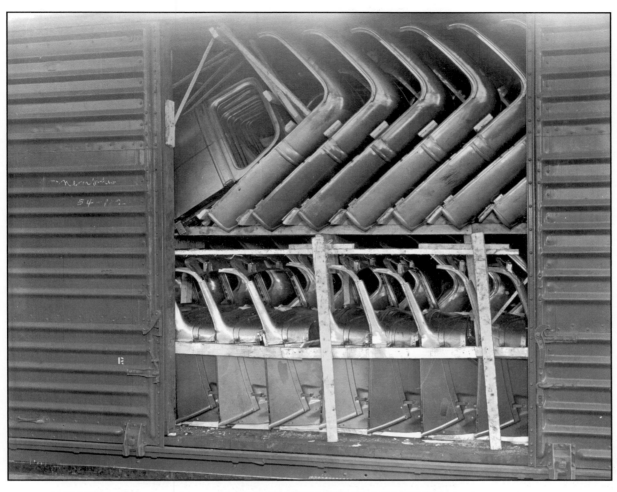

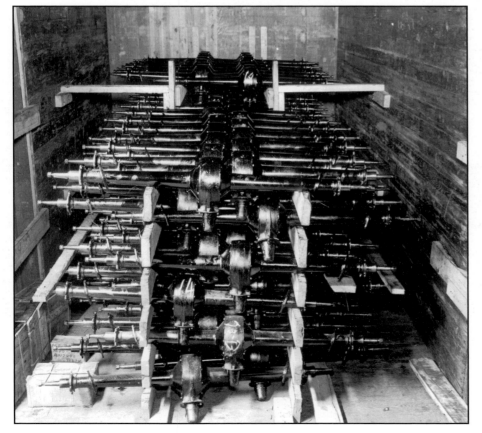

Above: Seen in the doorway of a railroad boxcar, these well-braced 1936 Ford body panels will soon be on their way to an assembly plant. (833.65441)

Left: Transporting rear axles in railroad cars by stacking them neatly together between wooden braces so that the axles do not touch one another. (833.65941-C)

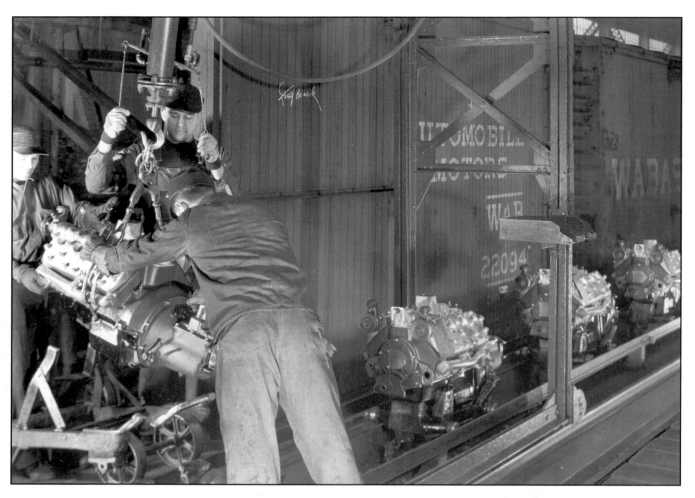

Above: From within the engine plant, 1936 V-8 engines arrive on a conveyor at the doors of a railroad boxcar destined for the Long Beach, California, assembly plant. Here at the door of the car, using a sling, men quickly move an engine from the conveyor to a hand truck in the doorway of the car. (833.65084-B)

Right: Inside the boxcar, the V-8 engines are placed on end in rows on the floor of the car. There is space for another tier of engines if the car will stand the weight. (833.65084-A)

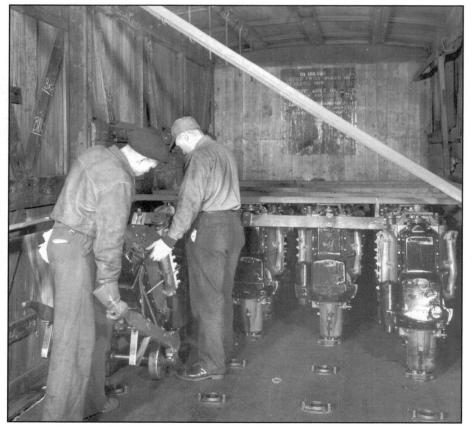

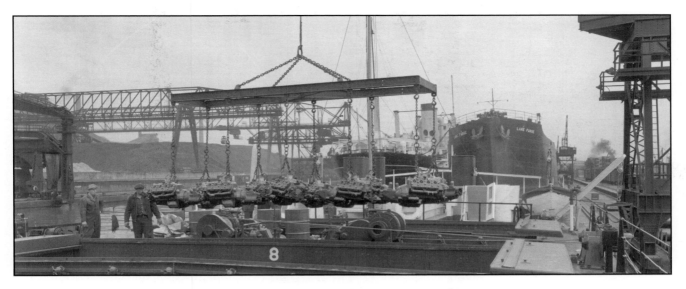

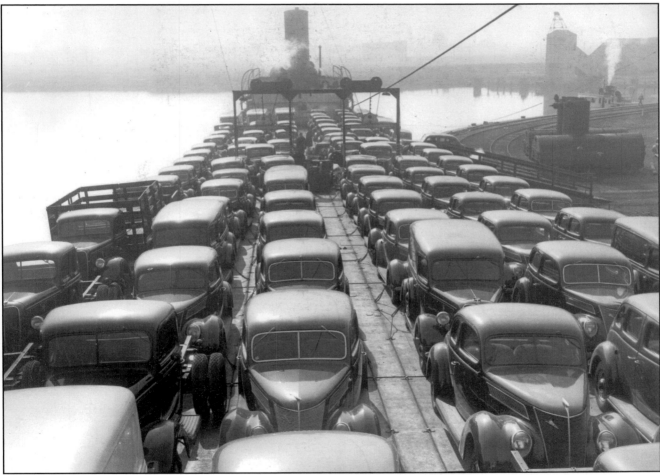

Top: Using a crane to load ten engines at a time into the holds of the *Green Island* on June 30, 1937. These engines are going to Ford's East Coast assembly plants. (833.68486)

Bottom: The first shipment of the season of fully assembled 1937-model cars and trucks destined for the East Coast. The waterways of the Great Lakes, together with the Canadian and New York canal systems, are not entirely clear of ice until the month of March. This Ford ship at the Rouge is loaded and ready to leave on March 3, 1937. (833. 67992-C)

31
TRADE AND APPRENTICE SCHOOLS

The Henry Ford Trade School was organized in 1916 at the Highland Park Plant for benefit of boys from ages twelve to eighteen whose circumstances compelled them to leave school and go to work. It gave them a chance to continue their education and at the same time become self-supporting. The Trade School was moved from Highland Park to the Rouge Plant in 1930, bringing with it more than 1000 students, 75 instructors, and a waiting list of about 4000 more students. Since its beginning, there had been a waiting list of thousands of boys. At the Rouge, classrooms were on the third and fourth floors of the B building, but workplaces were scattered throughout the plant.

Instruction typically consisted of one week in the classroom and two weeks in the shop. Class subjects consisted principally of English, civics, economics, mechanical drawing, shop arithmetic, algebra, geometry, trigonometry, physics, chemistry, and metallurgy. Shop training included the operation of shapers, lathes, mills, grinders, gauges, dies, heat treatment, forge, foundry, carpentry, sheetmetal, and nickel plating. The boys worked five days a week from 7:30 A.M. to 3:50 P.M., receiving an average of about $14 per week plus a free lunch. A boy starting in at age fourteen received 20 cents an hour and, if doing average work, received an increase of one cent per hour every six weeks, pay increasing with academic advancement. Graduates were considered to have the equivalent of three years of high school.

The Ford Apprentice School was an extension of the Trade School. It was a four-year course for men eighteen to thirty years of age leading to the title of journeyman toolmaker, diemaker, pattern maker, millwright, and so on. Again, well more than a thousand were enrolled. Pay was $6 or more a day, and work was provided in various tool rooms. Classes in mathematics and mechanical drawing were offered but taken on the student's own time.

The Ford Service School offered a two-year course to train men for company service largely in foreign countries. At times, there were as many as 450 attending classes in mathematics, mechanical drawing, electricity, and metallurgy. Over the years, more than 3000 were enrolled. Nationalities accommodated included Chinese, Indian, Mexican, Italian, Filipino, Czechoslovakian, Puerto Rican, Turkish, Persian, and Russian. In addition to attending classes, these men worked in various manufacturing and assembly departments to learn the automotive business. They were paid $6 a day.

All three of these schools were under the direction of Frederick E. Searle. The Henry Ford Trade School continued to operate at the Rouge until 1952, five years beyond the death of Henry Ford.

Left: Dr. Frederick E. Searle, superintendent of the Ford schools, with a student assistant in his office in the B building on September 16, 1940. Searle may be reviewing the huge number of applications for enrollment, which always far outnumbered the students enrolled. (833.74343-A)

Below: Youngsters at the Trade School are assigned rather light shop work such as repairing safety glasses in the commercial tool department. (833.74426-18)

Above: More advanced shop work for the boys includes rewiring small electric motor armatures in the electrical repair department. (833.74426-16)

Right: A Trade School student works in the analytical chemistry laboratory. (833.74426-11)

Left: A Trade School student at his drafting board with an instructor. (833.62853-A)

Below: The Trade School lathe department on the third floor of the B building in July 1935. (833.63413-B)

Above: Trade School students receive their pay in cash in little brown envelopes as they show their badges to the cashier. For the students' convenience, the pay truck arrives on the fourth floor of the B building on each payday. (833.74426-40)

Right: The Henry Ford Trade School basketball team on March 3, 1936. The smiles on their faces indicate they are recent winners. The school also has a baseball team. Competition includes various Detroit high schools. (833.65357-A)

Left: The Henry Ford Trade School orchestra in October 1930. The school also has a glee club and holds a daily song fest. (833.55580)

Below: The library of the Henry Ford Trade School in the B building on August 3, 1936. These may be monthly Apprentice School students at work. Trade School students are given three-week summer vacations. (833.66539)

A group of foreign students of the Ford Service School on March 15, 1926. Most are in their twenties and married. Some are college graduates from foreign universities. Their work and class instructions take place at both Highland Park and Rouge locations. (833.45707)

32
EMPLOYEE COMMUTE

At the start of the Rouge in early 1918, there was no public transit service available, and very few workers possessed automobiles. As the plant workforce grew in size, streetcar and bus lines were extended from Detroit to the Rouge at both Miller and Schaefer Roads. These public carriers brought workers to Gate 4 on Miller Road or to Gate 9 on Schaefer Road. Connecting these two public roads within the plant was Road 4, a pedestrian and vehicle roadway a mile long which, going from east to west, bisected the plant. When entering the plant at one of the gates, a worker was usually, but not always, within a walking distance of one-half mile from his time clock and work station.

As more and more workers could afford automobiles, large parking areas adjacent to Gates 2, 4, 5, 9, and 10 were provided for those who chose to drive to work in their own vehicles. In time, more workers were driving their cars than were using public transportation. As many as 70,000 parking spaces on 87 acres are said to have been allocated. These were unassigned spaces, and during a year a worker might never park in the same space twice. Finding one's car at the end of the day could be a problem. A few reserved spaces inside the plant gates were assigned to plant superintendents and such.

A typical daily labor report during the Depression (February 10, 1936) reveals a total workforce that particular day of 65,796, with 6870 workers on shift 1 (midnight), 37,765 on shift 2 (daytime), and 21,161 on shift 3 (afternoon). An additional 2115 Trade School students worked the daytime shift. That same day, six men and twelve boys were hired, and thirty-three men quit.

Whether workers used public transit or personal cars, shift-change times were especially crowded. During mornings between 7:00 and 8:00 and afternoons from 3:00 to 4:00, Road 4 and gates on Miller and Schaefer Roads were crowded with workers both coming and going.

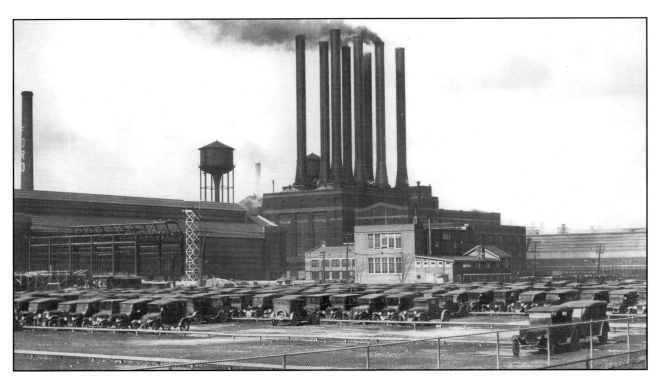

Top: In 1924, this small parking lot along Miller Road just south of the powerhouse has as many touring cars as sedans, with at least half of them Model Ts. These cars may have belonged to Ford railroad employees. (0.8541)

Bottom: Almost entirely Model A Fords are parked in this Rouge employee lot on March 7, 1932, the date the first Ford V-8 was introduced. (833.56826-3)

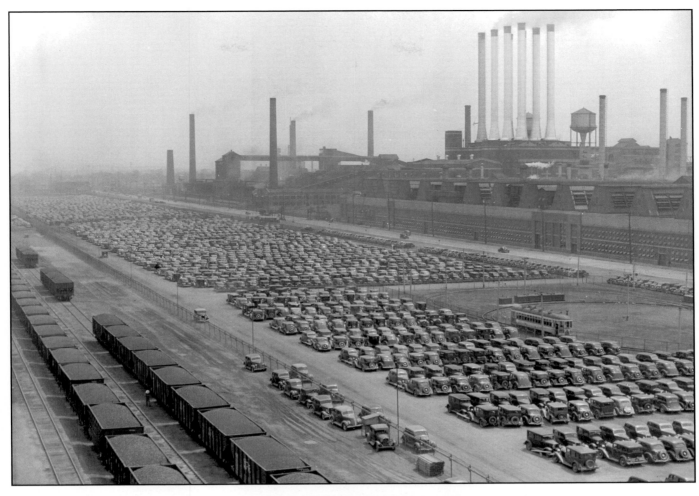

Above: The Rouge employee lot, perhaps the largest, stretches for almost a mile along Miller Road opposite the motor building, the production foundry, the powerhouse, and the coke ovens. On this July 1937 day, it is almost entirely filled with black 1935 and 1936 Fords. The streetcar turn-around at the right serves employees using Gate 4. (833.68501-A)

The overpass at Gate 4 on Miller Road, the main entrance to the Rouge Plant, on July 7, 1937. This spot is always a beehive of activity when work shifts are changing. This is the location of the "Battle of the Overpass" on May 27, 1937. (833.68501-B)

Some must work — some must wait. A dog on the steps leading to the overpass at Gate 4.

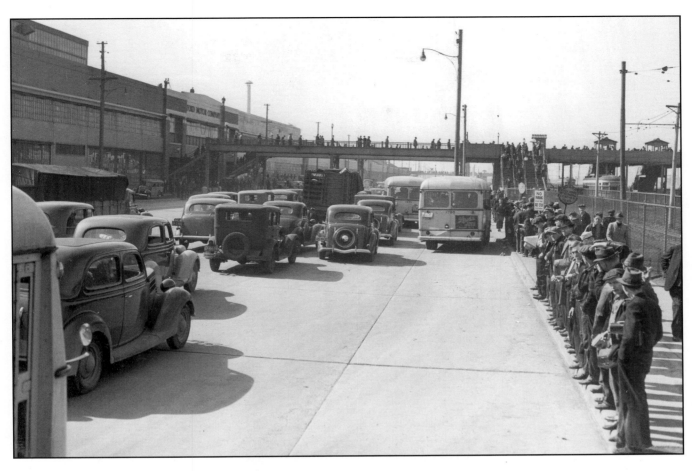

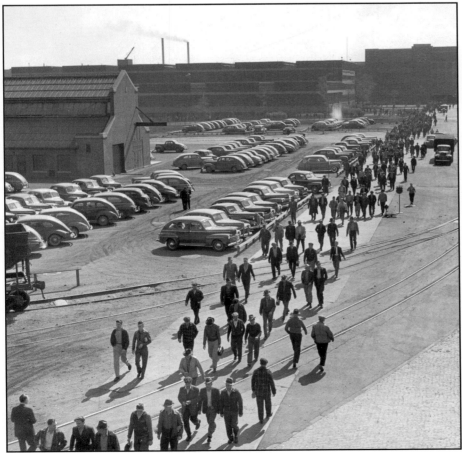

Above: The Gate 4 overpass looking north from the bus stop on Miller Road at quitting time on May 9, 1940. Streetcars are boarded at the far right. Buses manufactured by Ford Motor Company and operated by the City of Detroit are picking up workers at curbside. (833.73719-D)

Left: A view of Road 4 looking west within the plant from above Gate 4. Most of the pedestrians are leaving from the tire plant and from steel operations farther beyond. A bus carrying workers with disabilities is visible in the distance. At the time of this photograph in the 1940s, plant supervisors have been given passes to permit them to park their cars inside the plant gates. (0.9505)

A Detroit-bound streetcar leaving Gate 9 on the west side of the Rouge Plant onto Schaefer Road in 1937. The streetcar will go north on Schaefer Road past the Rouge administration building to Michigan Avenue and then east into Detroit. (0. 8879)

33
WORKERS WITH DISABILITIES

The policy of Henry Ford was to give equal opportunity for work to all, including those who did not have full use of their physical faculties. For blind applicants, in particular, a number of specific jobs were available in such departments as motor assembly, including especially the gasket department and the valve bushing department. This work could be handled efficiently by sightless employees. There were times when as many as 1200 employees who were blind or had seriously impaired vision were working at the Rouge Plant, earning wages equal to those of other workers. Also working at the Rouge were more than 150 deaf-mutes, 15 men in wheelchairs with both legs amputated, 130 employees minus a hand or a whole arm, and one with both hands gone. Including all of his factories, Ford was reported in March 1927 to be employing 13,000 people with disabilities.

Between World War I and World War II, great advances had been made in fitting seriously disabled men for industrial work. In appropriate jobs, workers with disabilities were sometimes more efficient than other workers. These workers asked no odds and were given none when work suiting their abilities was found.

In 1929, Ford stated that he preferred having employees who were thirty-five to sixty years old, but, in reality, the range extended way beyond in both directions.

This office worker without hands is able to write and use a typewriter. (833.77132-C)

With just one arm, this man can operate a freight elevator as well as any man. (833.69239-C)

A blind man with his leader dog is trained to assemble motor guide bushings by touch. (833.77082-O)

Top: Two blind men sort and fit together valve guide split bushings for motor assembly. (833.69239-B)

Bottom: A blind woman assembles ammeters for installation in the instrument panels of Ford automobiles. (833.68526)

Ben McLennan, at age eighty-one, continues to work as operator of a hot forging
press. (833.69672-A)

Top: Three older men assist in the Rouge boot repair shop during April 1936. (833.65729)

Bottom: It's all business for these elderly men at a steel mill stockroom counter on September 1, 1937. (833.68734-A)

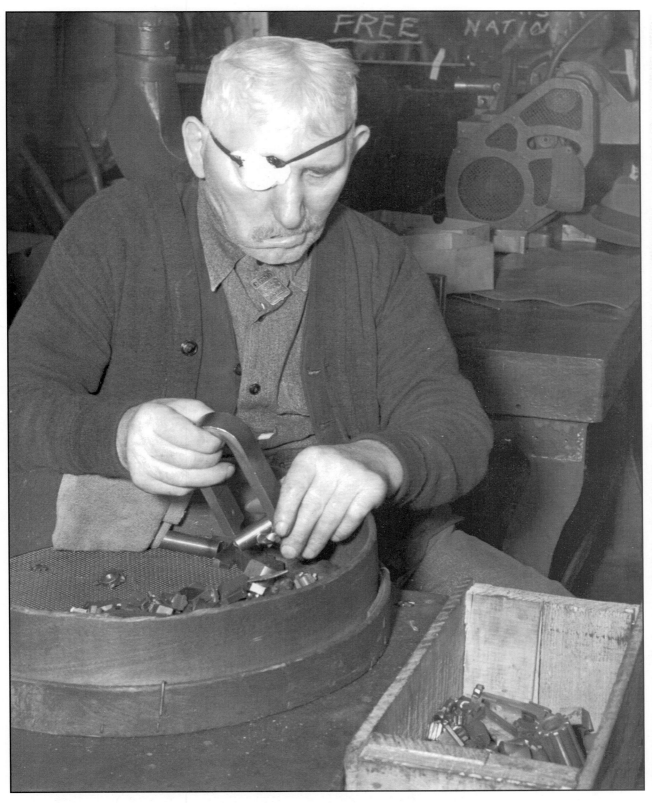

An elderly disabled man separates ferrous from nonferrous scrap with a magnet. The photo was taken during the period at the start of World War II. (833.77123-19)

34
INDUSTRIAL RELATIONS

The first few dozen employees hired by Ford Motor Company were acknowledged one by one as friends by Henry Ford himself. As the numbers grew to thousands by 1913, Ford organized the Sociological Department at the Highland Park Plant with authority to hire, transfer, and, as a last resort, fire employees. From January 1914, when Ford raised employee wages to five dollars a day, double prevailing wages for that time, Ford had a reputation for paying well. For the further benefit of employees, in 1920, Ford introduced "investment certificates" through which employees could invest a third of their wages with interest guaranteed at 6 percent and yielding as much as 12 and 14 percent in profitable years. Investment certificates were offered by Ford until August 1941.

The Rouge Plant employment office was under the direction of one man personally appointed by Henry Ford not only to manage all employment problems but also to operate within the Rouge a plant protection force of nearly 3000 men known as "Ford Service." These officials did not wear uniforms but could usually be recognized by their burly physiques typically garbed in dark suits and dark felt hats. When under the gaze of a "Service man," the most loyal worker could not help but feel a bit intimidated. In addition to checking badges of employees as they entered the gates, Ford plant protection men strictly enforced the rules of no smoking or drinking by employees while at work. Service men occasionally broke up fights between employees and vigilantly guarded exit gates to prevent theft of property by employees.

Although Ford paid his employees very well, he expected from them a full day's work. He could not tolerate loitering or sloppy workmanship. Industrial relations at the Rouge, as carried out by Ford's subordinates, were harsh. Workers were inclined to fear for their jobs especially during the Depression years. The typical middle-aged production worker appeared noticeably bedraggled and haggard when returning home from work.

During the Depression, wages varied from a minimum of seven dollars a day in December 1929 to a minimum of four dollars a day in 1932, improving to six dollars a day in 1935. The usual Ford workweek of five days was lowered to four days for a period during 1933. During the 1930s, although Ford was trying to employ as many workers as possible, the Rouge Plant was more than once under siege by unemployed workers and by unionists. The rough tactics used in these encounters by both sides were regrettable. Henry Ford did not believe a union was necessary in his plants. Edsel Ford was willing to negotiate with the United Automobile Workers. In June 1941, the UAW won a generous contract and permission to organize Ford plants. During the next three war years, however, there were 418 work stoppages.

Ford Bryan when working
at the Rouge with a Master
of Science degree and a
badge *685.

Top: The Rouge employment office on Miller Road at Gate 2, just south of the powerhouse. A Service Department guard stands at the street entrance gate on this warm August day in 1937. On the opposite side of the road is the "bull pen," where applicants for work are often herded by the hundreds waiting to be interviewed. (833.68508)

Bottom: Rouge Plant badges. The badge with the star and a number is worn by an employee of upper rank in the Ford Motor Company. The badge with the letter A and a number is worn by an employee who works in the motor building. A badge with the letter Z would be worn by an employee who works in the pressed-steel building. Workers are thus restricted to the particular buildings in which they are assigned to work. (Photographs courtesy of Timothy J. O'Callaghan)

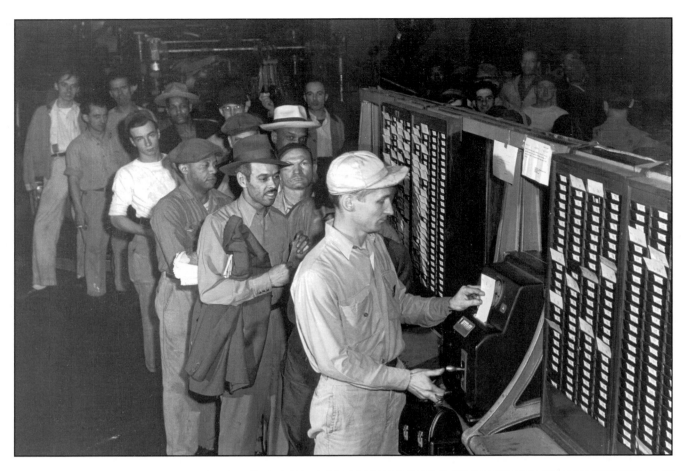

Top: Time clocks, located in nearly every Rouge building, require all employees to "ring in" and "ring out" within six minutes of their scheduled working hours. To get their pay, they go to the pay office at Gate 4 to show their badges and receive the small brown envelope containing two weeks' pay in cash. (15592)

Bottom: A Ford Rouge pay office, where employees receive their pay in cash after showing their badges and where orders can be placed for Ford investment certificates and low-priced residential coal and coke. (833. 78923-2)

Ford Investment Certificates—

—can be purchased only by Ford employes.

—are guaranteed to pay a return of six per cent per annum, but have actually always paid more.

—may be paid up in installments, the only restrictions are that no payment shall exceed one-third of the amount received on any pay day, and payment must be made within three days of the time pay is received.

Money Invested in them can be withdrawn anytime.

You Can Save Enough to Buy a Home

And Never Miss the Money

If You Use THE FORD INVESTMENT PLAN

Advertisements in the September 1922 issue of the *Ford News* promoting Ford investment certificates. At this time, there are about 25,000 employees enrolled with approximately $7 million invested.

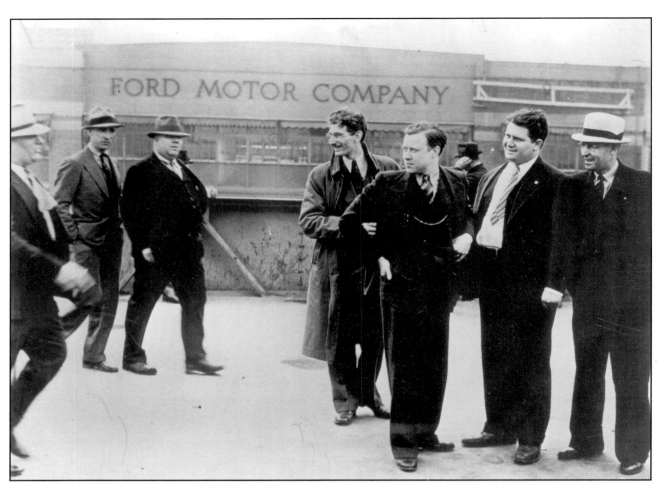

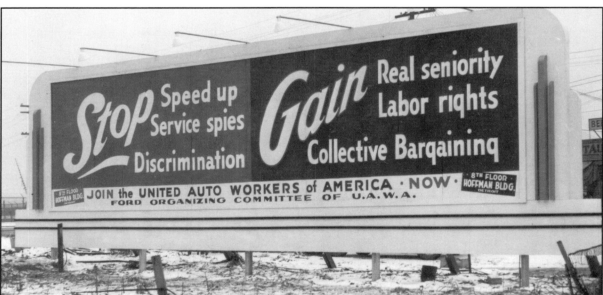

Top: Union leaders facing Ford Service men on the Gate 4 overpass on May 26, 1937. At the left are three Ford Service men; on the right are UAW members Robert Kanter, Walter Reuther, Richard T. Frankensteen, and J. J. Kennedy. This encounter will lead to a fracas in which several are injured. (833.68529-8)

Bottom: One of several billboards erected in January 1938 adjacent to Rouge property by the UAW. (833.69737)

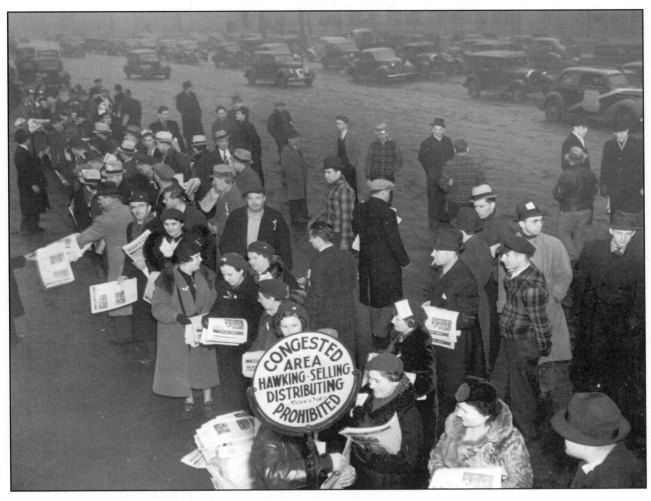

Above: Union literature is distributed at Gate 4 on January 21, 1938. Women are recruited by the UAW in order to prevent harsh treatment by the police. (833.69765-20)

Left: Extensive vandalism done by the UAW-instigated strike in early April 1941. Damage included shutting down open-hearth furnaces without having drained the molten metal. (833.75333-48)

Signing the Ford labor contract in June 1941. From the left are Philip Murray, Committee for Industrial Organization; Harry H. Bennett, Ford Motor Company; and R. J. Thomas, UAW. (P.O.15675)

35
FOOD SERVICES

The tens of thousands of employees at the Rouge Plant largely took care of their own food requirements while at work. Most brought lunches from home. A considerable number purchased lunches from the food carts that arrived at mid-shift at numerous locations and sold simple lunch essentials. Very few, other than top executives, would venture out of the plant, considering the short twenty- to thirty-minute lunch periods allotted. Production workers customarily ate their lunches relaxing by their machines. Salaried laboratory and office workers usually ate at their benches or desks.

As new manufacturing buildings were erected in the late 1930s, lunch rooms with tables and chairs were provided for hourly workers to eat the food they brought from home. By the 1940s, Ford Motor Company was operating cafeterias to accommodate both hourly and salaried workers. For executives, plush private dining rooms ranked A, B, and C were provided, with A being most exclusive.

Costs of food were minimal at the various cafeterias and dining rooms. The food was better than at most restaurants and was sold at little or no profit to the company. A typical Rouge cafeteria meal in the 1940s would cost about 70 cents, paid in cash. Private dining-room meals, considerably more expensive, were charged to an executive's account with the company and deducted monthly from his pay.

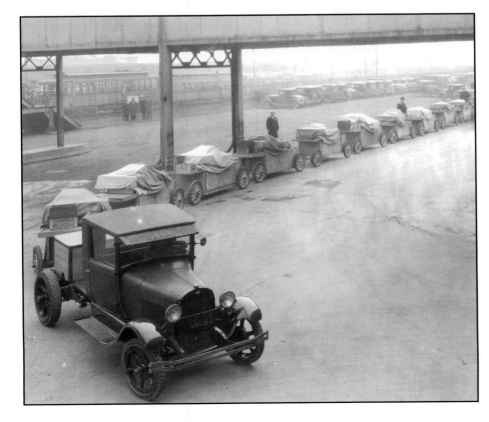

Every day, long trains of food trucks are pulled into the Rouge through Gate 4 and other plant gates. This photo was taken on a chilly March 17, 1931. (833.55987)

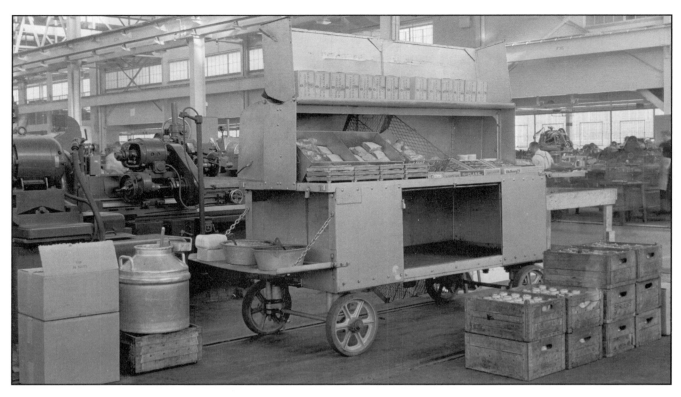

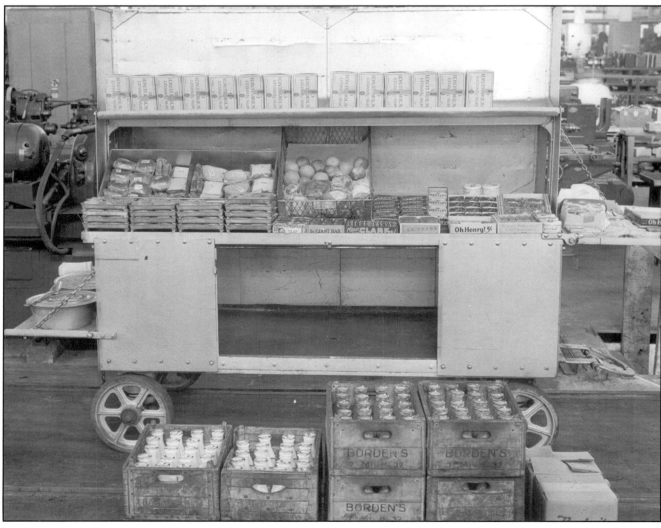

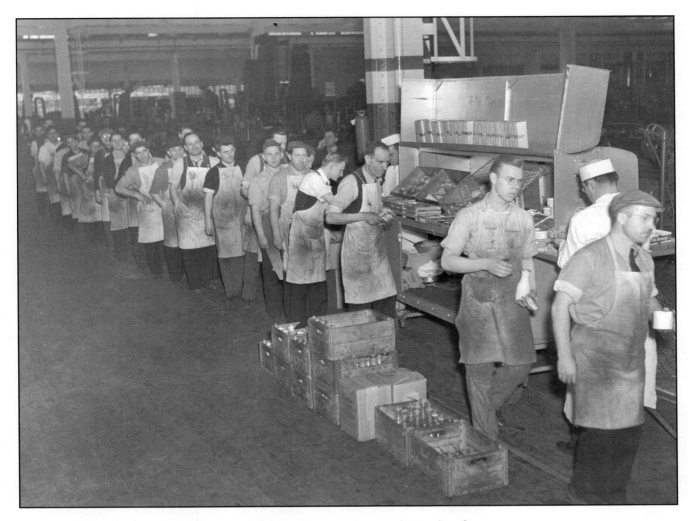

Production workers waste no time grabbing their lunches after standing in line for a considerable portion of their allotted twenty-minute lunch period. With food in hand, they return to their work stations to eat, often sitting on the floor beside their machines. In the photo, the man to the far right has a cup of soup in his hand, and the second man has a pint of milk. (833.71202-M)

Opposite, top: A lunch wagon open for business on December 15, 1938. For each wagon, two workers are assigned to open the wagon, display the goods, dish out the soup, and collect the money. Soup is in the large can to the left. Cardboard soup cups are in the boxes at the far left. (833.71202-C)

Opposite, bottom: At the top of the wagon, several "Factory Lunch" boxes are marked "Ham." From the left are sandwiches, apples, oranges, and a variety of 5-cent candy bars. On the floor are crates of milk at the left and crates of coffee at the right. Although it tastes vile, more coffee is sold than milk. (833.71202-A)

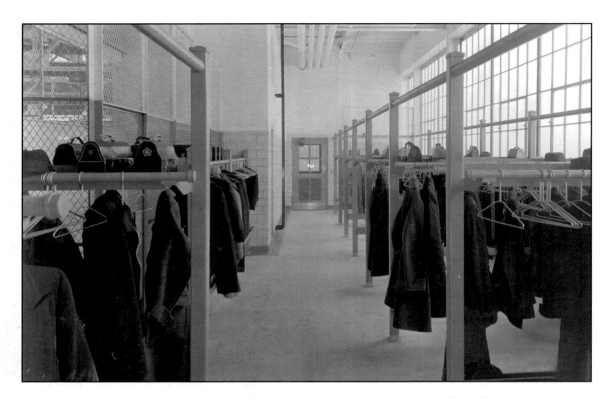

Above: In the new tool-and-die building on December 23, 1938, it appears the majority of workers have brought their lunches to work from home, leaving their lunch buckets above their coats in the coat room during working hours. Lunch buckets holding a drink in a thermos bottle are standard at this time. At lunchtime, workers can take their lunches to a nearby lunch room and eat at tables. Lunch wagons continue to be popular, however, since not all buildings have lunch rooms. (833.69463-94)

A typical lunch as carried in the standard workman's lunch bucket and eaten in the hourly workers' lunch room. (833.77837)

Opposite, top: The employee cafeteria counter on an upper floor of the Rouge administration building before mealtime on June 3, 1932. At the far end of the line are the coffee urns and cashier's station. This cafeteria was in operation before cafeterias were provided in Rouge manufacturing buildings. (833.56995-6)

Opposite, bottom: The cafeteria dining room in the Rouge administration building. Approximately a half-mile from the Rouge manufacturing area, these facilities are provided almost exclusively for the office workers who work in the administration building. (833.56995-7)

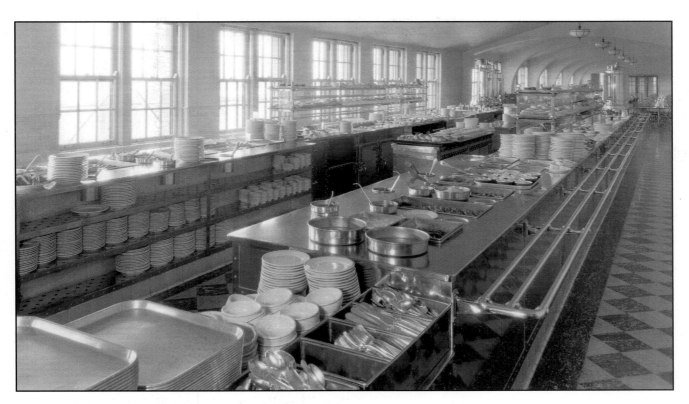
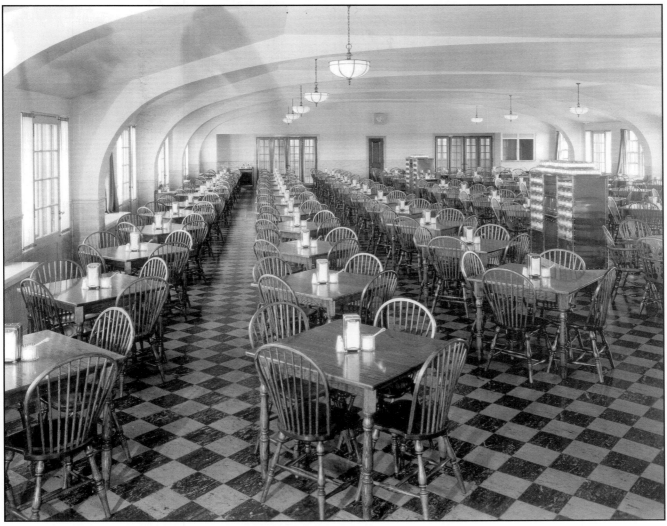

36
FORD COMMISSARIES

In 1919, Ford Motor Company became a retailer of household commodities. As Henry Ford stated, "We opened these stores as one means of raising our employees' salaries." Because of the postwar inflation, retail prices had risen to such heights that even the six-dollar-a-day wage was felt to be insufficient for Ford workers. To save money for his workers, Ford established a commissary right next to the pay office at the Highland Park Plant. There, on December 11, 1919, poultry, fish, and pork were sold to badged employees at close to wholesale prices. The Highland Park store was soon expanded to provide a fairly complete line of groceries, meats, dry goods, and drugs. The Ford commissaries differed from other department stores in purchasing in tremendous quantities, selling on a cash-and-carry basis, and providing no fancy surroundings.

A shoe store for employees was in operation at the River Rouge Plant in 1920. Safety shoes with steel caps over the toes were highly recommended. By 1926, a dozen or more full-line Ford commissaries had been established, including one of more than 30,000 square feet of floor space at the Fordson (Rouge) Plant. Store hours were from 8:00 A.M. to 6:00 P.M. Most of the store's fruits, vegetables, and flour were supplied by Ford Farms, and some of the drugs came from Henry Ford Hospital. Rouge by-products (coal, coke, and fertilizer) were available on order from the commissary. In 1926, total commissary sales in the Detroit area had reached more than $10 million. Profits to Ford Motor Company that year were $350,000, or about 3.5 percent of sales.

By 1927, Detroit merchants were loudly complaining that the Ford commissaries were selling to nonemployees and hurting their businesses. Because of such complaints, in January 1929, the Fordson (Rouge) commissary closed. The Highland Park commissary continued to operate but on a more restricted basis.

Opposite, top: The Fordson (Rouge) commissary on August 8, 1926, shortly after opening. The meat counter is at the right; shoes, gloves, and clothing are visible across the aisle. In floor space, this is the largest of the Ford commissaries. In sales, however, Highland Park is first. (833.47441)

Opposite, bottom: At the far left is the shoe department of the Fordson (Rouge) commissary in late 1926. To the right of the shoes are gloves, socks, and colorful woolen blankets priced at $5 each. A conspicuous sign hanging directly over the counter reads: "For Sale, Company Cars, New Models, Old Models." At lower right is a corner of the meat department. (833.48192)

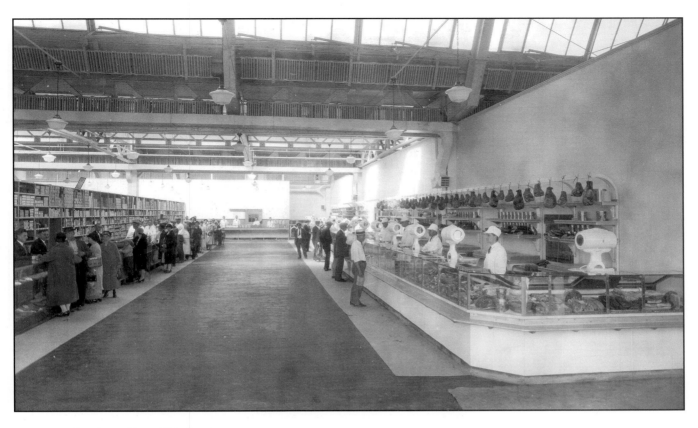

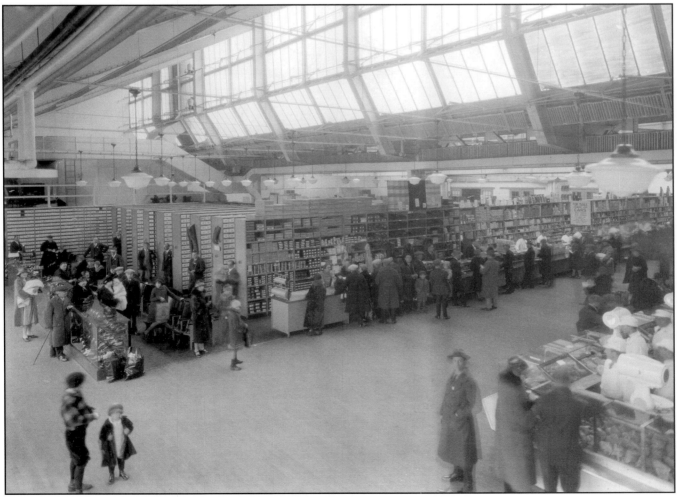

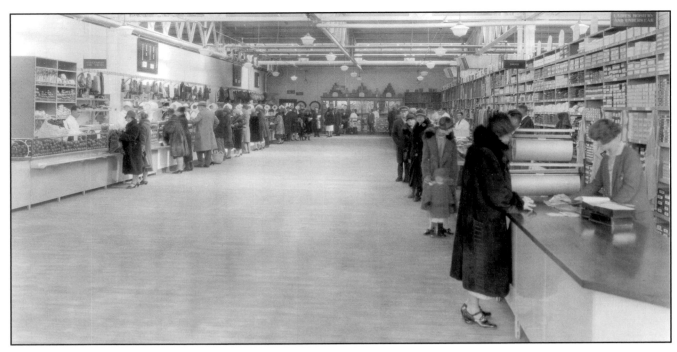

FORD MOTOR COMPANY
FORDSON PLANT

January 10th,
1 9 2 9

FORDSON PLANT COMMISSARY

SALES		GROCERIES	MEATS	DRY GOODS	MISC.	TOTAL
	1926	567,500.77	346,518.77	238,925.46		1,152,945.00 (5 months)
	1927	1,201,556.84	573,890.53	473,320.67		2,248,768.04
	1928	1,299,947.87	534,625.37	507,275.54		2,341,848.78
NET REVENUE						
	1926	8,342.52	1,438.97	14,881.50		24,662.99
	1927	30,433.83	3,134.31	30,612.22		64,180.56
	1928	83,590.89	16,727.19	15,851.34		82,715.04
INVENTORY (EST.) 12/31/28		66,517.82	7,331.60	108,790.38		182,639.80
EQUIPMENT VALUATION		12,774.63	59,557.45	1,566.10	38,375.97	112,274.15

W. E. CARNEGIE - ACCOUNTING DEPARTMENT.

Top: The opposite end of the Fordson (Rouge) commissary. Clockwise from the far left, signs read: "Vegetables and Fruits," "Lunch Meats of All Kinds," "Butter," "Fish," "Cheese," "Tires," "Tubes," "No Smoking," "Bread & Pastries," "Ginger Snaps," "Oyster Crackers," "Cheese Snax," "Drugs," "Ladies Hosiery and Underwear." Uniformly low prices are well displayed. (833.48661)

228

Bottom: Fordson (Rouge) commissary accounting records.

37
HOSPITAL

Perhaps the most widely promoted policy at the Rouge Plant was employee safety. Signs throughout the plant constantly reminded workers of the need to be careful. Rules enforced by foremen required the use of safety glasses, breathing filters, earmuffs, and shoes with toe protectors. Rules also forbade wearing such ornaments as finger rings, wrist watches, and four-in-hand neckties when working with machinery. In wet and slippery areas, boots with nonskid soles were supplied to the workers.

Despite the emphasis on prevention, each major building in the Rouge Plant had an emergency first-aid station, and on the second floor of the B building was the Rouge hospital. A staff of about 180, including 14 doctors and 23 nurses, was employed to take care of the medical needs of Rouge employees. Minor injuries were usually treated in one of the eighteen or more first-aid stations, where young medical students quite often were employed. More serious injuries were handled at the Rouge hospital, with the most serious cases being transferred to Henry Ford Hospital in Detroit.

The waiting room at the Rouge hospital on the second floor of the B building on November 22, 1934. (833.61040-1)

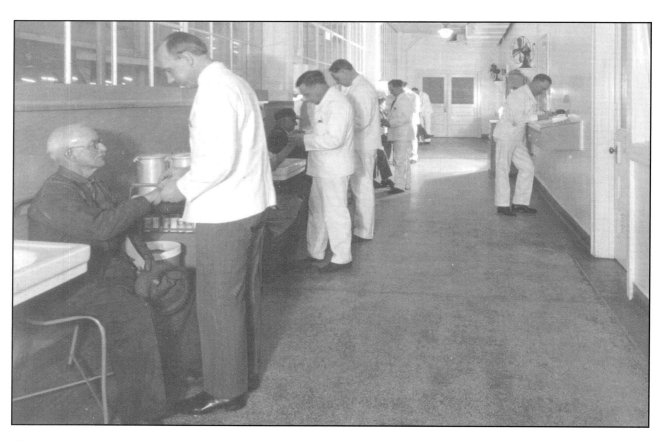

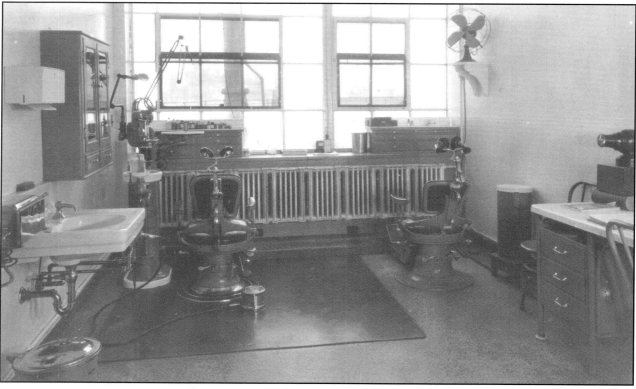

Top: Patients are interviewed by doctors in the corridor of the Rouge hospital.
(833.61040-2)

Bottom: The dental office in the Rouge hospital in 1934. (833.61040-3)

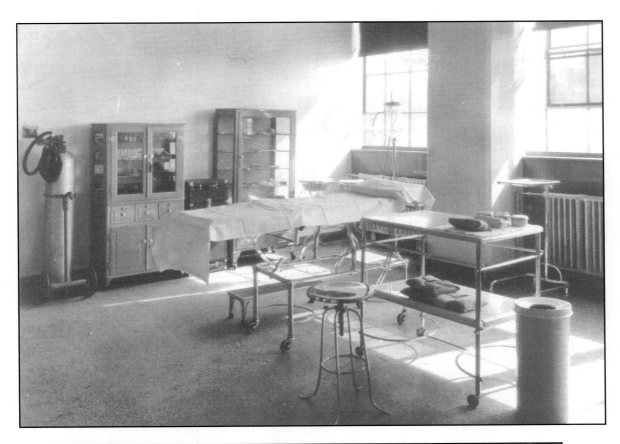

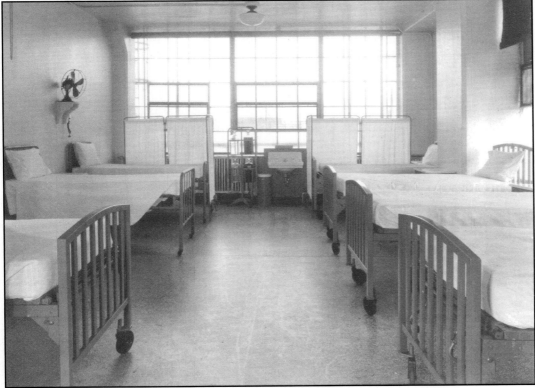

Top: The operating room at the Rouge hospital. (833.61040-4)

Bottom: A six-bed patient ward at the Rouge hospital on November 22, 1934. (833.61040-5)

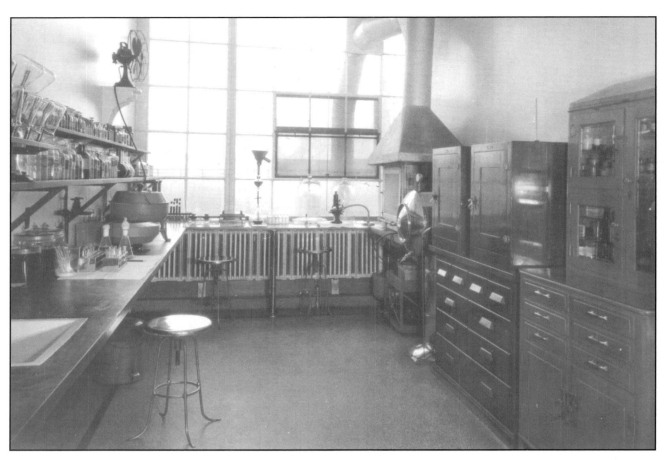

Above: Medical laboratory in the Rouge hospital. (833.61040-6)

Right: A Rouge hospital nurse draws blood from an employee during a blood drive at the beginning of World War II. (833.79883-1)

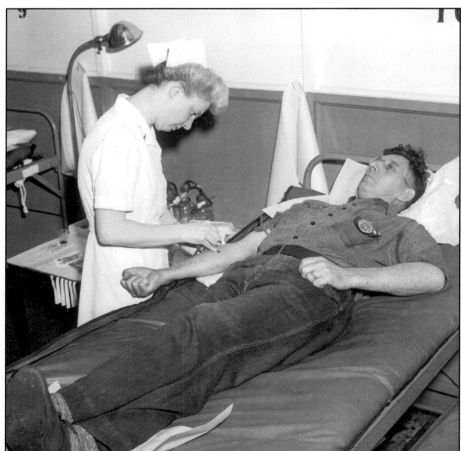

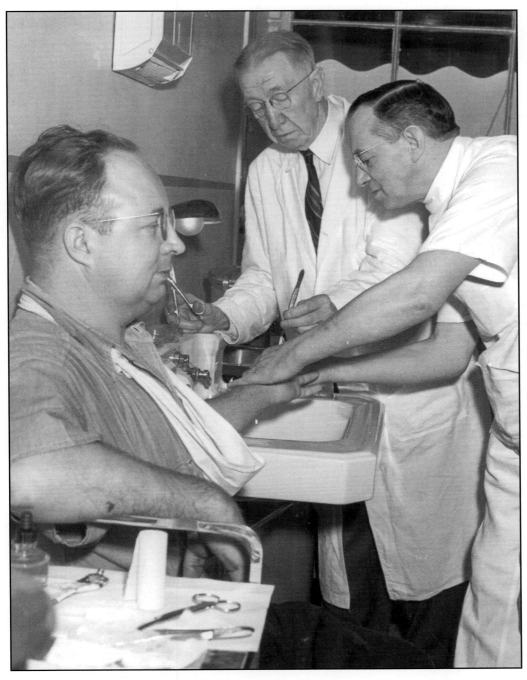

Two doctors attend an employee with an arm injury at the Rouge hospital in the early 1940s. (833.80259)

Above: A relatively large first-aid station in the new tool-and-die shop on February 24, 1939. (833.69463)

Right: An employee with her ring finger amputated. A companion photograph reveals her finger together with the ring that caused the accident. (833.80817)

38
FIRE DEPARTMENT

Although the City of Fordson and, later, the City of Dearborn possessed excellent firefighting equipment and responded to fires within the Rouge complex when needed, the Rouge had its own facilities for fighting fires. Located centrally within the plant, between the glass plant and the spring-and-upset building, was the firehouse. With Ford chemical and ladder trucks, firefighters were able to reach any of the many buildings within minutes. A cadre of nearly 100 uniformed men served on the twenty-four-hour fire protection force. All Ford buildings were well equipped with fire preventive devices. Water mains, hose racks, and hand extinguishers were installed throughout the Rouge. These devices were inspected and maintained at regularly scheduled intervals. Although thousands of fires were prevented and hundreds aborted, occasionally a fire would get out of hand, causing considerable damage.

In addition to their fire prevention work, the firemen also played their part in the general program of cleanliness by operating the plant laundry that provided workers with 130,000 sterilized towels every twenty-four hours.

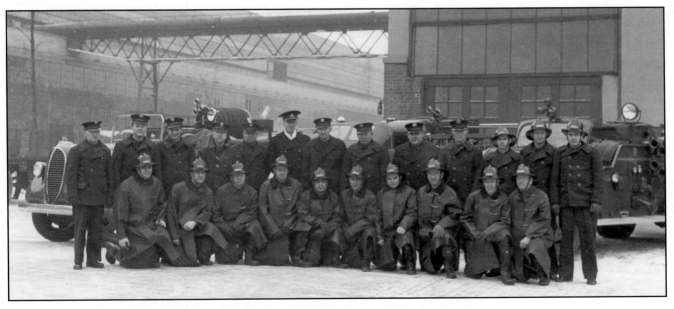

The Rouge fire department day crew in front of the fire station. The spring-and-upset building is visible on the left, and the glass plant (not visible) is immediately adjacent on the right. (833.82339)

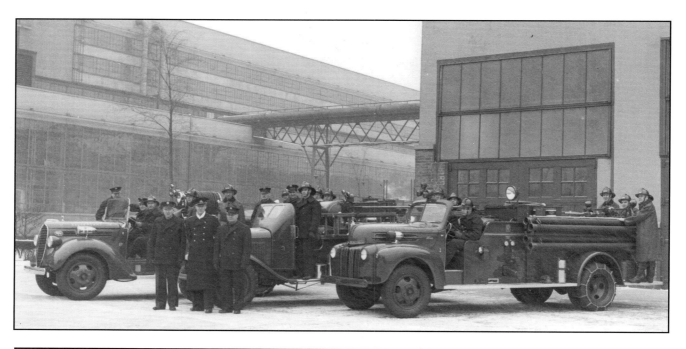

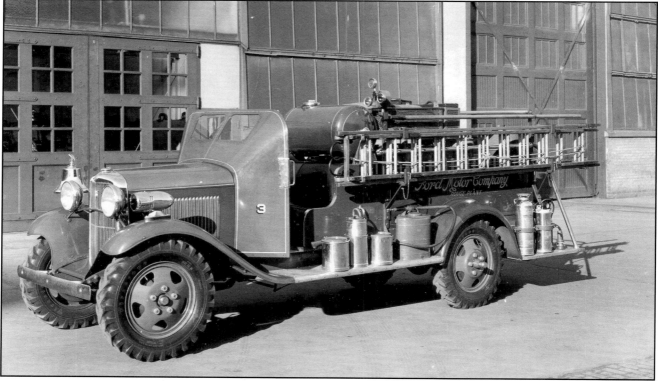

Top: The demonstration crew shows off its three vehicles. (833.82339-9)

Bottom: The 1932 Ford ladder truck beside the Rouge fire station. (833.82339-14)

Opposite, top: Fire hose and extinguishers are inventoried inside the fire station. (833.82339-7)

Opposite, bottom: A fireman cleans and repairs lanterns in the fire station. (833.82339-8)

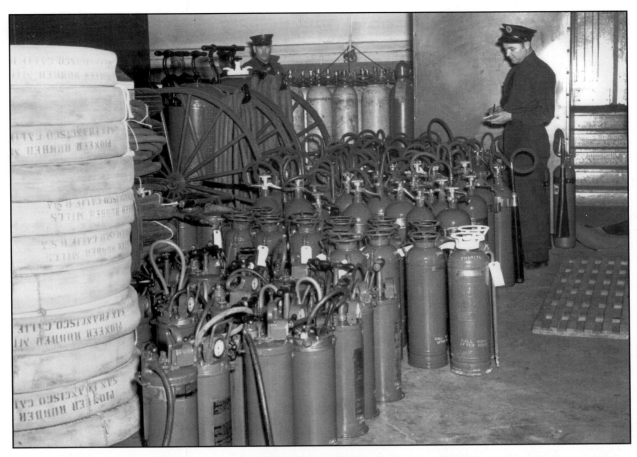

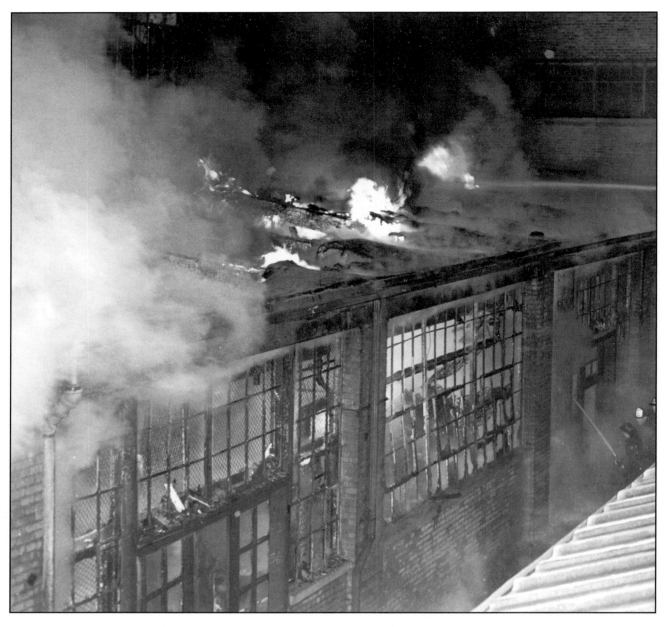

This fire in the B building on December 15, 1948, was a major conflagration. (833.87743-6)

Opposite, top: Workmen assess the damage caused by the B building fire. (833.87742-9)

Opposite, bottom: Damage to the Mercury assembly line in the B building. (833.87742-15)

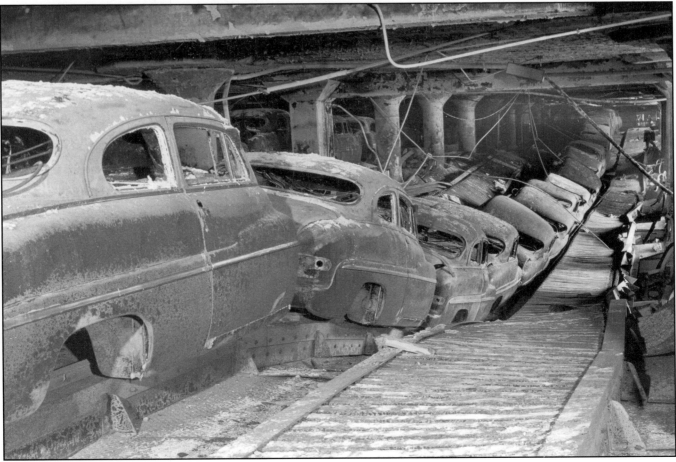

39
ADMINISTRATION BUILDING

Facing west on Schaefer Road, the administration building was at the far northwest corner of the Rouge property. Designed by Albert Kahn, constructed during 1927, and first occupied on January 26, 1928, this building became the headquarters of Ford Motor Company operations worldwide. Ford's main plant had been at Highland Park, north of Detroit. Now the main plant was equally as far west of Detroit. Highland Park had employed 68,876 workers in 1924, but by 1929, its employment was down to 32,918, while 103,951 were employed at the Rouge.

The front and sides of this new administration building were finished in white Indiana limestone; the rear wall and garage were of steel and brick construction. This four-story office building with two spacious wings featured a large top-floor cafeteria and rooftop promenade overlooking the Rouge Plant to the east and the residential countryside to the west.

The administration building not only housed elegant private offices for Henry and Edsel Ford but also provided administrative headquarters for Ford Motor Company business functions such as purchasing, sales and advertising, accounting and auditing, legal, real estate, and personnel. For a short time, Ford's DT&I Railroad had its main office in this building. Other administrative functions such as plant engineering and manufacturing engineering were headquartered at Gate 4 in the Rouge Plant, and automotive engineering was based at the engineering laboratory in Dearborn.

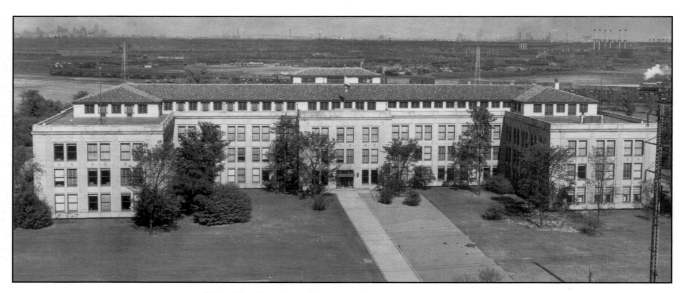

The Ford Motor Company's administration building, built in 1927 on Schaefer Road in Dearborn. Here it is viewed from the top of the Ford Rotunda looking east toward the Rouge manufacturing area on May 29, 1936. Albert Kahn, the architect, said the building was built to stand a thousand years. (833.66145)

Visitors at the front entrance to the Ford administration building observe the bronze panel inscribed with words chosen by Henry Ford. This main entrance leads through a bronze revolving door to a spacious reception room. Separate entrances at the ends of the building are provided for employees and for purchasing department guests. (833.55932-1)

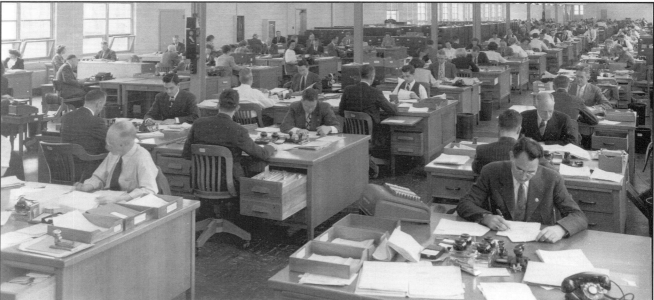

Top: The office of J. R. Davis as it appears on September 26, 1938. Davis is in charge of sales. (833.70709)

Bottom: The accounting and auditing departments in the north section of the administration building. (833. 82320-99)

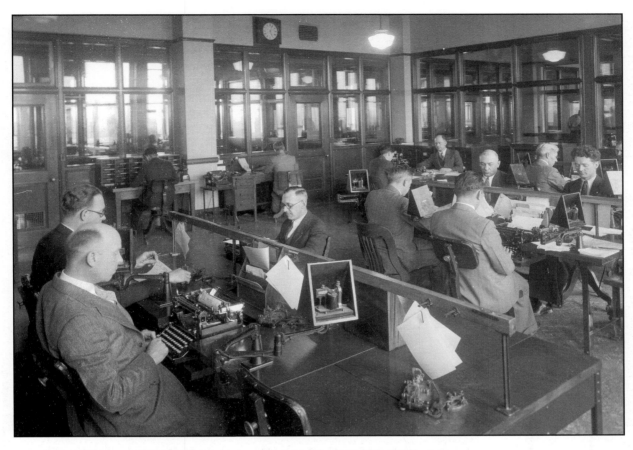

Above: The busy telegraphic department in May 1931.
(833.56217-1)

Left: The mailing department.
(833.79196-14)

The administration building auditorium set up for a banquet on September 1, 1936. (833.66660-A)

Left: An executive dining room on the fourth floor of the administration building in June 1932. (833.56995-2)

Below: The interior of the executive garage attached to the administration building on July 26, 1938. Typical are the shiny black Fords and an occasional Lincoln Zephyr. Employees of lesser rank park their not-so-clean Fords outside in an area behind the building. (833.70478-H)

40

PHOTOGRAPHIC DEPARTMENT

Henry Ford was an early advocate of photography. He had purchased a still camera for personal use in 1896 and took it to New York when he first met Thomas Edison. He purchased his first moving-picture camera in 1913 and, in 1914, ordered the start of the Ford Motor Company motion-picture department at the Highland Park Plant. With dozens of photographers and elaborate film-processing equipment, the company could boast photographic facilities matching those of Hollywood. Along with still photographs to record manufacturing processes, silent movies of Ford operations were distributed widely as both educational films and as a form of advertising. However, with the popularity of "talkies" during the early 1930s, the increased cost of producing sound on film prohibited Ford's continued wide use of movies. Approximately 1.5 million feet of Ford silent films, presented to the National Archives in 1963, are identified in the publication *Guide to the Ford Collection in the National Archives.*

Photography as practiced at the Rouge Plant was intended largely for private instructional and record purposes. Photographs recorded both situations about which management felt proud and those with which management had problems. At the Rouge, facilities were much less elaborate and personnel fewer than those at Highland Park in the earlier days. Nevertheless, a single large collection of Rouge 8-by-10-inch still photographs, taken by Ford Motor Company photographers from the beginning of the Rouge Plant in 1917 until the beginning of World War II in 1941, contains more than 75,000 images. It is from that collection that photographs for this book were selected.

Opposite, top: Filming a batch of red-hot engine crankshafts in April 1930. (833.65716-H)

Opposite, bottom: Filming a scene on the engine assembly line over a pile of hundreds of V-8 engine blocks. Adequate illumination was a necessity. (833.65716)

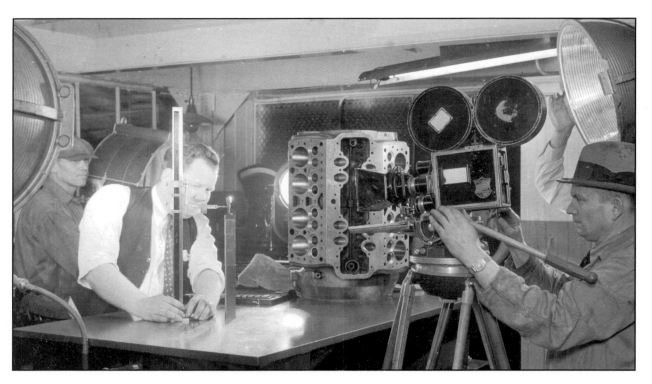

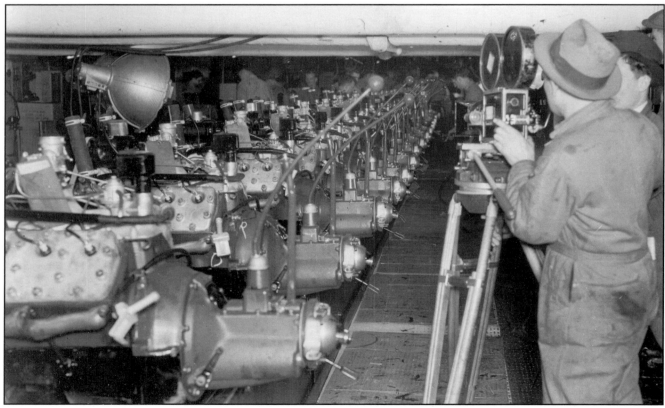

Top: Photographing a technician using Johannson gauge blocks to calibrate a device with which he can very precisely measure the length of a V-8 engine block. (833.65716-B)

Bottom: Filming a long moving line of fully assembled engines with attached transmissions on a conveyor taking them to the B building for assembly in vehicles. (833.65716-K)

Top: The same photographer at work filming the lowering of an engine and transmission onto an automotive chassis as the chassis moves forward on the assembly line. (833.65716-G)

Bottom: The same photographer again filming 1936 Ford cars as they are driven off the final assembly line in the B building. (833.65716-M)

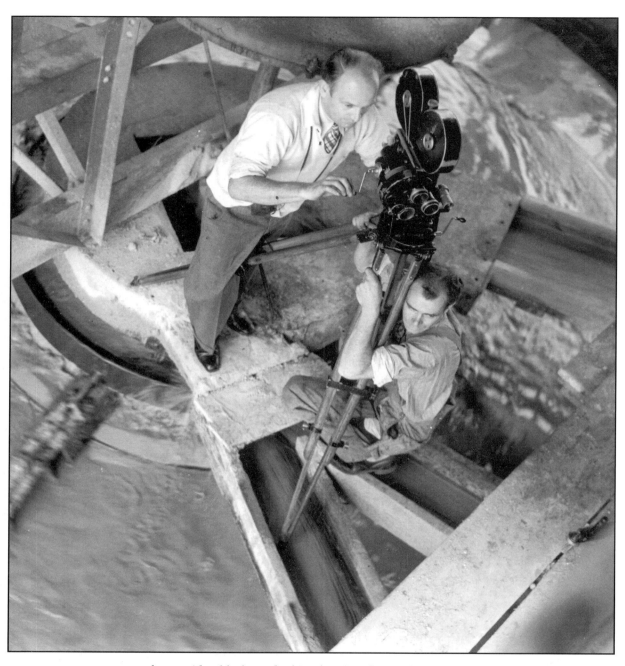

At considerable hazard, this photographer and his helper record the manner of operation of a giant silica sand washer while it is in motion on September 27, 1937. (833.68869)

Opposite, top: A film-processing area in the photographic department in the administration building. Shown are two Rectograph machines with a dryer between them. (833.83926)

Opposite, bottom: This photographic power truck, housed at the administration building, is equipped with electrical generators and long, heavy electrical cables to provide auxiliary illumination whenever and wherever needed. (833.68669-B)

41
FORD ROTUNDA

The Ford Rotunda was built in 1934 for the Century of Progress Exposition in Chicago. The Rotunda's popularity at Chicago convinced Ford management that the same structure would serve well as a welcoming center for the approximately 100,000 tourists visiting the Rouge Plant each year. Dismantling, moving, and reconstructing the Rotunda in Dearborn were completed in May 1936. Strictly speaking, the Rotunda was not reconstructed on Rouge property; it faced the Ford administration building from across Schaefer Road and was connected by a pedestrian tunnel and surface sidewalks. Using the Rotunda as a starting place, more than 100 guides escorted visitors on Ford buses to the Rouge Plant, where the steel mills, machine shops, and final assembly lines were especially popular attractions.

The Rotunda was an attraction in itself. The latest Ford automotive products were always on display. The giant geographic globe in the center was open to the sky, and the large photographic murals of Rouge industrial scenes covering the walls could not but attract attention. Special holiday and children's events drew enormous crowds. The Ford Rotunda was indeed the showplace of the City of Dearborn, as well as of the Ford Motor Company.

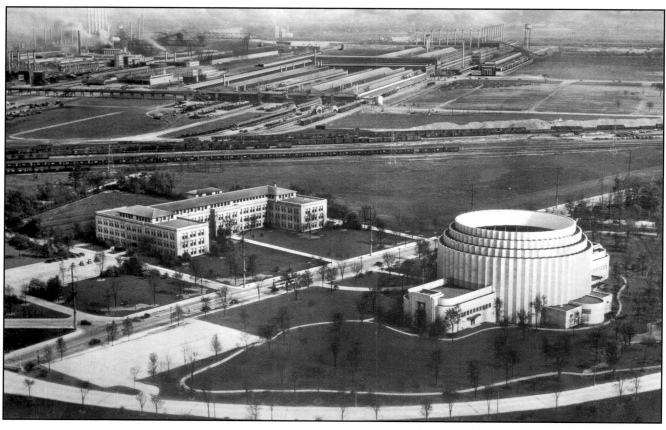

An aerial view of the Rotunda, at the right, facing the administration building, with Schaefer Road between them. Beyond is the Rouge Plant. The circular highway in the foreground was named Rotunda Drive. (833.71349)

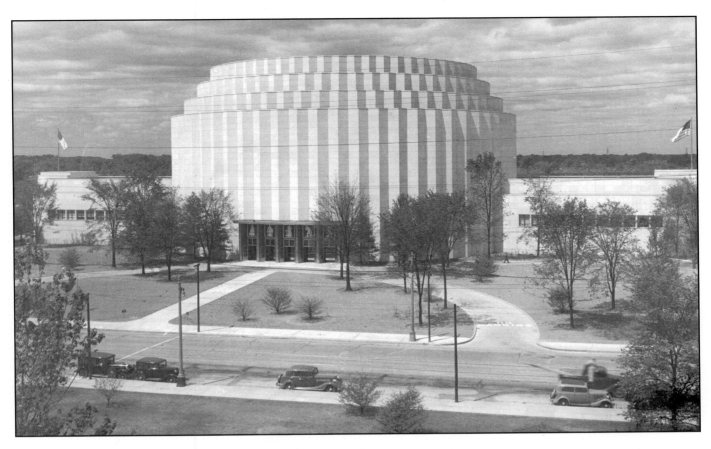

Above: The front of the Rotunda with Schaefer Road in the foreground. The photograph is dated June 1, 1936. (833.66152)

Left: Looking down from the rim of the circular atrium of the Rotunda to a large and colorful world globe mounted on a compass. (833.66811-B)

Right: A close-up view of the world globe. The inscription over the Indian Ocean reads, "Ford Industries Cover the World — Plants, Forests & Mines shown in yellow." (833.68493)

Below: A crowd in the Rotunda attends a musical concert by Fred Waring and his Pennsylvanians on May 6, 1936. (833.66060-A)

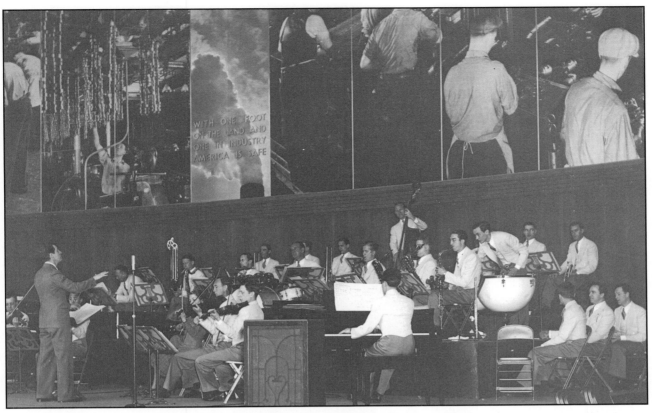

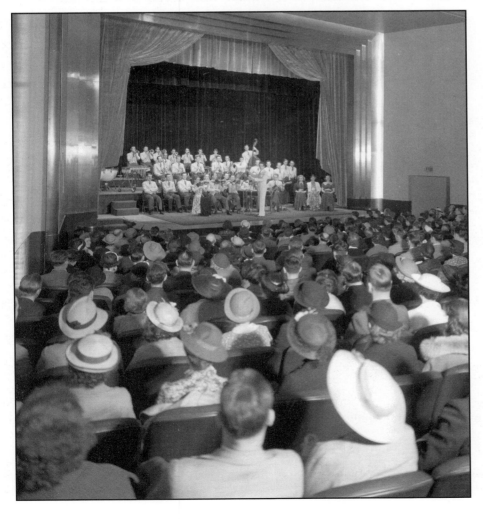

Above: Opening day at the Ford Rotunda on May 14, 1936, with Fred Waring's orchestra seated below the wall of murals. Visible with the murals is Henry Ford's quotation, "With one foot on the land and one in industry, America is safe," one of several such quotations among the murals. Each photograph in the 600-foot mural is a 20-foot enlargement of an original 10-inch photograph of a Rouge manufacturing scene taken by George Ebling, Henry Ford's personal photographer. (833.66036-E)

Left: Fred Waring and the Pennsylvanians entertain on May 16, 1936, in the Rotunda auditorium in the south wing of the building. Featured at this moment is "Evelyn and Her Magic Violin." To the right sit the Lane sisters and "Babs" Ryan. (833.66059-A)

255

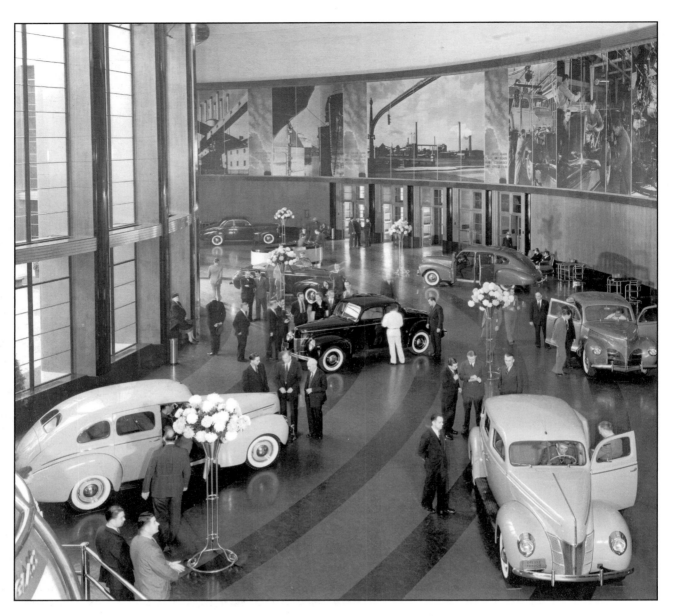

Above: Near the entrance of the Rotunda is a display of 1940 Fords, Mercurys, and Lincolns on October 6, 1939. (833.72517)

Right: A Ford tour guide with his visitors at the north end of the B building on April 18, 1940, as cars and trucks are being assembled. The tours are free, and the guide is not allowed to accept gratuities. The first public tour of the Rouge Plant took place on August 5, 1924. (833.73546)

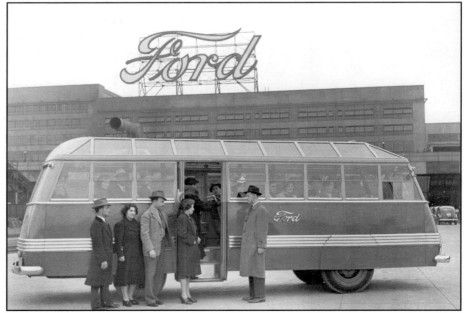

42
SOYBEAN OPERATIONS

Farmers had always made up the majority of customers for Henry Ford's automobiles and tractors. So when the Great Depression struck in 1929, Ford was searching for a crop that farmers could raise and sell to industry, providing money with which farmers could purchase automobiles and tractors. At Greenfield Village in Dearborn, Ford that year built a destructive distillation plant, where dozens of different agricultural crops were separated into their respective constituents to determine which crops contained industrially valuable ingredients. These experiments resulted in the choice of soybeans as the most promising crop. By developing a new and simple solvent extraction method of separating the soy oil from the bean, Ford found the resulting oil useful as a major constituent of a very superior auto enamel. The oil was also useful as an ingredient for automotive brake fluid and as a core binder in foundry operations. The residual soybean meal could be plasticized to provide an extensive variety of small automobile and tractor parts.

Based on the methods developed at Greenfield Village, in late 1935, an industrial prototype soybean-processing plant was built as an addition to the Rouge glass plant. The chief product of the soybean used in Ford car manufacture at that time was the oil. For the one million cars built that year, 850,000 gallons were used for paint, 540,000 gallons for shock-absorber fluid, and 200,000 gallons for foundry core oil. The Rouge soybean-processing plant also produced a sizable number of small plastic automotive parts until 1939. Much of the soy oil extracted at the Rouge Plant was sent to Highland Park, where Ford paints were manufactured.

During 1939, a much larger and more conspicuous Rouge soybean-processing plant was constructed facing Miller Road, south of the powerhouse. Ford, by this time, was proud of his industrial use of soybeans and wanted their use in automobiles and tractors to be well advertised. At this new location, soy oil continued to be extracted for paints, brake fluid, and core oil, and a much greater number and variety of plastic parts were manufactured. In 1940, Ford proudly demonstrated the application of soybean plastic as a material for automotive trunk lids and predicted that entire automotive bodies would soon be manufactured of such plastics.

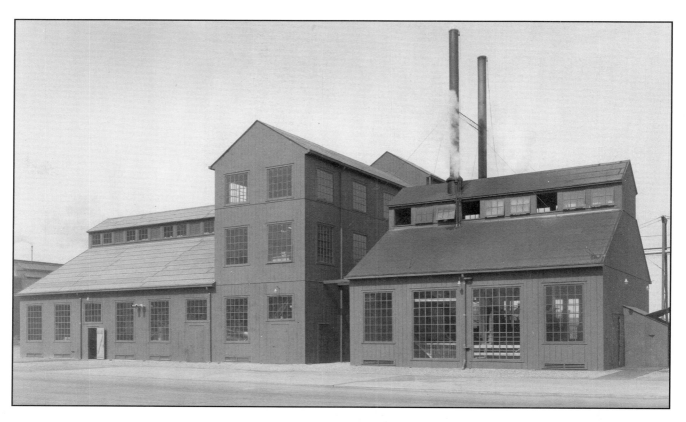

Above: The wooden-framed building next to the Rouge glass plant housing the pilot-sized industrial soybean oil extraction equipment and plastic molding equipment. The building was completed in 1936. (833.66250)

Right: A pile of 60,000 bushels of soybeans stored at the west side of the glass plant on March 12, 1936. This represents the amount of soybeans grown on about 5,000 acres of Ford-owned land. (833.65421)

Left: Crushed and flaked soybeans ready to be fed to the extractor for the removal of oil. With oil extracted, the remaining meal will become a constituent of soybean plastics. (833. 66420)

Below: Tilted oil extraction tubes through which crushed soybeans are mixed with hexane which dissolves the oil from the beans, the hexane being driven off by evaporation to provide pure soybean oil. The photo is dated July 20, 1936. (833.66250)

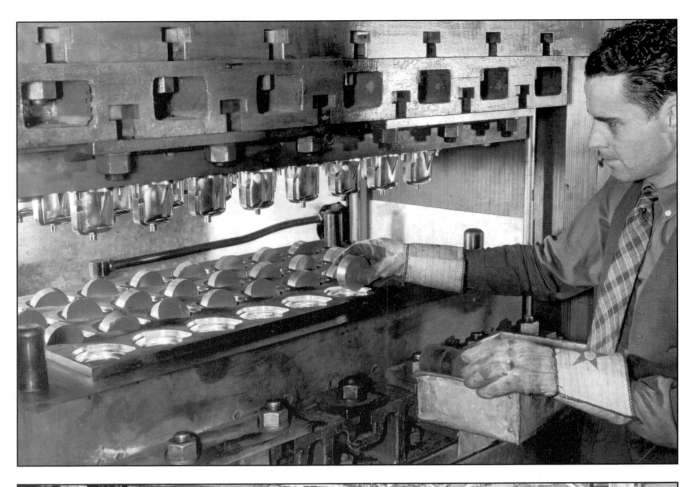

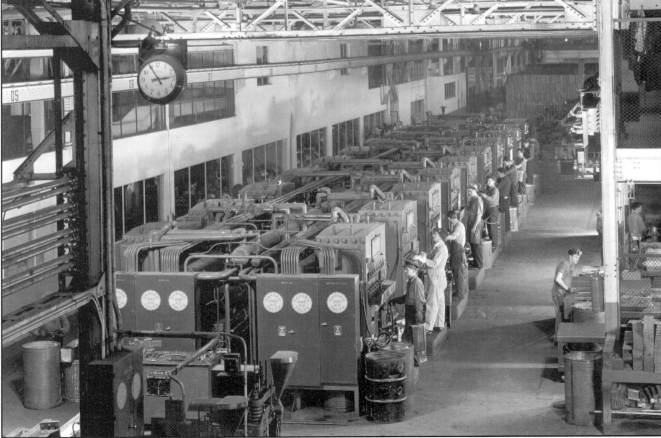

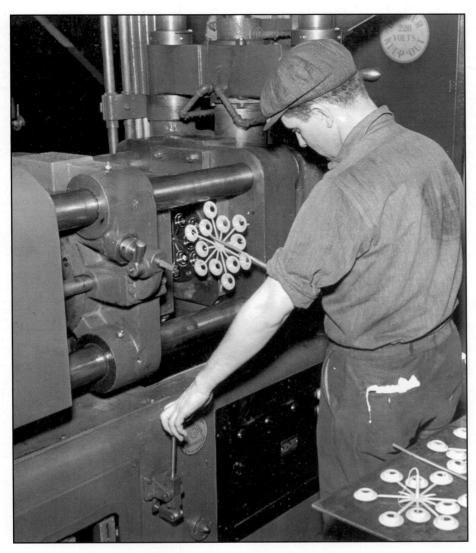

An injection-molding machine that can produce small thermoplastic window hand-crank bezels by the dozen as fast as the worker can remove them from the machine. Pressure of 10 to 15 tons injects the granular materials into a cold mold for about thirty seconds. A battery of these machines produces 70,000 parts in eight hours. These are parts for the 1938 Ford. (833. 70088)

Opposite, top: A man at a plastic molding machine that will form thirty-two automotive distributor contact cases in one operation. These thermo-setting soy materials are heated to 340 degrees Fahrenheit and subjected to 2500 pounds of pressure for about five minutes before being ejected. (833.68087-B)

Opposite, bottom: A battery of twenty back-to-back molding machines, each capable of molding thirty-two distributor contact cases in a single operation. In addition to distributor parts, gearshift lever balls, horn buttons, coil case covers, and other small thermo-setting plastic parts are likewise molded of soybean plastic. The date is March 24, 1937. In the coming years, these machines will be producing plastic steering wheels and seats for Ford-Ferguson tractors. (833.71720-A)

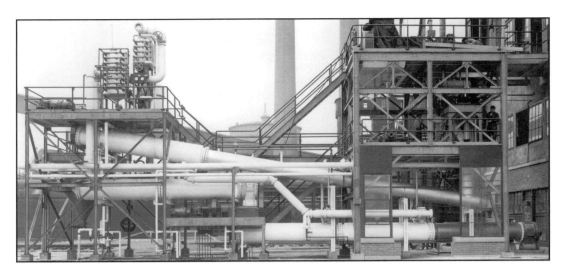

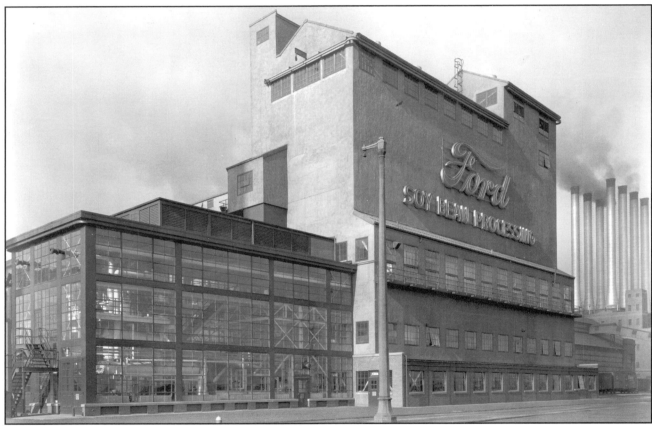

Top: Henry Ford was so proud of his method of extracting oil from soybeans that he encased his entire extracting system in a building of glass so that people could view it. This photograph, taken during construction on August 28, 1939, shows the contents before enclosure. Conspicuous are the large tilted stainless steel tubes in which hexane absorbs the oil from the crushed beans. (833.72292)

Bottom: The new soybean plant facing Miller Road south of the powerplant on November 6, 1940. Here the same manufacturing process is used as was used in the pilot plant next to the glass plant but on a larger scale. Soybean oil is prepared in the building to the left, while in the taller building the beans are crushed and the meal made into a large variety of plastic parts. The large neon advertising sign on the taller building is illuminated day and night. (833.74603-A)

43
TOOL-AND-DIE SHOP

Henry Ford's success in the automobile business was largely a result of continually having improved production machinery designed and built within Ford Motor Company as needed for special purposes. In addition to his automotive chassis and body designers were larger numbers of production machinery designers. During the 1927 changeover from the Model T to the Model A, several thousand men were employed to design and rebuild machinery necessary for efficient production of the Model A.

In the early years at the Rouge, tool and die, pattern making, and machine work were done in several buildings wherever needed. The production foundry machine shop, for example, had a tool-and-die shop of considerable size, and the stamping plant was involved in preparing and maintaining its own dies. In 1938, however, a large new tool-and-die building was constructed in which die, tool, and special machining requirements of the Rouge Plant were largely consolidated.

The men employed as tool-and-die makers were an elite class at the Rouge. Many had graduated from four years of training in the Ford Trade School and additional training in the Ford Apprentice School. With years of working experience, they had become highly skilled in designing, constructing, and repairing machinery in minimal time and with utmost accuracy.

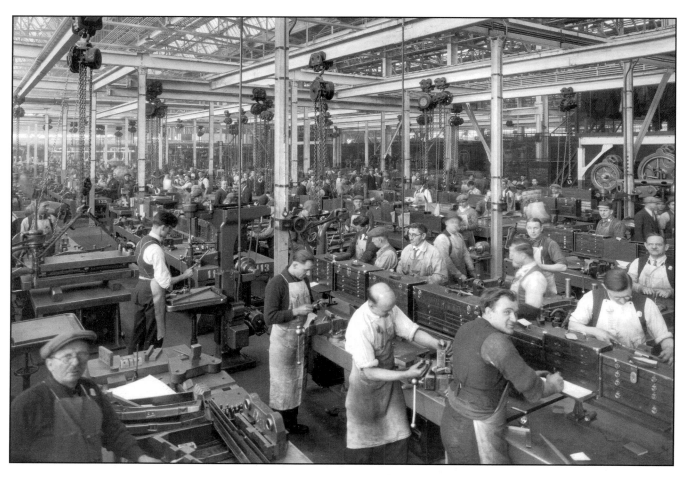

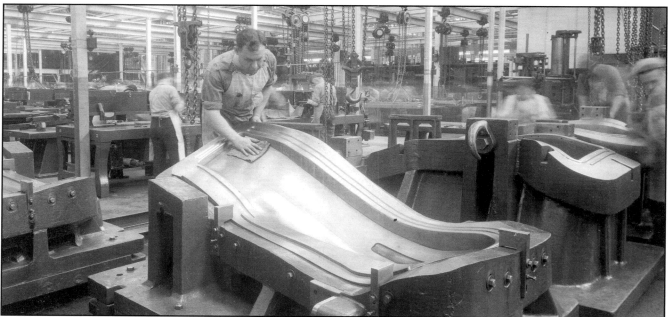

Top: The tool-and-die department in the pressed-steel building on February 1, 1928.
(833.50971)

Bottom: Making sheetmetal dies in the tool-and-die department of pressed-steel
operations in June 1931. Building a set of dies by hand can take several months.
(833.56285)

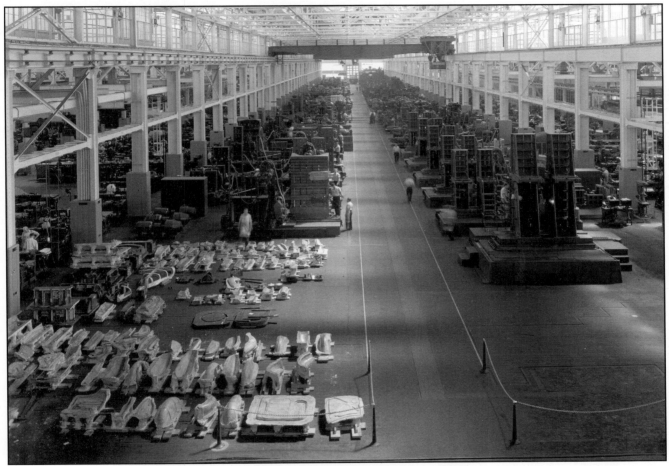

Top: The new tool-and-die building designed by Giffels & Vallet, as photographed on December 8, 1937, shortly following construction. The building is 300 feet wide and 1225 feet long, especially equipped for "no shadow" lighting. There are 95,285 panes of glass in the building. With $3 million worth of equipment, together with spotless dining rooms, marble shower chambers, and tiled lavatories, this is very likely the finest tool, die, and machine construction building in the world. (833. 69463-A)

Bottom: The new tool-and-die building on August 16, 1939. There are 1366 machines in the building, ranging from 100-pound wet tool grinders to 122-ton tryout presses. A group of dies prepared in the shop is shown at the lower left. (833.72259-A)

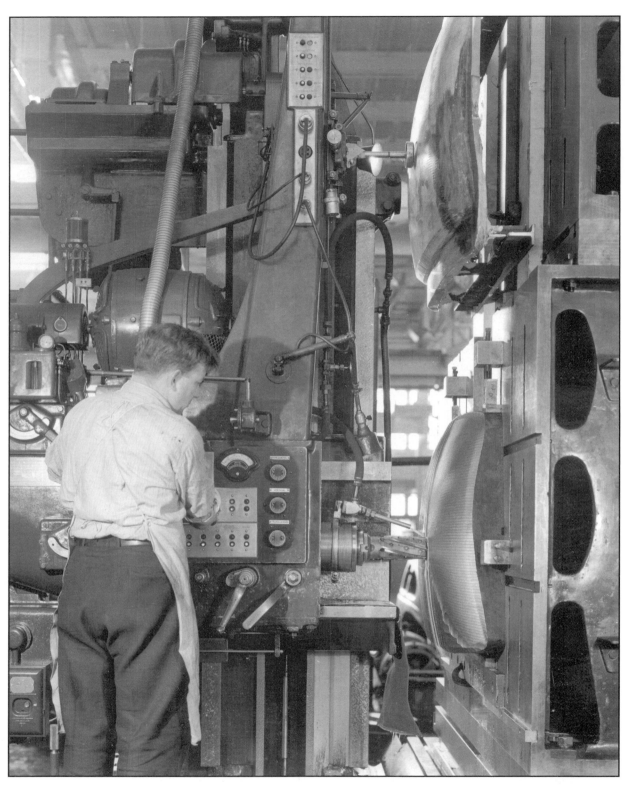

A diemaker, operating a Goddard & Goddard serrated end-mill cutter, is preparing a die for use in the press shop to stamp out an automotive body panel. These mechanical engraving machines allow a die to be prepared in hours rather than months. (833.72760)

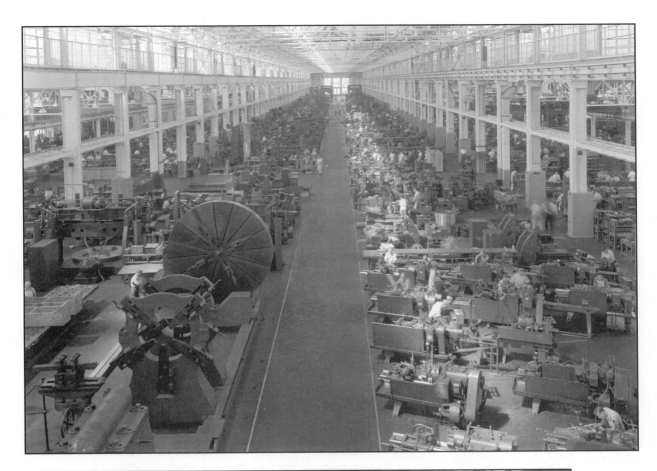

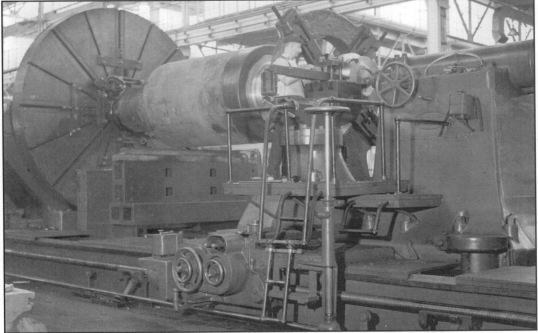

Top: A view down another aisle of the tool-and-die building. Note the giant lathe at the lower left. (833.72259-C)

Bottom: A large lathe in the tool-and-die building turning down a welded shaft on a used roller from the steel mill. This lathe has a swing of 14 feet and is 42 feet between centers. (833.74905)

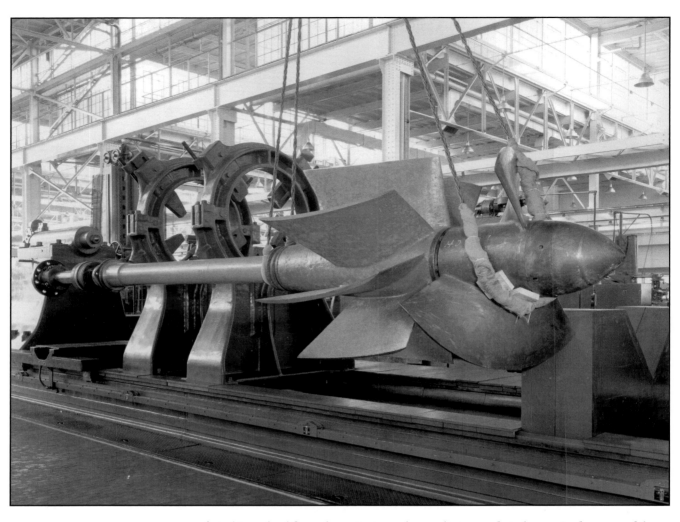

A turbine wheel from the water tunnel pumphouse ready to be repaired on one of the tool-and-die building's giant lathes. (833.72565A)

44
TUNNELS

The largest tunnel serving the Rouge Plant was 2.2 miles long and brought water from a point downstream on the Rouge River and close to the Detroit River to a pumping station adjacent to the Rouge main powerhouse. Following negotiations with the City of Detroit, the tunnel was started in 1929 and finished in 1931 at a cost of $2.5 million to Ford Motor Company. The inside diameter of the tunnel was 15 feet, and its carrying capacity was one billion gallons daily. The tunnel was considered necessary because of the installation of larger turbo-generators in the powerhouse together with the need for more cooling water for steelmaking.

Throughout the Rouge Plant, a service tunnel connected major buildings. This tunnel system, measuring 12 feet wide and 9 feet high, with a total length of about 1.5 miles, connected open hearth, steel mill, pressed steel, spring and upset, glass plant, B building, foundry, and powerplant. Installed in the tunnel were two 12-inch lines for steam at 250 pounds, one 16-inch mill water line, one 16-inch city water line, one 10-inch compressed air line, and 16-inch hot-water piping.

During 1936–37, a sizable service tunnel was constructed across the southern end of the Rouge Plant and under the boat slip. This circular concrete tunnel of about 12 feet in diameter carried a 48-inch gas line, a 36-inch mill water line, a 24-inch city water line, and a 20-inch steam line, together with 6-inch oil and tar lines and a dozen or so electrical conduits. The major purpose of this tunnel was to supply the open-hearth building with coke-oven gas for the furnaces and to supply the steel mill with cooling water.

A workman operates a hydraulic jack pressing 3410-pound cement blocks into place
to form the 15-foot-diameter, 18-inch-thick inner lining of the Rouge water intake
tunnel. The tunnel is about 60 feet below ground level, with the greater part of the
work in blue clay of the consistency of putty. (833.56356)

Left: A Ford car in the Rouge water tunnel in May 1931, the year the tunnel was finished. From the intake gates in the Detroit River, the tunnel passes under a dozen streets, streetcar and railroad tracks, bridges, city sewers, a creek, and a cemetery. (833.56124-1)

Below: Interior of the lift-pump house next to the Rouge powerhouse. These pumps draw 650 million gallons of Detroit River water into the Rouge Plant daily to serve manufacturing operations. (833.57219-6)

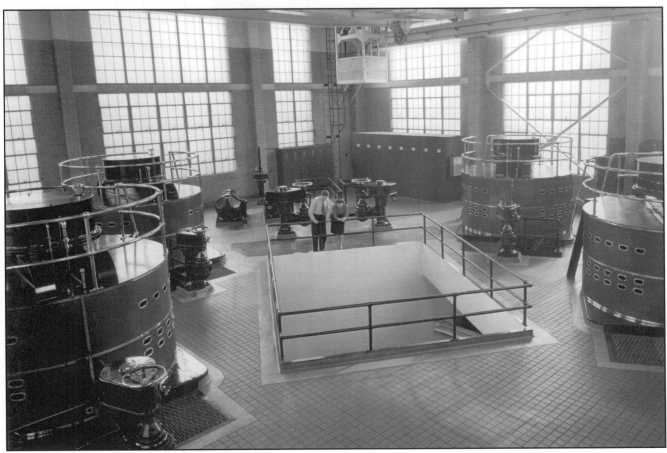

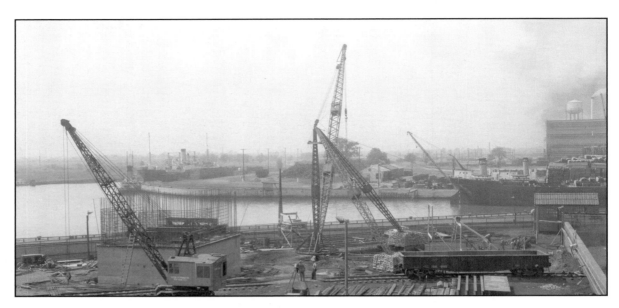

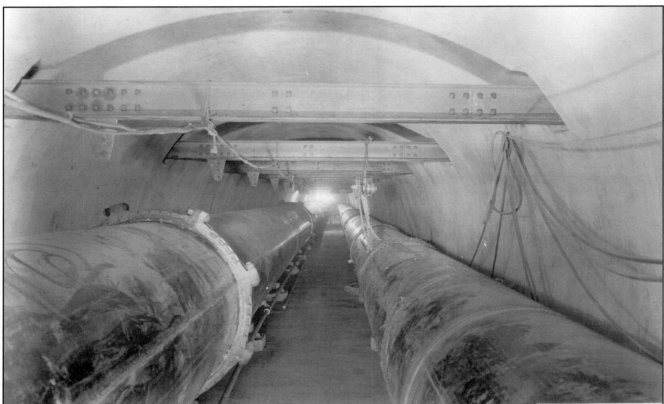

Top: A construction scene looking southwest across the ship turning basin, the site of a large plantwide service tunnel. The tunnel head houses are being built on each side of the basin in August 1936. Steel reinforcing rods are visible as progress is made on this east bank of the basin. On the far right in the distance is the open-hearth building with its water tank, to which the tunnel will go. (833.67975-12)

Bottom: Interior view of a section of the Rouge Plant service tunnel under construction in February 1937. The 48-inch gas line on the left is to carry coke-oven gas, while the 36-inch pipe on the right is to carry mill water. Other lines yet to be included are a 20-inch steam line, a 24-inch city water line, 6-inch oil and tar lines, and a dozen or so electrical conduits. (833.67975)

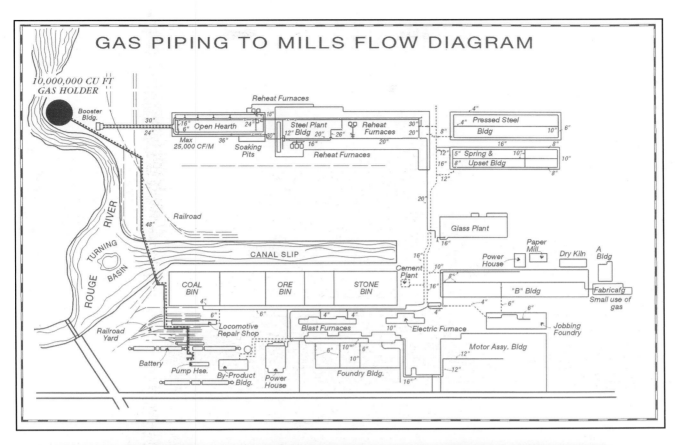

GAS PIPING TO MILLS FLOW DIAGRAM

10,000,000 CU FT GAS HOLDER

Booster Bldg.

Reheat Furnaces

Open Hearth

Steel Plant Bldg

Reheat Furnaces

Reheat Furnaces

Soaking Pits

Pressed Steel Bldg

Spring & Upset Bldg

Max 25,000 CF/M

ROUGE RIVER

TURNING BASIN

Railroad

CANAL SLIP

Glass Plant

Cement Plant

Power House

Paper Mill.

Dry Kiln

A Bldg

COAL BIN

ORE BIN

STONE BIN

"B" Bldg

Fabricatg

Small use of gas

Railroad Yard

Locomotive Repair Shop

Blast Furnaces

Electric Furnace

Jobbing Foundry

Battery

Pump Hse.

By-Product Bldg.

Power House

Foundry Bldg.

Motor Assy. Bldg

Top: Distribution chart showing sizes of gas pipe leading to each building throughout the Rouge by means of the plantwide service tunnel when first planned in 1936.

Bottom: A later section of the plantwide service tunnel being installed to connect the rolling mill with the new tire plant in 1938. Again, gas, mill water, city water, and steam pipes dominate. (833.69466)

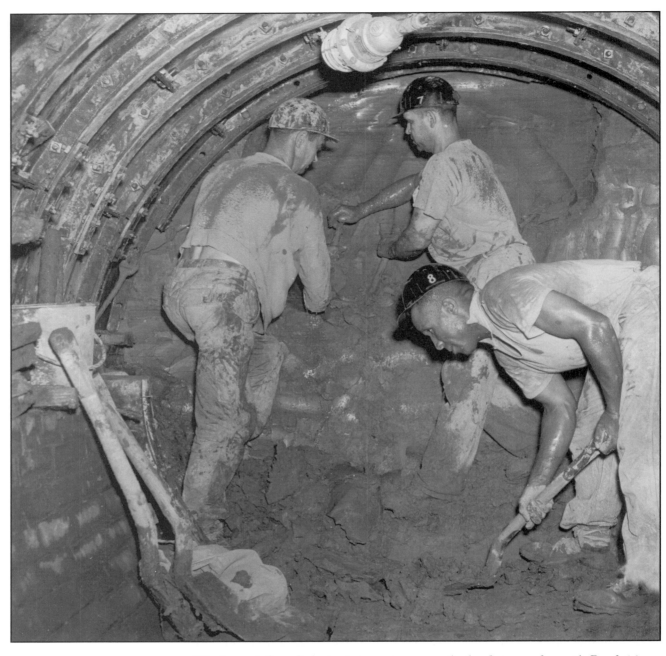

Digging a 6-foot-diameter interceptor sewer the hard way underneath Road 4 in August 1937. (833.68520)

45

TIRE PLANT

Although he was a very close friend of Harvey Firestone, and indeed Firestone's major customer, Henry Ford felt the need to control his own supply of raw materials, including rubber for tires. Especially in 1922, when the British rubber cartel doubled the price of Indonesian rubber, Ford and Firestone combined their efforts to find places where they could raise rubber trees for themselves. With Thomas Edison, they conducted experiments to find a rubber-bearing plant native to the United States. (Edison eventually found goldenrod worthy of consideration.) For large-scale rubber production, however, Firestone selected Liberia in West Africa, and by 1927, Ford had obtained a concession of 2.5 million acres on the Tapajos River in Para, Brazil. The first plantings of rubber tree seedlings on Ford's rubber plantations in Brazil were begun in 1928; by 1937, they had matured sufficiently to warrant building a tire factory at the Rouge.

On February 1, 1937, ground was broken for a new 250,000-square-foot Rouge tire plant. Total cost was estimated at $7 million, of which $5.6 million was for tire and tube machinery manufactured by the National Rubber Machinery Company of Akron, Ohio. Firestone personnel assisted Ford in construction and initial operation of the plant. Edgar F. Wait, an experienced Firestone employee, was hired to manage the Rouge tire plant. Production of tires was under way in 1939, with designed capacity of 16,000 tires a day. About 2000 workers were employed. Design of the plant was extremely innovative; it was said to be the world's most advanced tire plant, employing the latest in equipment. Using a continuous flow principle, the time consumed from raw material to finished product was less than five hours, rather than the usual two to four days. It was the first rubber plant to weigh automatically the compounding chemicals and automatically control the giant mixing machines. The processes were so designed that a tire of highest quality was obtained without the use of skilled labor.

By 1942, the Rouge tire plant had produced nearly 8 million tires bearing the Ford label, using latex primarily from the Far East until that source of supply was cut off by the Japanese. Only 750 tons had arrived from Ford's young Brazilian trees. At that time in the United States, there was a severe shortage of rubber. At the same time in the Soviet Union, there was plenty of rubber but a shortage of tire-making machinery. So the U.S. government, in 1942, acquisitioned Ford's tire-making equipment and sent it to the Soviet Union by way of Vladivostok. Reports are that the equipment was never reassembled.

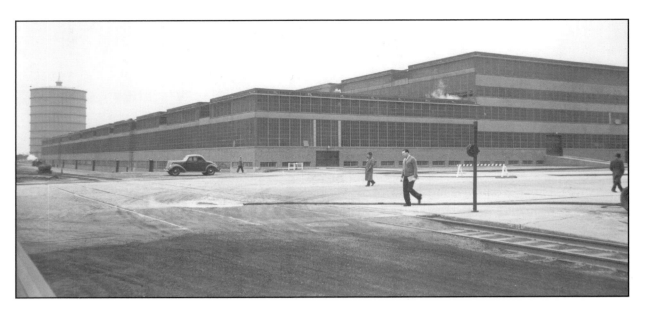

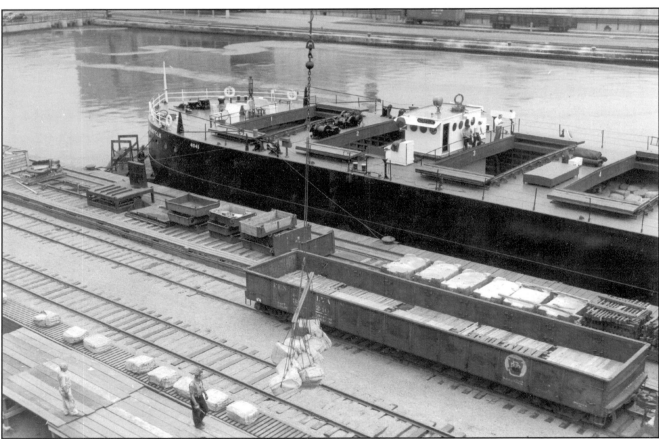

Top: The Rouge tire plant, designed by Albert Kahn, shortly after being built facing Road 4 on a rather chilly day in May 1938. To the left, out of sight, is the boat slip where the boats supplying latex dock. The gas holding tank at the left is not part of the tire plant. (833.70202-Y)

Bottom: Motorized barges owned by Ford Motor Company brought Indonesian raw rubber transshipped from New York City. Here are bales weighing the standard 225 pounds being lifted by crane from the ship's hold onto a conveyor taking the rubber directly into the tire plant. (833.72140-B)

Ingredients to be mixed with the rubber are stored on the top floor of the building and measured with great accuracy before being blended with the rubber. In addition to whiting, zinc oxide, clay, and lime is a blend of fillers consisting of softeners, carbon black, sulfur, accelerators, anti-oxidants, and so on. (833.20202-O)

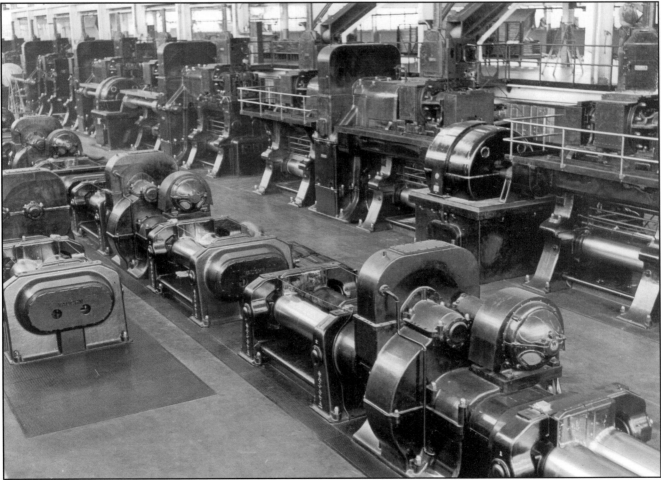

The ground floor of the tire plant, where twelve giant Banbury mixers (masticators) built by Farrel-Birmingham provide the means of blending the necessary additives with the rubber. Each Banbury is positioned directly over a sheeting mill. Together these machines turn out 275,000 pounds of tire rubber stock every sixteen hours. (833.70202-F)

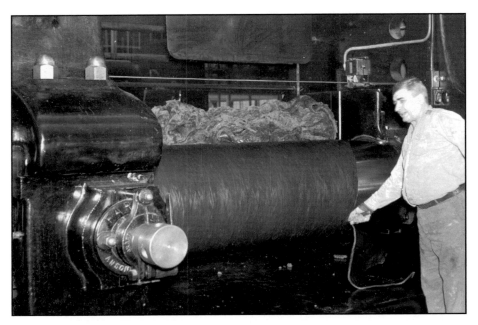

Top: Close-up of a Banbury mixer. The machine consists of two heavy, smooth iron rolls in a heavy frame. The rolls rotate toward each other, with the back roll 25 percent faster than the front roll to produce friction. A batch of about 325 pounds is mixed for 15 minutes before being transferred to the sheeting mill to produce smooth rubber sheets. (833.70021)

Bottom: For the production of cord necessary for the tire carcass, a large loom for spinning cotton is used. It consists of a creel with hundreds of bobbins. The resulting cotton warp is seen at the upper left. (833.71233-D)

Left: After weaving, the cotton cord is dipped into molten rubber and pressed between two rollers (calendered) to provide the rolled sheets of "gum-dipped" cord used as tire plies. (833.71173-E)

Below: On the tire-building machine, cord and rubber plies are layered together on a revolving drum. The worker's right foot starts and stops the turning of the drum as the plies are fed from above. There are eighty of these tire-building machines in the tire-building department. (833.70202-A)

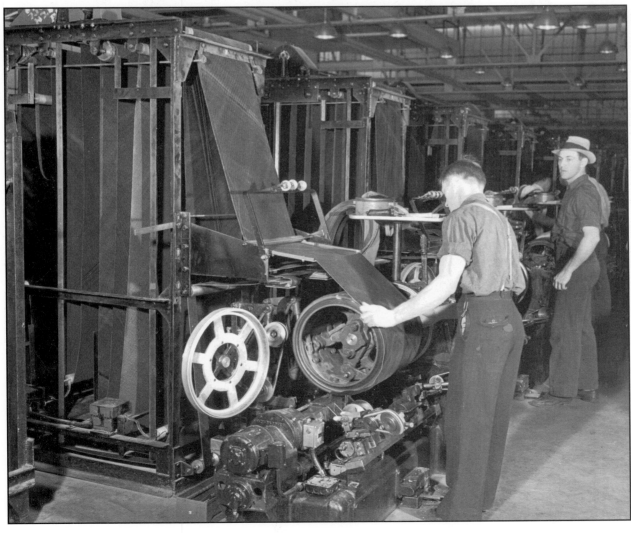

The curing department. Each curing unit vulcanizes one tire by means of steam at 180 to 190 pounds per square inch. This step also impresses the tread design. Inside the tire is a bag inflated to 300 pounds of pressure with an inert gas. Curing requires forty-five minutes. As an innovation, at the Rouge tire plant the inert gas is carbon dioxide from the exhaust of Ford V-8 engines. An automatic timing device opens the mold so that the tire can be removed. (833.70303)

Finished tires are picked from the conveyor and checked for balance. Imprinted on the sidewall are "Ford," "Ford Motor Company," and "6.00-16." (833. 71467A)

EPILOGUE

The period covered by this book (1917 to 1940) includes primarily the formation of the Rouge and its concentration on the manufacture of automobiles, trucks, and tractors. At the end of this period, focus quickly shifted to the manufacturing needs of the U.S. military during World War II. Ford Motor Company, including the Rouge Plant, became a major participant in the nation's Arsenal of Democracy. Every division of the company became involved one way or another in government defense work. Edsel Ford was particularly assertive in leading the company during this massive transition.

Defense contract work prevailed at the Rouge Plant from 1941 to 1945. During that period, there were several major additions, including a large aircraft engine plant, an armor-plate building, a magnesium smelter, a magnesium foundry, an aluminum foundry, and a naval training station accommodating 2000 students. Products such as aircraft engines, tank engines, jeeps, amphibians, military trucks, armored cars, and aircraft engine superchargers were built in quantity. During the war, however, soybean operations and cement production were shut down. Following the war, the aircraft engine plant, the armor-plate building, and the magnesium smelter were purchased from the government by Ford.

By the end of World War II, Edsel Ford had died, Henry Ford was in ill health, and Henry Ford II became president of Ford Motor Company. With the arrival of Henry Ford II in 1945 and with the complete reorganization of the company, employee morale was greatly enhanced. A new era included better relations with the unions and such welcome employee benefits as annual vacations, unemployment compensation, and a generous pension system.

Following the war, besides producing iron and steel, the Rouge did not have the central importance it once had. Its fleet of ships, with the exception of the ore carriers *Henry Ford* and *Benson Ford,* were sold in 1947. In November 1948, the third and largest blast furnace, named the William Clay Ford, began producing iron, and a new and larger *Willian Clay Ford* ore carrier was added in 1953.

At least two reasons led to decentralization of the Ford Motor Company following World War II. Ford executives, some but not all, realized that a plant the size of the Rouge could be a prime target in a nuclear conflict with the Soviet Union, and its size was thus a disadvantage. In addition, it was acknowledged that efficiency of production required highly automated factories and that plants of single-floor construction were advantageous. Such plants required more acreage than was available at the Rouge. Dispersal of Rouge manufacturing was noticeable as early as 1949, when Ford tractor facilities were moved from the Rouge to Highland Park and soon after farther out to Troy, Michigan.

By 1958, the company had spent $2.5 billion on expansion and modernization, but a relatively small amount was spent on the Rouge.

Total company expansion was to include more than twenty new and modernized plants, such as foundries at Cleveland and Canton, Ohio, and at Flat Rock, Michigan; engine plants at Cleveland and Lima, Ohio, and at Windsor, Ontario; stamping plants at Buffalo, Chicago, and Cleveland; trans-

Henry Ford II in his office at the Rouge administration building on December 12, 1946. (833.83655-1)

mission plants at Cincinnati and at Livonia, Michigan; and a glass plant at Nashville, Tennessee. In 1956, a new twelve-story Ford World Headquarters was erected on Michigan Avenue in Dearborn, about two miles from the Rouge Plant. This new building replaced the Rouge administration building which had served as Ford's headquarters for thirty years. That same year, Ford Motor Company common stock was offered to the public.

In steelmaking, however, the Rouge remained dominant within the company. By 1960, plans were under way to construct two giant basic-oxygen furnaces displacing the ten open-hearth furnaces. First tapped in March 1964, these giant basic-oxygen furnaces produced 250 tons of steel at 3500 degrees Fahrenheit in less than an hour using pure oxygen as fuel. In 1974, a new 68-inch hot strip mill was added. In December 1981, Rouge Steel Company was formed as a wholly owned subsidiary of Ford Motor Company. The Ford ore ships *Benson Ford* and *Henry Ford II,* as part of Rouge Steel operations, were sold during the 1980s. In 1986, a $145-million continuous-slab-casting plant was added to Rouge Steel operations. The 181 coke ovens were abandoned in 1987, and coke needed for blast furnaces was purchased.

In December 1989, Rouge Steel, occupying approximately 500 acres and operating equipment consisting primarily of blast furnaces, basic-oxygen furnaces, the continuous-slab-casting plant, rolling mills, ships, docks, coal and ore bins, together with 60 percent of the number 1 powerhouse, was sold to Marico Acquisition Company, a group of investors headed by Carl L.

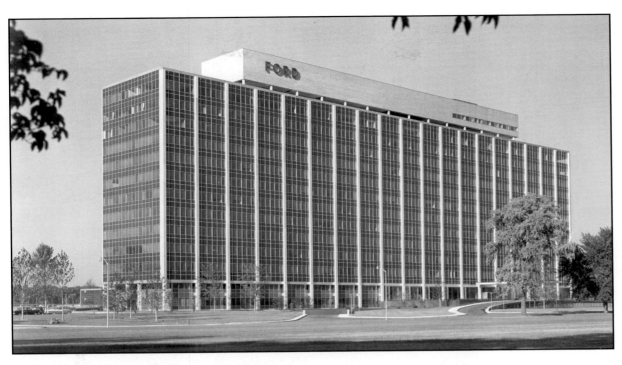

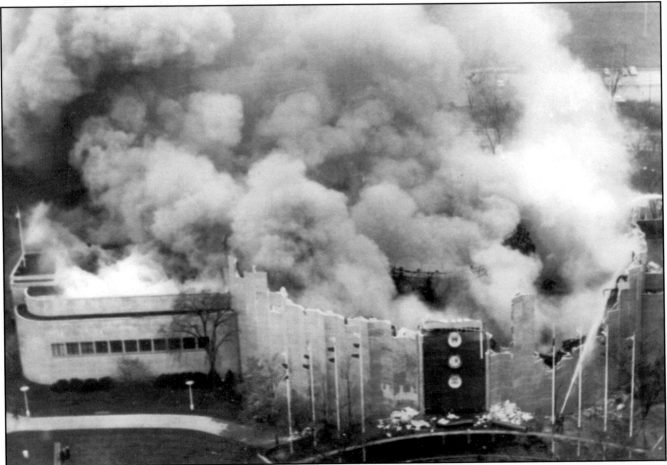

Top: The new Ford World Headquarters, built in 1956 on Michigan Avenue in Dearborn. (833.110171-2)

Bottom: Accidental fire at the Ford Rotunda in Dearborn on November 9, 1962. (833.130646-132)

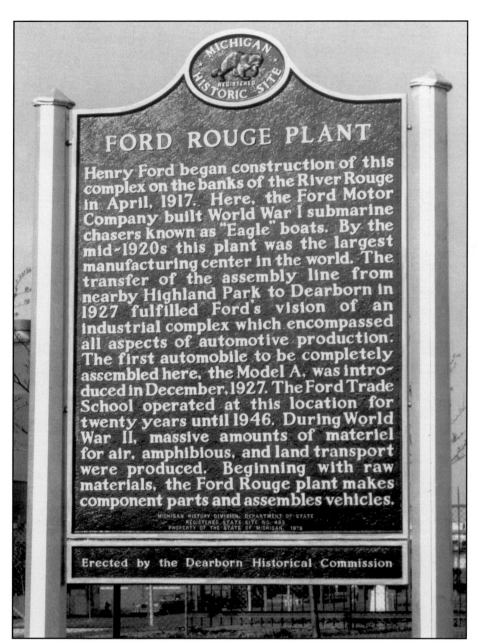

One of three historic markers placed on the perimeter of the Rouge Plant and photographed in May 1978; this one is near Gate 4 on Miller Road. (Photo courtesy of Dearborn Historical Museum.)

Valdiseni. Now known as Rouge Industries, an independent integrated steel producer, it went public on the New York Stock Exchange in 1994.

Prior to the sale, in 1987, the oldest of the three blast furnaces, the Henry Ford, had been taken down, leaving two blast furnaces to supply the two basic-oxygen furnaces. On November 9, 1962, the Ford Rotunda had caught fire accidentally and was destroyed. By the end of the 1980s, other large Rouge landmarks, such as the production foundry, the original motor building, and the conspicuous 10-million-cubic-foot gas tank, had been torn down. By 1996, the administration building on Schaefer Road, built to last 1000 years, was scheduled for demolition. Most disheartening was a disastrous boiler explosion in the number 1 powerhouse on February 1, 1999, killing six workers and injuring thirty more.

The remaining Rouge area now owned by Ford Motor Company consists

A Rouge historic marker at Gate 2 as photographed in 2002. In the distance, at the left, are the two blast furnaces operated by Rouge Industries. (Photograph courtesy of Rouge Industries, Inc.)

of about 600 acres on which remain the tool-and-die building, a frame plant, a stamping plant, an engine plant, a glass plant, an automotive assembly plant, and a two-story office building. A new powerhouse, fueled with natural gas instead of pulverized coal, has been built directly across Miller Road from the original powerhouse but is owned and operated by CMS Energy.

Future plans for the Rouge, now that Henry Ford's great-grandson William Clay Ford, Jr., is in charge, include a $2 billion investment to revitalize the site. In 1997, Ford Motor Company and the UAW signed a "Rouge Viability Agreement" to modernize the site rather than let it die from obsolescence. Plans are to save portions of the Dearborn assembly plant (B building) and the glass plant, both designed by Albert Kahn, as representative examples of early industrial architecture. An entirely new truck assembly plant, designed for flexibility as well as top efficiency, is being constructed with exceptionally innovative ecological features. The extensive use of native plants to reclaim toxic soil and control surface water is to be demonstrated in this twenty-first-century Rouge Center.

In 2004, the Ford Motor Company in partnership with Henry Ford Museum & Greenfield Village, will again operate a Rouge factory tour. After a lapse of twenty-three years, visitors will again be able to witness Rouge in action. From Henry Ford Museum & Greenfield Village in Dearborn, visitors will be taken by motor coach to the Rouge Plant Visitor Center adjacent to the new and innovative vehicle assembly plant. At the visitor center, viewing of an elaborate visual history of the Rouge Plant will be followed by a visit to the assembly plant to see Ford F-150 trucks being assembled.

Ford Bryan has written six other books about Henry Ford, including:

THE FORDS OF DEARBORN
An Illustrated History

HENRY'S LIEUTENANTS

BEYOND THE MODEL T
The Other Ventures of Henry Ford

HENRY'S ATTIC
Some Fascinating Gifts to Henry Ford and His Museum

CLARA
Mrs. Henry Ford

FRIENDS, FAMILIES AND FORAYS
Scenes from the Life and Times of Henry Ford

For more information, please see this web site:
http://wsupress.wayne.edu

to order books, call Wayne State University Press
1-800-978-7323

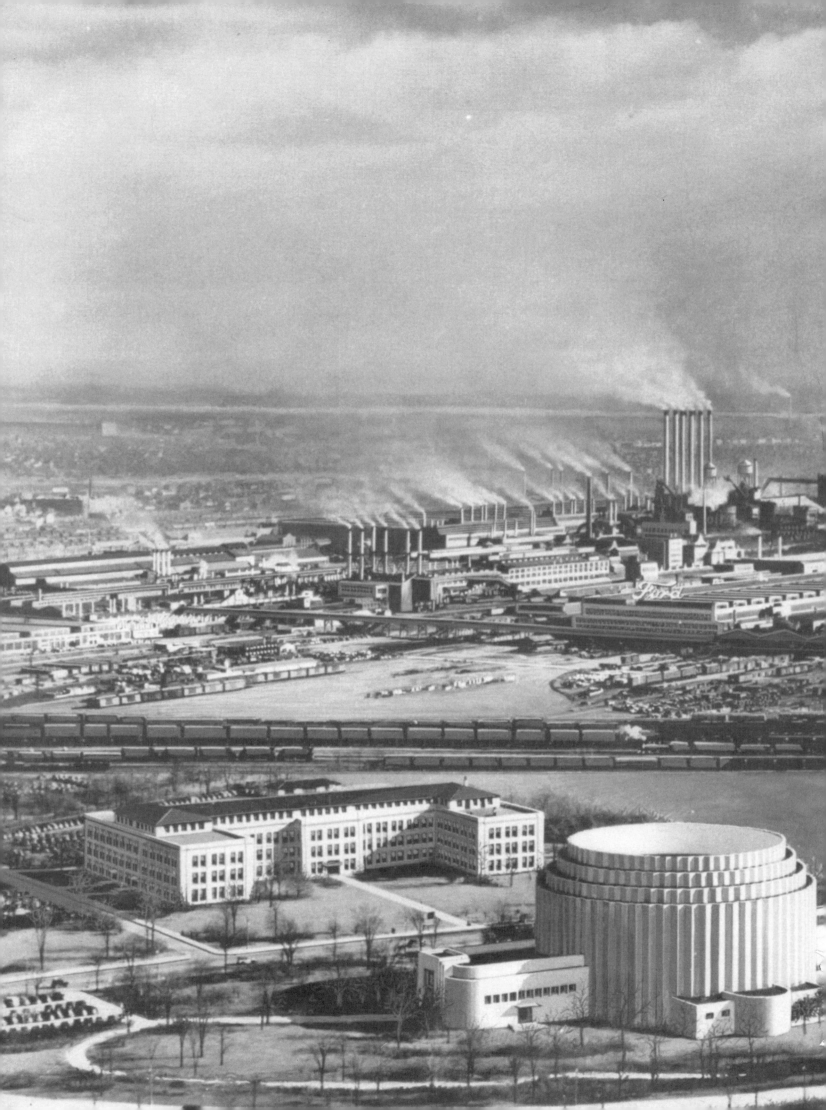